The Photographers

Craig and Nadine Blacklock

Tom Blagden, Jr.

Jim Brandenburg

Willard Clay

Carr Clifton

Kathleen Norris Cook

Jack Dykinga

Tim Fitzharris

Jeff Foott

Jeff Gnass

Fred Hirschmann

Charles Krebs

Frans Lanting

Wayne Lynch

Tom Mangelsen

Joe McDonald

David Middleton

David Muench

William Neill

John Netherton

Pat O'Hara

Bryan Peterson

Rod Planck

James Randklev

Galen Rowell

John Shaw

James Sugar

Steve Terrill

Larry Ulrich

Kennan Ward

Art Wolfe

Norbert Wu

Additional Photography by

Bill Fortney

Hugh Morton

Cliff Zenor

THE NATURE
OF AMERICA

Images by North America's
Premier Nature Photographers

Created by Bill Fortney and David Middleton
with a Foreword by Charles Kuralt

Text by David Middleton

Designed by Tom Walker

Edited by Robin Simmen

AMPHOTO ART
an imprint of Watson-Guptill Publications/New York

Dedication

*For our families, especially Sherelene and Claire, who have helped us
make this dream come true, and for our exceptional team of photographers
who so wondrously captured the beauty of North America.*

Library of Congress Cataloging-in-Publication Data

Middleton, David, 1955-
 The nature of America : images by North America's premier
photographers / text by David Middleton ; created by Bill Fortney
and David Middleton ; with a foreword by Charles Kuralt.
 p. cm.
 ISBN 0-8174-4994-9
 1. Nature photography--United States. I. Fortney, Bill, 1946-.
 II. Title.
TR721.M54 1997 97-11471
799'.3'0973--DC21 CIP

*(Page 1, © Jack Dykinga) Red maple in autumn, Acadia National Park, Maine.
(Previous pages, © Jack Dykinga) Sunset through passing storm, Grand Canyon National
Park, Arizona.*

Edited by Robin Simmen
Designed by Tom Walker
Graphic production by Sharon Kaplan

Manufactured in Italy

1 2 3 4 5 6 7 8 9 /05 04 03 02 01 00 99 98 97

Acknowledgments

When we hatched this book project, we had no idea how involved it would eventually become. In the past, we've relied solely on our wits and wily ways to bring projects to completion, but this book could never have been published without the help of many people. Foremost among these are Wayne Lynch and John Shaw, accomplished photographers and writers in their own right, who freely lent their experience and wisdom to us on all matters relating to this book.

Many others helped us along the way by providing information, access, or equipment. These people include Tom Ackerman, David Alexander, John Altberg, Marc Boris, Rick Browne, Jim and Jamie Clark, Jerry Grossman, Richard LoPinto, Greg Lowe, David Lyman, Ray Moncrief, Hugh Morton, Robert and Karen Rankin, David Riley, Bill Pekala, George Pugh, Jack Renner, Scully, Dan Steinhardt, and the folks at *Outdoor Photographer* magazine.

A number of companies lent their experience and expertise to us. All the photographers were supplied with film from Eastman Kodak Company, outerwear from W.L.Gore & Associates and Marmot Mountain Works, photography gear from Nikon USA, hiking boots from Vasque Boot Company, and camera backpacks from Lowe-Pro. Also, A&I Color provided the project with very high-quality reproductions and digital scans. We thank them all for their support.

We especially wish to thank the technical reviewers of the text—Dr. Wayne Lynch, Dr. Michael Middleton, and Dr. David Pearson—as well as the text readers—Claire Beck, Laura Bohlke, Aubrey Lang, Eliso Chatara-Middleton, Anne and Don Middleton, and Stephen and Diana Middleton—for their comments and suggestions.

Of course, this book would have been impossible without the cooperation and artistry of our 32 photographers. Several books could have been produced from the thousands of images we received from them, and we regret that we could only include a small portion of their outstanding work in this book. We also wish to thank Charles Kuralt for his compelling Foreword and for supporting this project from the very beginning.

Finally, the folks at Amphoto Art and Watson-Guptill Publications embraced our dream from the very beginning, and nourished it with their expertise and enthusiasm. We especially would like to thank Robin Simmen, senior editor at Amphoto Art, for her professionalism and calm reassurance when things appeared to be out of control (which was often) and Tom Walker, the book's designer, who took our nebulous ideas and laid them out beautifully on paper.

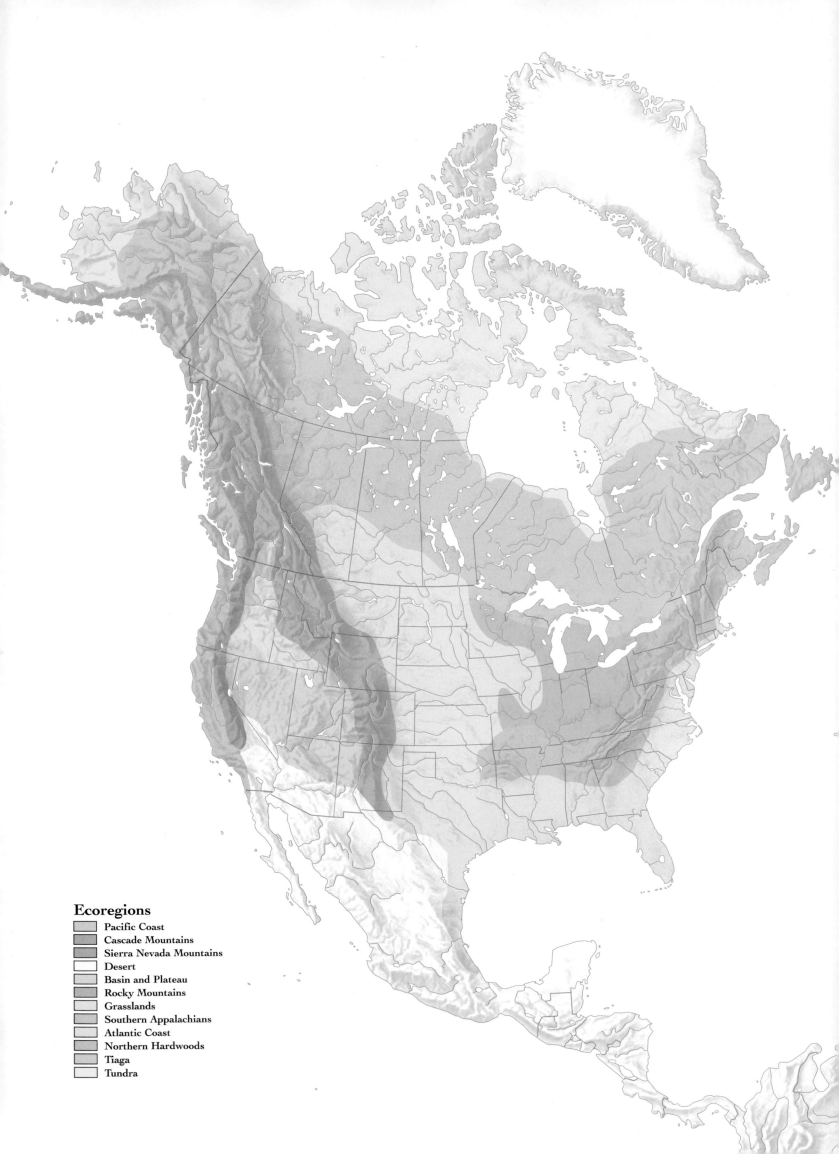

Ecoregions
- Pacific Coast
- Cascade Mountains
- Sierra Nevada Mountains
- Desert
- Basin and Plateau
- Rocky Mountains
- Grasslands
- Southern Appalachians
- Atlantic Coast
- Northern Hardwoods
- Tiaga
- Tundra

Contents

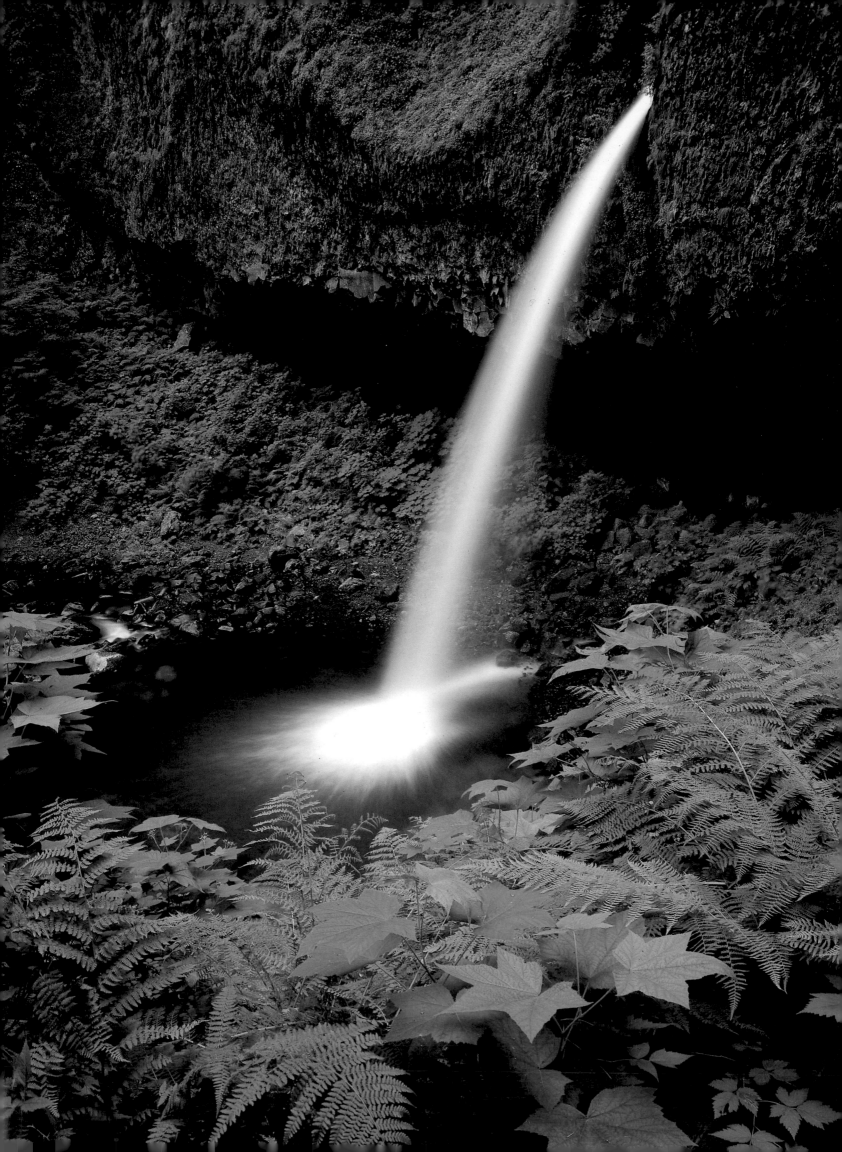

Foreword

Note to my grandsons: Turn these pages slowly. Do not be in a hurry to leave one image and go on to another. This is how part of your country still looked at the end of the twentieth century.

When I was your age, fifty years ago, my brother and I often packed sandwiches, walked down to the creek that meandered behind our house, and followed the little stream through the pine woods for hours. We saw no footprints and heard no human voices but our own. It was easy to imagine that we were the first explorers in the country, the first to cross a log from one side of the creek to the other, the first ever to visit a rock outcropping above the creek that we called "the secret place." We scouted out the rabbits and squirrels along the way. We knew the brushpile where the muskrat lived and the pool where the polliwogs swam and the open field where the low-flying hawk stalked the meadow mice. We knew the thicket where the persimmons turned ripe after the first frost. Songbirds sang to us on our way down the creek in the mornings, and owls hooted us home in the half-light of evening. Had a good photographer walked with us, we might have made a picture worthy of inclusion in this book: "Late Summer on Unnamed Creek, Southern Mecklenburg County, North Carolina."

But that picture was never made. Now it cannot be made. The creek is buried forever in a culvert; the rabbits and squirrels, the muskrat, the hawk, the mice, the thrushes and owls have died out or moved on; the "secret place" is a landscaped rock garden beside a house on a paved street with curbs and fire hydrants; the thicket that yielded sweet persimmons in the fall has been replaced by a row of tidy shrubs along somebody's suburban driveway. To the newcomers who live there, no doubt, it's land that has been nicely developed. To me, it's a sweet, remembered world that is gone for good.

So turn these pages slowly, my grandsons. Before you reach my age, some of these heart-lifting vistas will vanish as surely as my rural Eden did. They are building roads down into the Louisiana bayous; there go the 'gators and the herons. They are converting the lonely Outer Banks into a vacation metropolis; there go the sand dunes and the sea oats. A concrete condominium sits astride one of the loveliest of the Blue Ridges, a huge, squat building that intrudes on the view for many miles around and looks out on an acid haze blown in from the smokestacks of the Middle West. They are terracing the Rocky Mountains for housing developments, chopping for profit into America's very spine. The mighty Alaskan forest is being leveled, turned into pulpwood, and shipped to Japan.

Upper Horsetail Falls, Columbia River Gorge National Scenic Area, Oregon. (© Steve Terrill)

And yet, and yet . . . Wildness survives in magnificent patches, mostly within the borders of National Parks and Wilderness Areas. By tradition, Americans are proud of these places, even Americans who have never seen them. The idea of fruited plains and purple mountain majesties is in the national bloodstream, and most people assume that once a place is protected, it is protected forever. This is not necessarily true. Within recent memory, a big mining company was—just in the nick of time—prevented from gouging out a gold mine that eventually would surely have poisoned the pure trout streams of Yellowstone Park. A dam was narrowly averted that would have turned part of the Colorado River in the Grand Canyon into a placid lake. (See Kathleen Norris Cook's photograph of the shimmering silver ribbon of river coursing through the pink canyon and try to imagine *that* calamity.)

The towering redwoods of California, nine-tenths cut down already, are still being turned into shingles and grape stakes. A movement is underway to restore power boats and water skiing to the silent sanctuary of the Boundary Waters Canoe Wilderness Area on the Minnesota-Canada border. "In wildness is the preservation of the world," wrote Thoreau, but the preservation of wildness is a struggle that never ends. We should be grateful for the places where, so far, the natural beauty of mountains, rivers and grasslands have won out against the unnatural ugliness of billboards, shopping malls, and power lines.

By great good luck, I have seen most of the places depicted in these pages, though not always in the same light or the same season, and not with the expert eyes of these master photographers. Valuable as the pictures are as art and as archive, they become even more precious if you are able to see them through the filter of your own memory.

Take Willard Clay's photograph of lupines, stream, and mountain range in Grand Teton National Park, for example. If you look at it long enough, the picture takes you to that place. It puts you right into the aching beauty of the breathless alpine morning. I have walked past that very spot and looked across that same creek to those same mountains. No doubt, I had a fishing rod in my hand instead of a camera. How lucky I am that Willard Clay had a camera! His picture brings it all back for me, as clear as day—or rather, as clear as the two different days when he and I were there.

I could go on this way about dozens of the other photographs. But the reader will want to bring his or her own memories to the turning of these pages, or use this book (are you still with me, my grandsons?) as a guide to the glories of their land.

In spite of all we have done to spoil natural America, these glories are still considerable. Before it is too late, we need a sumptuous illustrated record of the places in North America that look much as they did before civilization arrived.

Here it is. Treasure it.

—Charles Kuralt

California poppies with filaree, Antelope Valley, California. (© Jack Dykinga)

Introduction

Impressions of the year flow by me, David Middleton, like leaves floating down a river of days—impressions of a stony beach in Oregon passed by untold seabirds far offshore; of a hallelujah sunset shining on the snowy slopes of an ice-etched ridge; of cockle shells and angelwings, yellowlegs and sanderlings, all dancing with the waves on the Georgia coast; of polar bears and caribou shuffling past Arctic waters; and of broad-winged and long-tailed hawks rising at dawn from a Texas forest in spring. Together these memories eddy and flow until one becomes another and all become one, each inseparable yet distinct, like the nature of all that is wild.

Confined between three oceans and embroidered by bounding mountains, North America is caught between the icy polar north and the hot tropical south. Between its shores exists almost every ecosystem found in the Northern Hemisphere. Offshore are deep marine trenches and shelving shallows where coral reefs, forests of kelp, and spineless sea creatures thrive. Inland are three great deserts, an ocean of grass, magnificent broadleaf and conifer woodlands, interior basins separated by mountain ranges, and a low cold land, far to the north, where life's grasp is only a few inches deep.

Within each of the 12 ecoregions recorded in this book is an ecological extravagance that disappeared from other continents long ago but that borders on hyperbole in North America. There are more than 3,000 distinct habitats within this continent, each harboring unique communities of plants and animals. As a result, the sum of life supported by this incomparable land is staggering: more than 500 species of reptiles and amphibians, 11,500 species of butterflies, more than 150,000 kinds of insects (including 23,640 kinds of beetles and 19,562 kinds of flies), 17,000 species of plants, and an estimated 20 billion individual birds on any given late summer's day!

This abundance is not happenstance. North America is still a young land with a brief history of human development, as yet untouched by the millenia of civilizations that have shaped Asia and Europe. Although much of this continent has been altered during the last two hundred years, it generally hasn't changed so much that it has lost its wild heart. For example, migrating birds still rest in city-park trees. Coyotes still travel through the green swards surviving in urban corridors. And elk, moose, and deer, like upwardly mobile commuters, are increasingly familiar in suburbia.

North American land that has escaped the modifying hand of man is as rich and glorious as it ever was, thanks to the foresight of generations of conservationists. Today more than 300 million acres are protected within national parks and wildlife refuges in the

United States and Canada, and more than 100 million acres have been set aside as wilderness areas. This wild legacy is for generations to come and also reminds us of what has passed away.

Fortunately, the wild lands of this continent don't only exist behind federal fences. In almost every neighborhood lurks at least a hint of wildness. For example, a walk through a garden on a late summer's day might present monarch butterflies fluttering south with the seasons. Part of a great orange wave that annually washes across the entire continent, they return in the spring as a new generation. Or we find an old orchard and, when it's dark, hear an owl's quavering call. Even a glance up at the moon sometimes reveals the seasonal passage of migrating birds, silhouetted against its full face.

I found looking for the right words to capture the wildness of North America considerably more demanding than looking for butterflies or listening for the call of an owl. To do this vast subject justice, I visited every ecoregion, often several times, in order to collect information and impressions for the text. I wish I could say that I just sat down next to a tree and listened to what the wind had to say; in fact, I read many books and relied heavily on my years of experience studying the natural history of this continent.

As for the photographs in *The Nature of America*, over a million images were taken for this book, and five thousand were submitted for our review. Only about two hundred and twenty of these are included herein, but ten times that number could have easily been chosen. And bear in mind that none of the photographs in this book were digitally enhanced or manipulated in any way. Also, no captive mammals were photographed. We all agreed that it was better to wait and find what may, than to manufacture photographs of that which is not.

Hobbs, the cartoon tiger, once said "If people could put rainbows in zoos, they'd do it!" The goal of *The Nature of America* is to celebrate the rainbows and kingfishers and seals and meadows of flowers that are only found in the wild. We hope that you will make every effort to preserve and participate in our rich natural heritage by supporting our National Park Service, our wildlife preserves, and your local conservation organizations. As nature photographers, all of us who have contributed images to this book hope that our efforts will leave a lasting impression on you. To us, there is no greater reward than to preserve and protect what we cherish—that is the ultimate goal of our work.

Rick Bass writes of "a consciousness beyond our own, an awareness of being" that can be felt "in New York City as much as in a Utah desert or a Montana wilderness." He calls it a "sentience of place," and I know that it survives in North America for I've found it in my travels and I've seen it in the images of my peers. You, too, can find it if you are willing to seek what has been forgotten and what is still wild. Just listen for the mighty pulse of America's wild heart, and follow where the rhythm leads you.

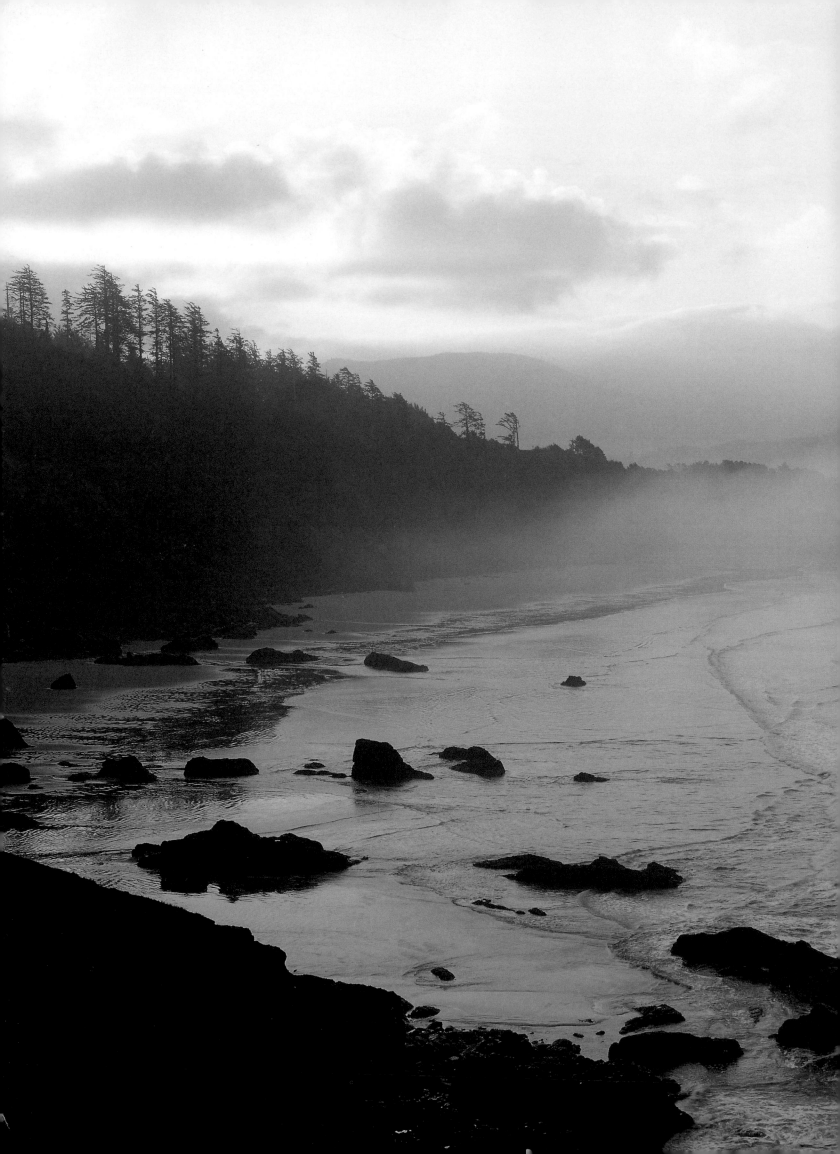

THE PACIFIC COAST

"Salmon embody the essential unity of mountain, forest and sea. A timeless cycle of death and rebirth informs their migrations, and the beauty of these seafaring creatures resonates throughout the forests, rivers and streams like a slow and silvery pulse."

—Rose Houk

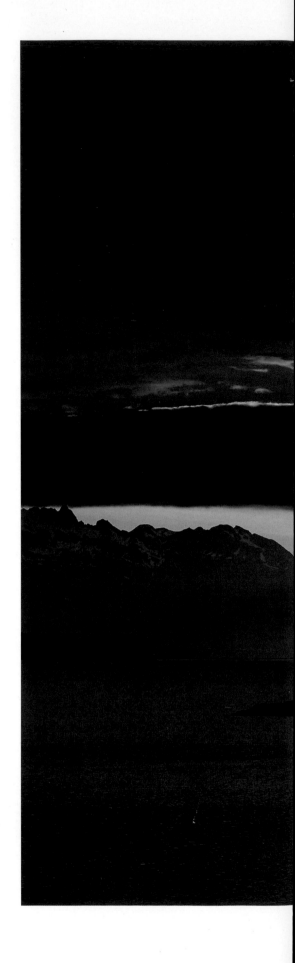

Halfway along the coast of Oregon on a narrow finger of land jutting far into the waves, a tiny beach is tucked into dark cliffs, protected by offshore rocks where seals loaf on wave-carved couches. No sand clings to this beach, only cobbles: rounded, the color of a rainy midnight, and varying in size from beans to baseballs. Walking on these stones is a balancing act, like being a kid on roller skates for the first time or a tightrope walker with sore feet.

What draws me to this beach is the sound of the surf. The beach resounds not with the cries of birds (although there are many) nor with the rush of the wind that never stills, but with the ping of stones rocked by every wave. The beach is all ratta-tat-tat and no tune, a rising crescendo of toy drums followed by a

descending flourish as each wave hurries back to the sea.

Behind the beach, and over the bluffs where puffins and murres nest, is a little creek that sneaks out of a forested cleft in the coastal cliffs. On one side of the creek, a logging road leads to acres of land roughly scarred and freshly scabbed-over with a new crop of firs. On the other side, the bank remains forested and still shelters a green glen of wildflowers, ferns, and berries: black, huckle, thimble, and goose. In the water stirs a small run of salmon, "a slow and silvery pulse."

The salmon are the beating heart of the Northwest's wild lands. The salmons' sinew and scale are the fiber and limb of the forest, and the wind and wave of the sea. The forest seeps river, the

(Previous pages: © Steve Terrill) Sunrise along Cannon Beach, Oregon, where fog and waves mix to start the day. (Above © Tim Fitzharris) Wood ducks, British Columbia.

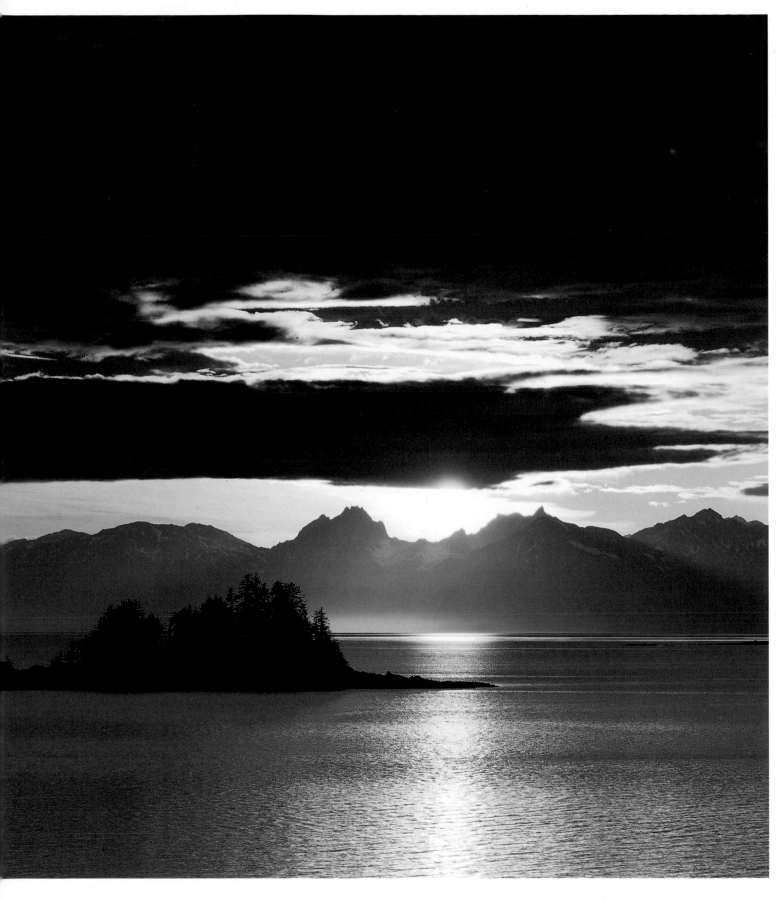

Cohen Island and the Chilkat Range in Tongass National Forest, Alaska, are bathed in a late summer's sunset. (© Jeff Gnass)

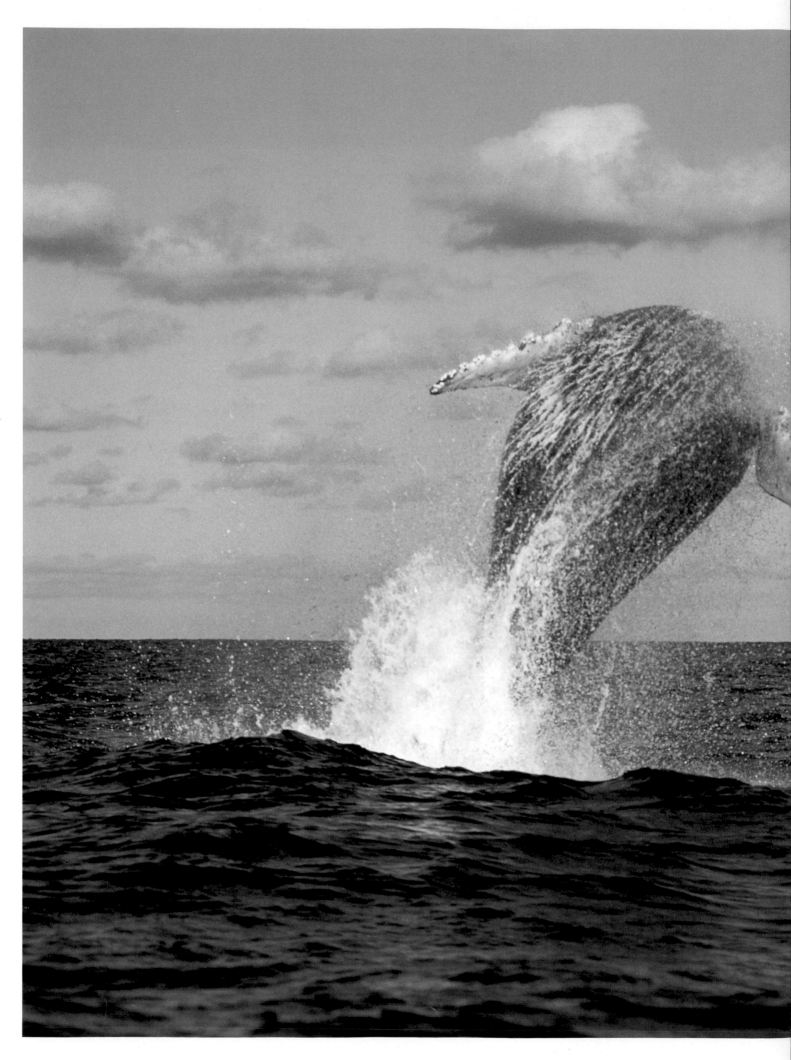

river flows salmon, the salmon breath forest. It is a sacred round that binds together in a wild song this western edge of the continent.

The Pacific Coast ecoregion stretches five thousand miles from the sandy shores of Southern California to the treeless coast of the Seward Peninsula in western Alaska. The coast is defined here as all that could be seen from an offshore dory, plus all of the

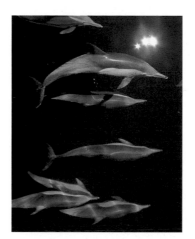

countless straits, gulfs, and bays of the near-shore marine waters. This may seem a bit arbitrary, but the mountains, rivers, and forests actually contribute as much to the coast as the tidelands and ocean do; for the mountains catch the clouds and squeeze from them prodigious amounts of rain that fill the rivers that, in turn, bathe

the coast with woody nutrients. A coast that has lost its connection to its backland is but a shadow of what it once was.

All the geography of this long coast shares a similar geologic pedigree—all of its land is born of the sea. Along most of the western edge of the continent lies a deep sea trench, created by the oceanic Farallon tectonic plate (a piece of the earth's crust) as it moves eastward and slips under the North American plate. As this happens, the top layer of the Farallon plate is scraped off by and builds up against the western edge of North America, the way bits of scrambled egg build up against the edge

of an omelet as a spatula slides underneath it. These piles of scrambled land on the continental edge have become the coastal ranges of California, Oregon, and Washington, and the low

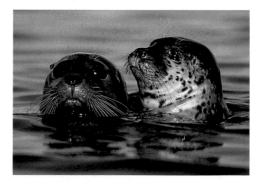

foothills of British Columbia and Alaska.

The higher mountains of the Pacific Coast have a slightly different geologic origin. As various tectonic plates were sliding eastward beneath North America, oceanic islands (or what

The Pacific Coast abounds with marine mammals, including the humpback whale (left, © Jeff Foott), schools of common dolphins (above left, © Norbert Wu), and harbor seals (above right, © Frans Lanting).

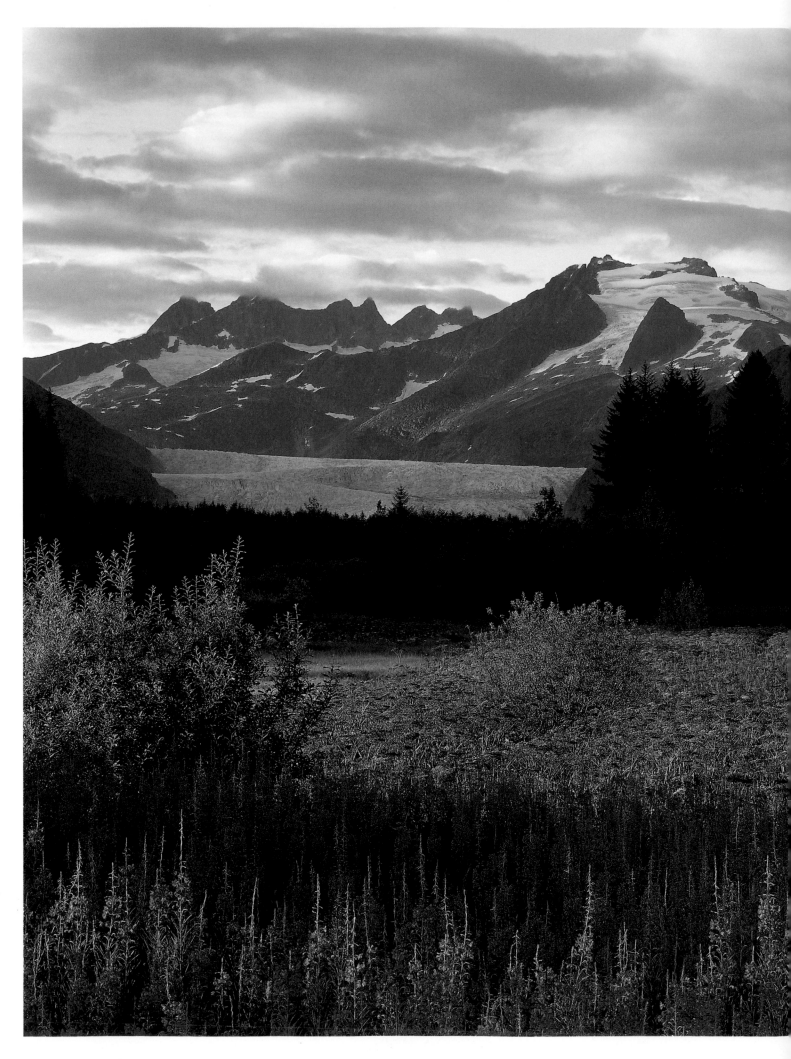

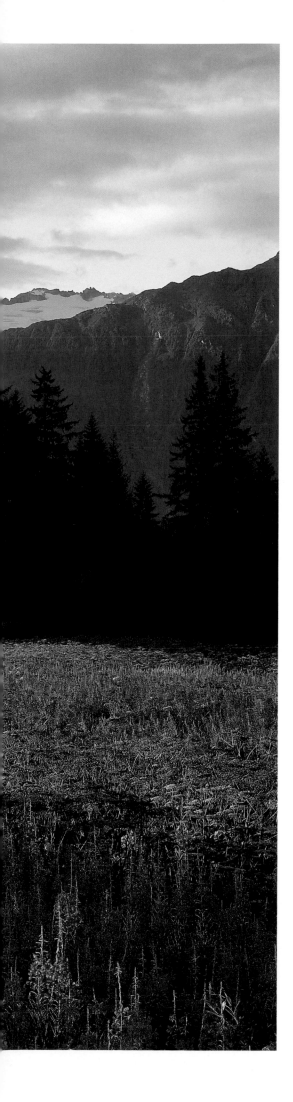

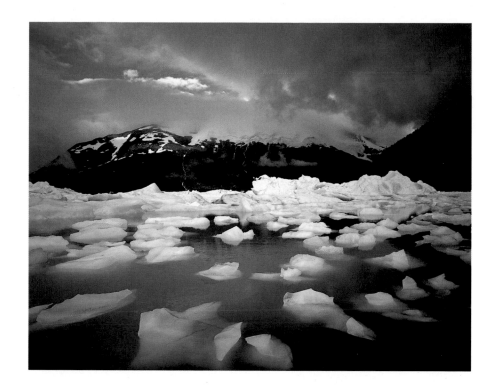

geologists call "exotic terranes") collided with the western edge of the continent and they, too, became part of North America. The Olympic Mountains of Washington, and the Coast Mountains of British Columbia and Alaska are a pile-up of oceanic islands with bad driving records.

Parts of the Pacific Coast are infamous for being wet. Much of the central and northern coast receives more than 10 feet of rain per year. This is not the wettest area in the world (a distinction that goes to an obscure mountaintop forest in Hawaii), but it's close. Despite being not quite wet enough in Southern California, where summer and autumn wildfires are common, the northern Pacific Coast goes far beyond being simply rainy. Many inhabitants of the Northwest feel saturated for months at a time. For the people of coastal Washington, British Columbia, and Alaska, winter sogginess is more of a daily grind than their cherished expresso beans.

Washington State writer Robert Michael Pyle has coined new words to describe the degrees of sogginess on the northern Pacific Coast. Inspired by the Arctic's Inuit people who have different words for different kinds of snow, Pyle found the word "rain" to be inadequate for capturing the daily subtleties of the Northwest's winter weather. "Mossehurr is the soft falling rain that

Southeastern Alaska breaks from winter's grasp suddenly, as glacial ice rafts toward the misty shores of Portage Lake (above, © James Randklev), and fireweed blooms near the Mendenhall Glacier (left, © Jeff Gnass).

soaks and nourishes the mossy mats without quite wetting the hair," according to Pyle, and "virkkaplotz is the falling puddles that set the slugs to slipping off their alder bark perches and concuss the leaping salmon." Let me offer "buzzbur" for the rain that is driven horizontal by a grounded Pacific storm, as well as "whispleweep" for just the rumor of dampness, perhaps being a distant prelude to a thundering virkkaplotz or the end of a fading mossehurr.

When it is not actually raining on the Pacific Coast, it is usually foggy. Born of a daily conversation between warm land air and cool offshore water, fog envelops the coast in dull chatter for days at a time. And yet, because summer rainfall along the Pacific is often disappointing, the moisture condensed from fog sustains the coast's evergreen flora. Fog's daily dialogue with the coast is the reason why the area north of California's Big Sur and south of Alaska's Kodiak Island is a temperate rainforest. This type of ecosystem flourishes in regions with moderate temperatures and year-round moisture. Such benign conditions allow for annual growth of stupendous proportions. In the few uncut forests surviving in the Pacific Northwest, some evergreens reach 6 to 8 feet in diameter and are 600 to 800 years old. Surpassing even these old-growth forests are the redwood forests on the northern California coast, where trees grow to be 3,000 years old, 20 feet wide, and more than 300 feet tall.

Not so long ago, forests of tall trees fed by streams teaming with silvery fish were common. Now, with the integrity of these streams compromised by overlogging and unchecked development,

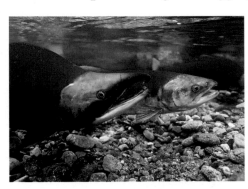

most of them have lost their wild heart. There were once about 500 wild populations, or stocks, of salmon in the Pacific Northwest. Today, 100 of these stocks are extinct, and another 200 are threatened with extinction. Rivers that 20 years ago held 125,000 salmon now have populations of less than 1,000 fish.

Fortunately, there are rivers where the wild salmon still run, where the water is clear and the rapids growl, where the banks are overhung with drooping vine maples and drowsy hemlock

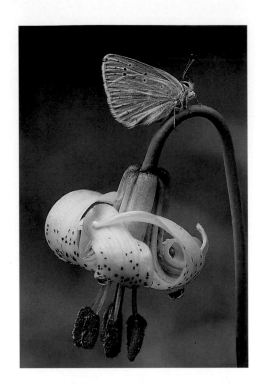

The columbia lily is a showy flower of coastal subalpine forests. Here, a common blue butterfly rests on one in Olympic National Park, Washington. (© John Shaw)

In July, brown bears gather at streams to feast on runs of salmon (left). When two adults want the same fishing spot (right, both © Jeff Foott), arguments over dominance—like this one in Alaska's McNeil River—are common.

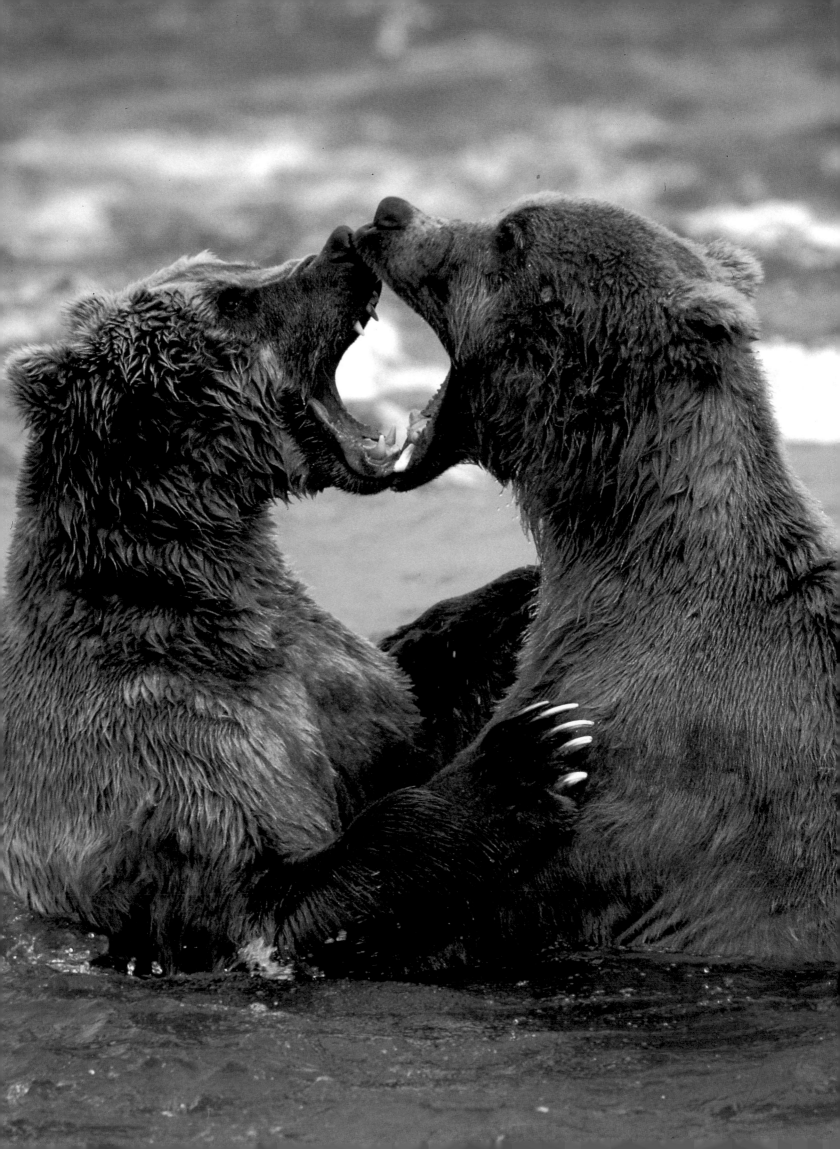

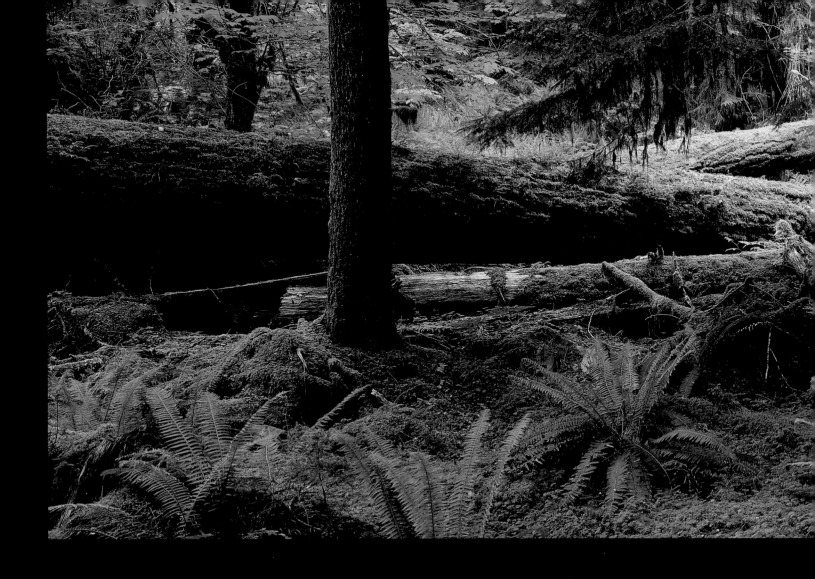

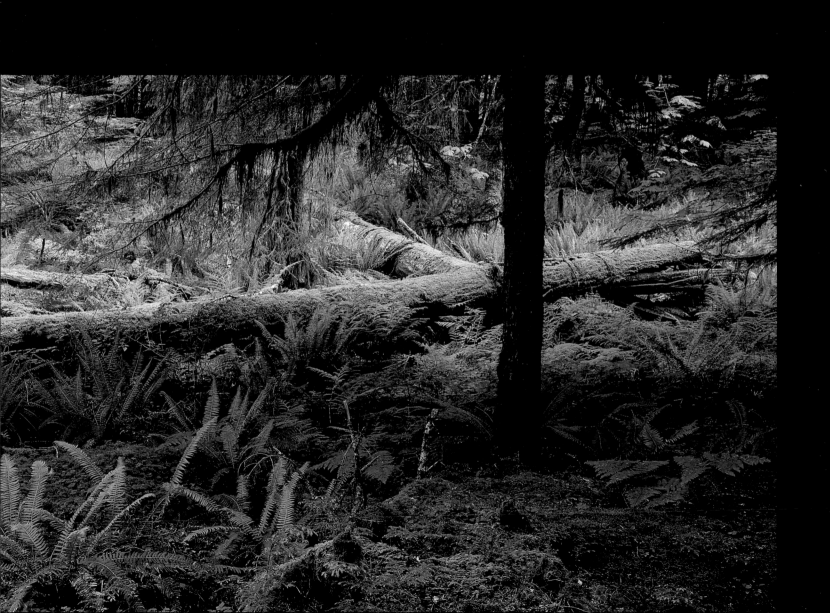

boughs. Salmon are born in fresh water but then migrate to the sea, where they grow and flourish in salt water. Three to seven years later, they return to their birth waters. This journey home can last many weeks, during which the salmon don't eat, relying on stored fat to power the voyage. Back in freshwater streams, the salmon languidly sidestep the current, sashaying left and allemanding right as they dance upstream on their way home. They will never see the ocean again, for as soon as they reach fresh water they begin to decay, running from death to give life to the generation to come.

Pushing their noses into the water's flow, the salmon taste their way back to their natal riverbed gravel, sampling the current for the flavor of home. Once there, the female excavates a shallow nest, or redd, in the river cobbles and deposits her eggs. A male then washes the redd with his sperm as the female showers it with a light coat of stones for protection. They will do this less than 10 times before they are exhausted. In a day or two both will be dead, casting their flesh back to the river and all that it waters.

A salmon-spawning stream flows with fertility and suste- nance. Twenty species of birds and mammals feed on salmon. Brown bears are particularly attuned to the returning salmon. They provide the fat that bears need to survive their seven months of winter hibernation. So a bear catches summer salmon to see the spring moon, plowing the water for the seasons to come. Fishing trawlers and eagles harvest these waters as well, as do the forest and its animals. They are all spokes on a wheel that turns through the year with a salmon aswim at the hub.

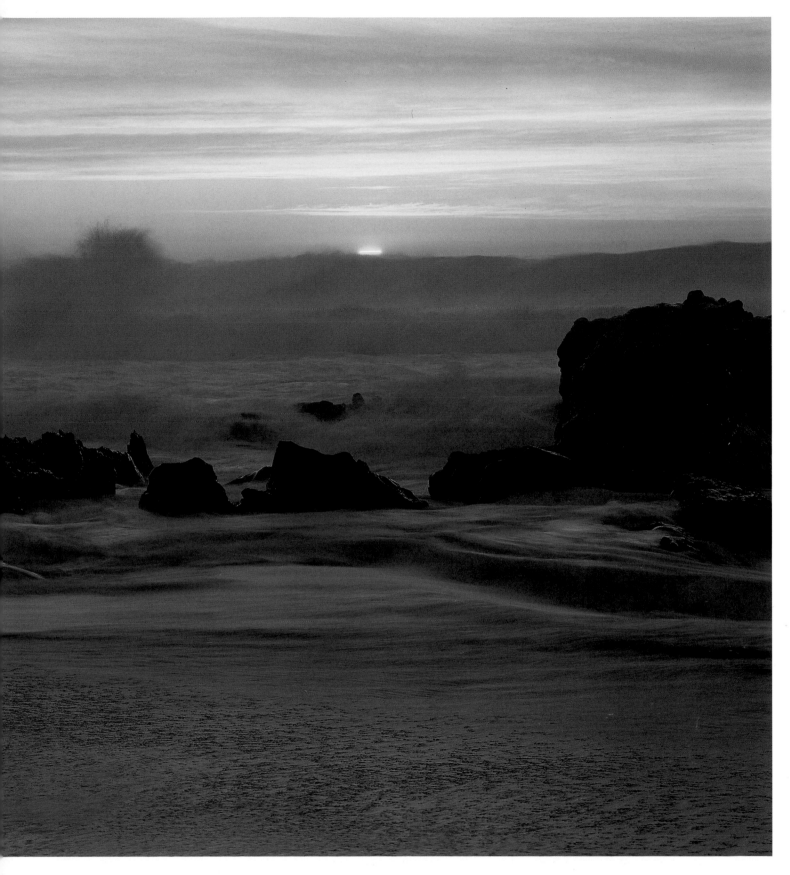

Fog is a way of life up and down the Pacific Coast. Big Sur at sunset (above, © Carr Clifton) is often shrouded in fog, as are the hills of Berkeley, California (left, © Galen Rowell), above San Francisco Bay.

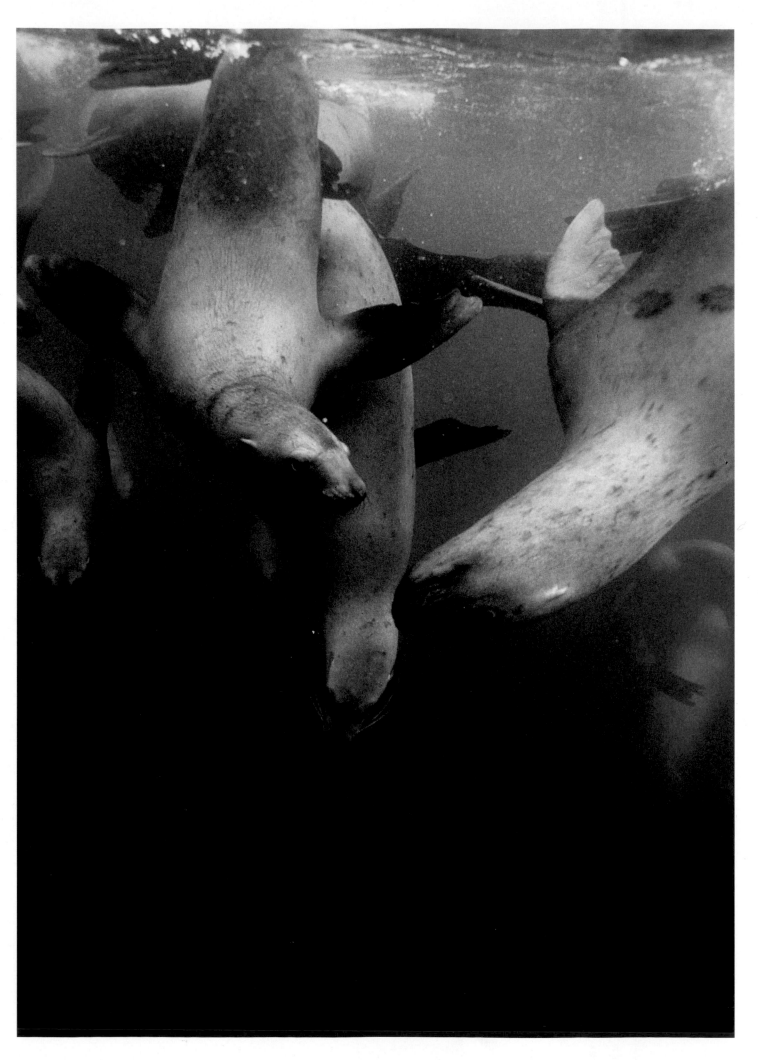

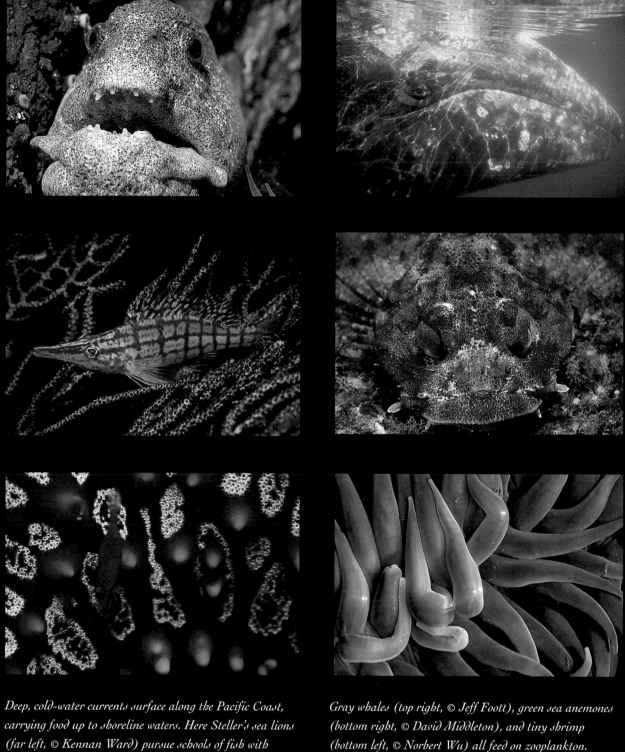

Deep, cold-water currents surface along the Pacific Coast, carrying food up to shoreline waters. Here Steller's sea lions (far left, © Kennan Ward) pursue schools of fish with astonishing aquatic grace. Wolf eels (top left, © Norbert Wu) prey on fish by ambush.

Gray whales (top right, © Jeff Foott), green sea anemones (bottom right, © David Middleton), and tiny shrimp (bottom left, © Norbert Wu) all feed on zooplankton. The shrimp, in turn, are fed upon by such fish as the red Irish lord (middle right) and the longnose hawkfish (middle left, both © Norbert Wu).

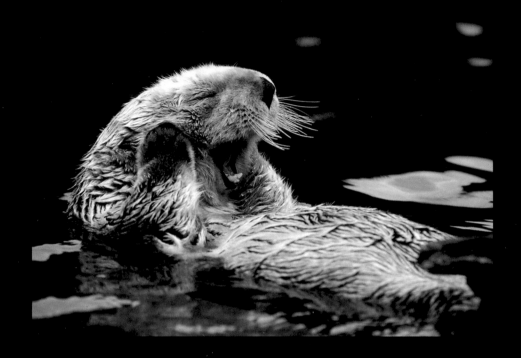

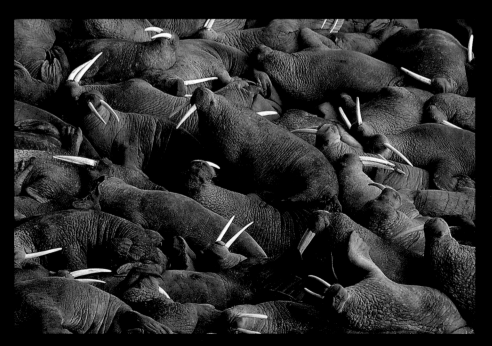

Populations of sea otters (top, © Jeff Foott), once hunted heavily for their fur, are rebounding along the Pacific coast.

Walruses (bottom, © Charles Krebs) haul themselves onto protected beaches on Round Island, Alaska, for warmth and rest in great masses.

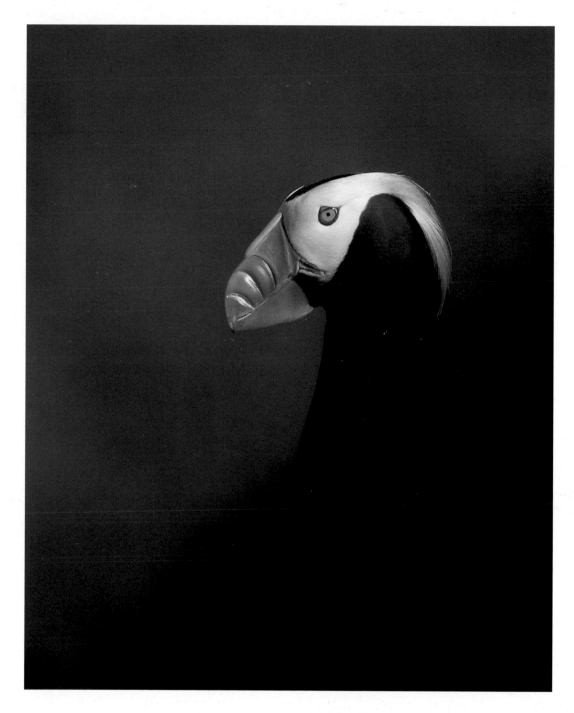

*Tufted puffins are found on steep grassy
slopes in British Columbia, where they nest
in burrows under the sod. (© Wayne Lynch)*

THE CASCADE MOUNTAINS

*"Eventually, at the toe of the mountain slope, I found the largest
tree in the grove. I stood soaking in the presence of this
grand old colossus and the squirrels quieted. Something of the
tree's own stillness slipped into my very being. Toward
dark, the sweet song of a winter wren followed me as I wound
my way back to the trail."*

—*Tim McNulty*

*(Previous pages, © Steve Terrill) Mt. Rainier on
the left and Mt. Adams on the right, as seen from
Barrett's Spur, Oregon.*

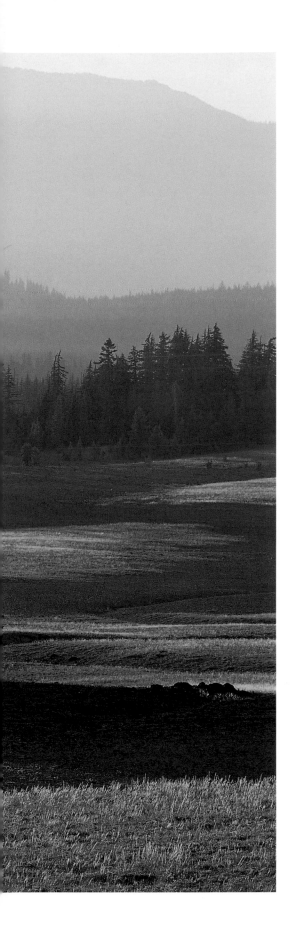

The directions to drive to Crabtree Lake in Oregon are to follow Crabtree Creek upstream until it stops flowing. Unfortunately, the only approach is via a snarl of logging roads that defy topography or logic. I remember the route as straight-left-straight-left-straight, but it has been a few years since I've been there. You'll know the place once you finally arrive, though, because Crabtree Lake is a beautiful sapphire pool enveloped by a towering emerald forest, within view of the glittering peak of nearby Mt. Jefferson. Standing on the edge of Crabtree lake, you are surrounded by the crown jewels of the Cascades.

The Cascades extend 500 miles from southern British Columbia, down through the mountains of central Washington and Oregon, into northern California. They are part of the western mountain rim that, together with the Sierra Nevada Mountains far-

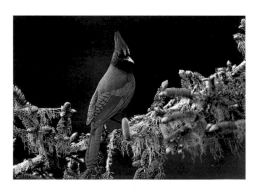

ther south, shields the interior West from the full wrath of Pacific storms. The resulting "rain shadow" is responsible for the high desert of the Great Basin and also reduces the rain reaching the Palouse grasslands of the Columbia Plateau.

This rain shadow is felt closer to the mountains, too. A few miles east of the Cascade Mountains' crest, moisture is so dimin-

The sun sets (left, © Jeff Gnass) over the pumice meadows and wooded ridges of Crater Lake National Park, Oregon, where bracken fern (above left, © Charles Krebs) and Steller's jays (right, © Art Wolfe) are common.

ished that Rocky Mountain plant species—for example, ponderosa pine and juniper, which are adapted for long periods of drought and frequent wildfires—are common. On the western side of the crest, mountainsides are drenched by the rain they wring from

Oregon's Mt. Hood (left, © James Sugar) is a dormant volcano with ridges sculpted by glacial ice.

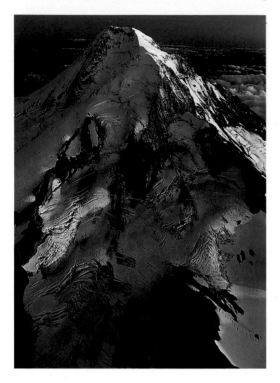

Pacific storms, which keeps their forests lush year-round. Some areas of the Cascades receive more than 45 feet of annual snowfall, enough to entomb a three-story house and its chimney.

The Cascades are the volcanic wrinkle in the continent, a line of a dozen or so snowcapped peaks that dot the verdant forest like a string of pearls across a woolly green scarf. The north to south roll call of these volcanoes sounds like a mountaineer's romance novel: Mt. Giribaldi, Mt. Baker, Glacier Peak, Mt. Rainier, Mt. Adams, Mt. St. Helens, Mt. Hood, Mt. Jefferson, the Three Sisters, Mt. Thielson, Mt. Shasta, and finally Mt. Lassen. Each has 150 years of written history that is part heroic, part mystic, and part catastrophic. And each has a millennium or more of oral history that has been woven so tightly into the traditional fabric of the Northwest that the line between faith and fact is widely blurred.

Foremost among these volcanoes is stately Mt. Rainier, whose history is more lively than its current serenity suggests. Seventy-five thousand years ago, it was more than 16,000 feet tall, or 2,000 feet higher than it is today. The mountain erupted six thousand years ago, reducing itself to a lopped-off cone not quite 14,000 feet high with a lake in its summit crater. The mountain began to reconstruct itself thirty-five hundred years later when a dome of lava rose and brought the summit to its present 14,410-foot elevation. Today Mt. Rainier is the signature mountain of the Cascades, cloaked with 26 glaciers that cover more than 40 square miles of mountainside. If the spirits of the Cascades live anywhere

Mt. Rainier in Washington (right, © Art Wolfe) is the highest peak in the Northwest and the best known of the Cascade Mountains.

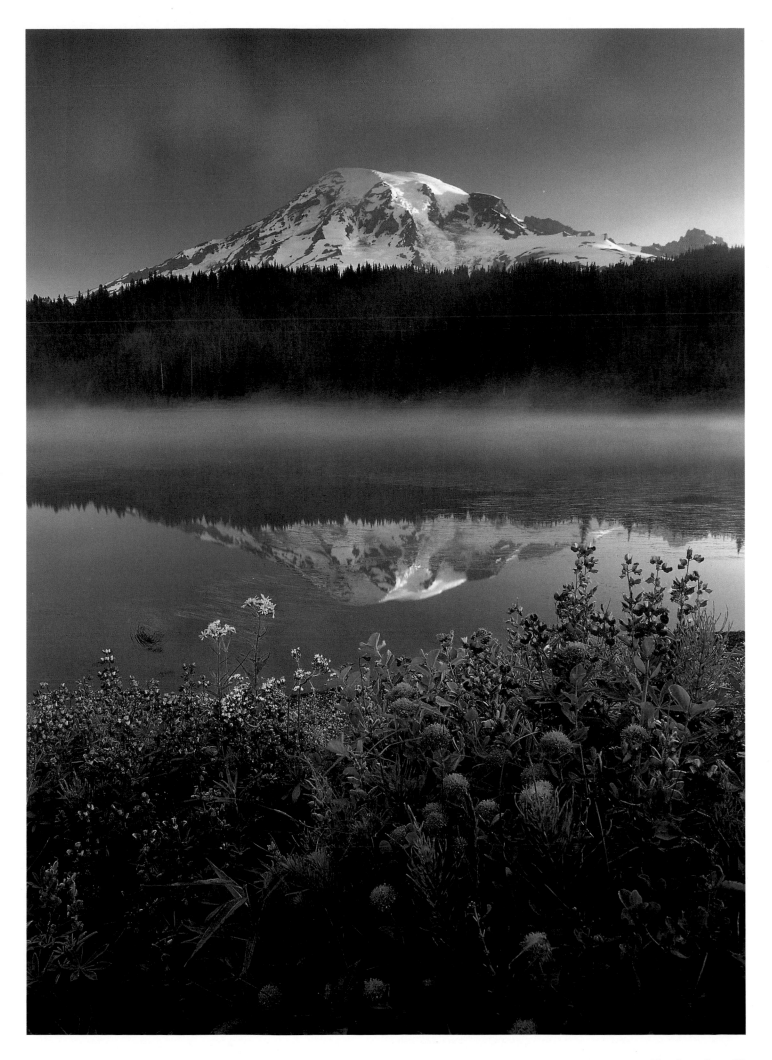

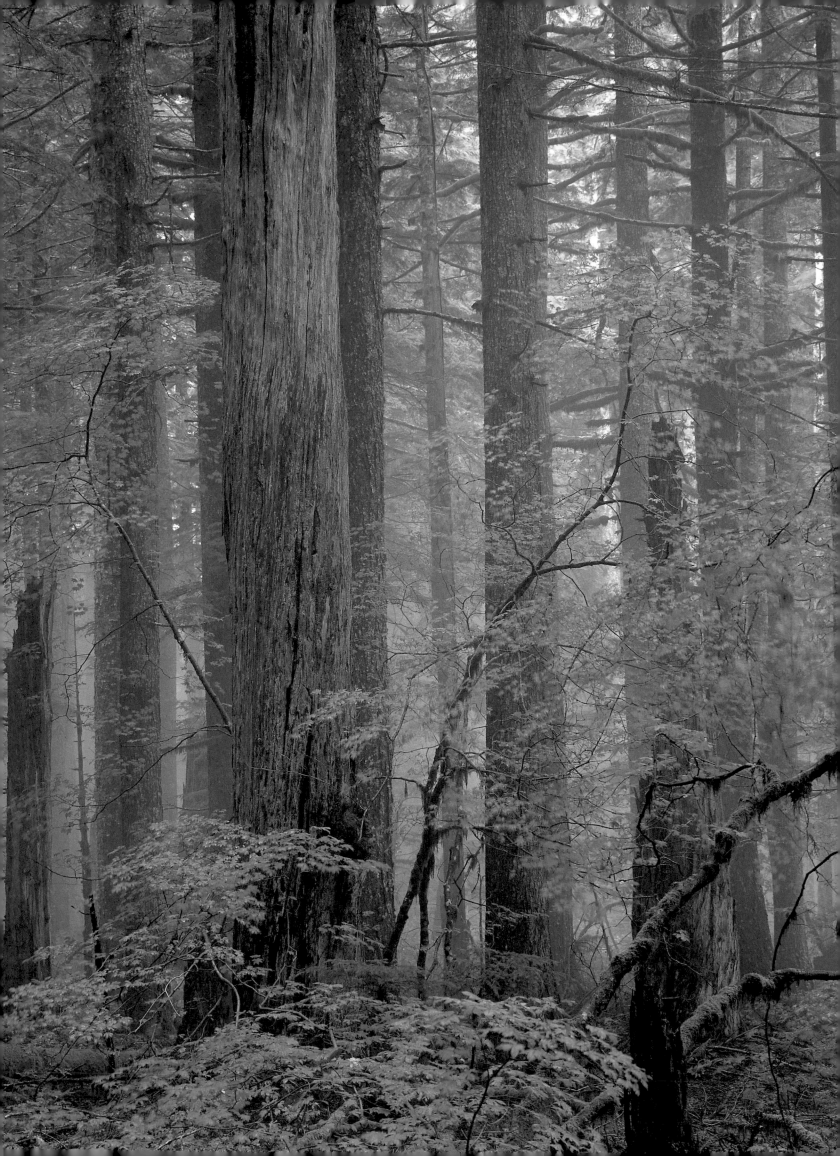

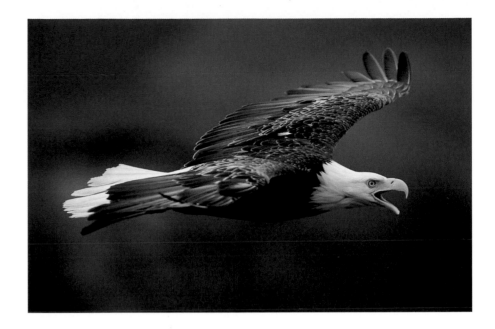

A bald eagle (right, © Art Wolfe), flying over Unalaska Island, Alaska, hunts the bays but nests in the forest, tying together the land and sea.

Opal Creek Preserve in Oregon (left, © Steve Terrill) is one of the last-remaining, lowland, old-growth forests in the Northwest. On the forest floor, fairy-bells (above, © David Middleton) and other diminutive wildflowers are widespread but often overlooked.

at all in the Northwest, it is on Mt. Rainier's lofty white crown.

Surrounding the slopes of the Cascades are perhaps the most magnificent conifer forests in the world. Twenty species of evergreens grow here, a gathering of incomparable diversity. The weight of so much forest life is twice that found in the mythic tropical rainforests, and if creatures of the earth are included in the tally, the sheer number of species present in these forests exceeds that found anywhere else. If you know where to look, it isn't hard to find cedar trees that are a thousand years old and 8 feet wide, living in noble groves that are gothic in dimension.

Finding these groves is increasingly difficult, for they exist in isolated pockets far above the down-in-the-valley sawmills. What was once a continuous cloth of trees is now chewed ragged from the teeth of chainsaws. The Cascade ecoregion is timber country, North America's primary supplier of wood products. It is the best tree-growing environment in the world. Some Douglas firs, the primary timber tree of the area, can grow trunks that are a yard wide in less than 40 years. With proper management and without greed, these forests can continue to supply the raw materials for the building industry. Unfortunately, the most ancient and the most treasured of these forests, the old-growth forests, are also the ones most threatened by the sawyers' blades.

Time spent in this ecoregion can be frustrating if you are seeking animals. Many are shy and retiring. The old-growth forest is home to the most primitive rodent in the world, the aplodontia, a beaver-sized animal that riddles hillsides with burrows and stores

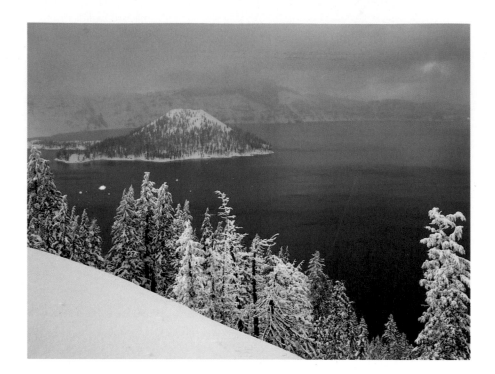

plant food underground for the long winter. Old-growth forests also harbor mountain goats and lions, bobcats, bears, elk, otters, deer, martens, weasels, eagles, owls, songbirds, salamanders, salmon, and insects adapted to the cool, moist habitat.

The air in an old-growth forest is like no other I've ever known. It is the breath of fertility, the sigh of potency, like the air pressed between young lovers on a warm summer's evening. It is the air caught in an old church and breathed in devotion, solemn and respectful. With each step taken, the forest floor groans with growth and the vapors of decay. Apprehension arises that pausing too long here might result in being overgrown by all that creeps, sprawls, and spreads. Here you can't help but lift your head and point your eyes to the treetops, where the songs of warblers and flycatchers tumble down upon you like rain. But they are so high in the canopy that, trying to get a glimpse of these tiny birds, you might as well be looking for angels in the clouds.

Diane Ackerman writes, "There is a furnace in our cells, and when we breathe we pass the world through our bodies, brew it lightly and turn it loose again, gently altered for having known us." Such is the case in an ancient grove of trees. The furnace there is spiritual, but it burns in all of us, too. I know because I've many times been "lightly brewed" by entering such a grove. And I know that I've been "gently altered," gently bettered, for having been there.

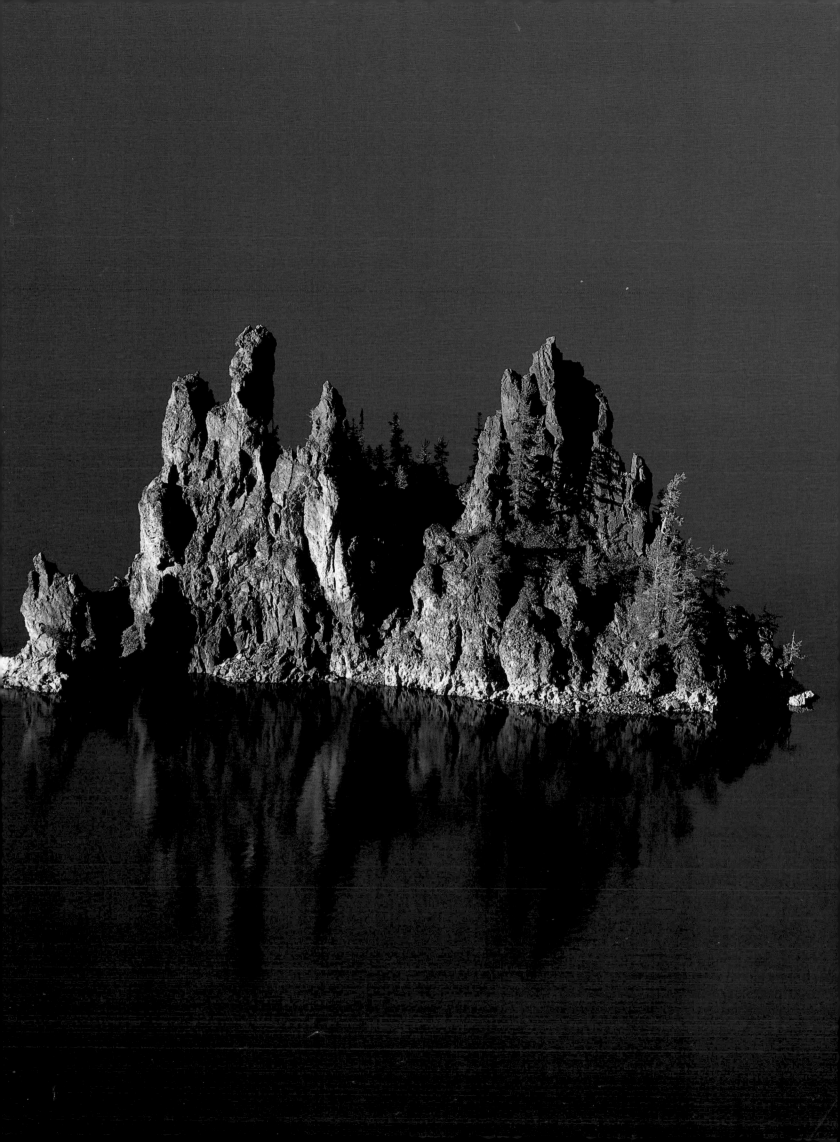

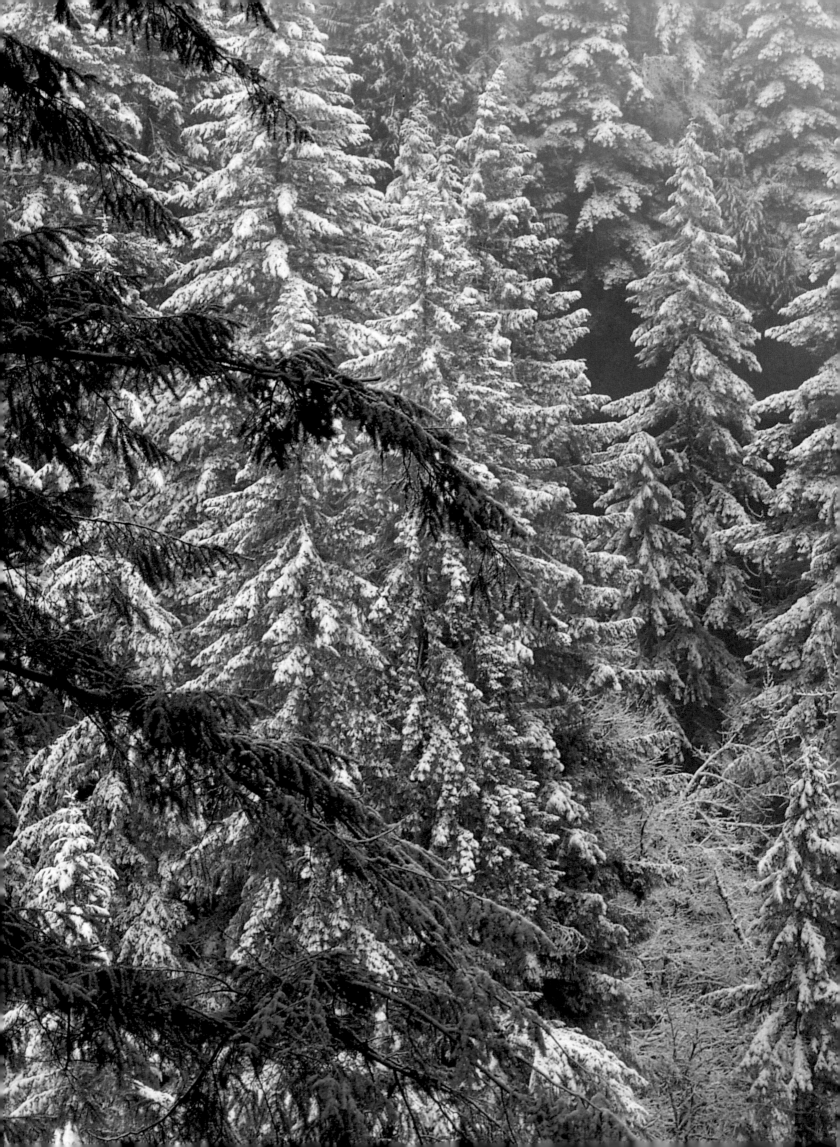

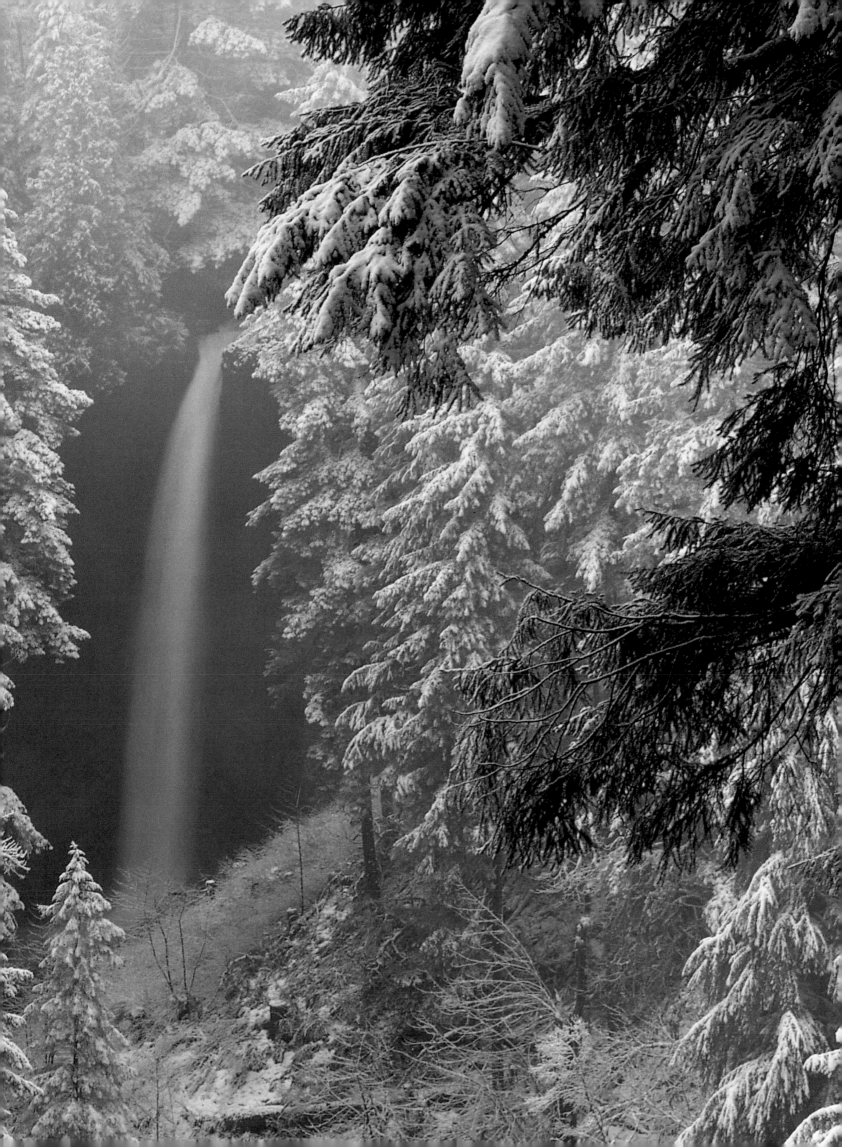

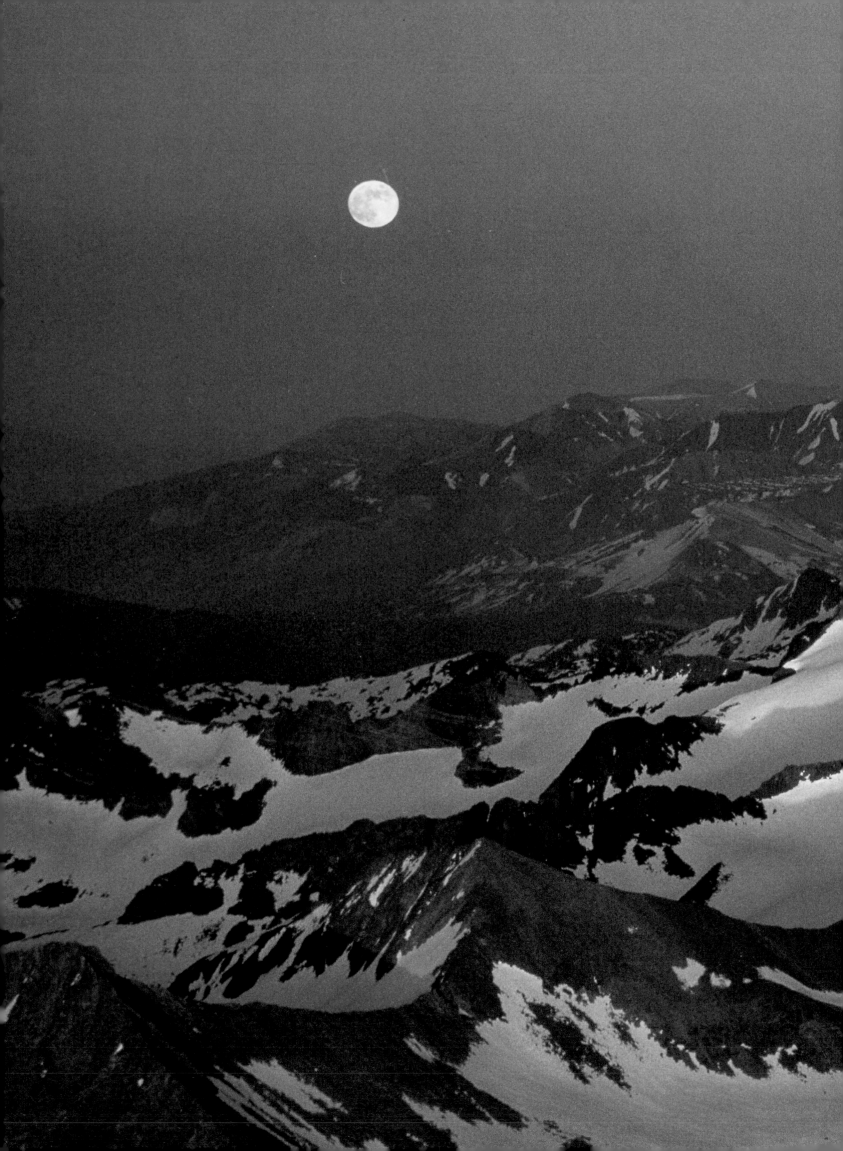

THE SIERRA NEVADA MOUNTAINS

"And after ten years spent in the heart of it, bathing in its glorious floods of light, seeing the sunbursts of morning among the icy peaks, the flush of alpenglow, and a thousand dashing waterfalls with their marvelous abundance of irised spray, it still seems to me above all others the Range of Light."

—John Muir

The Sierra Nevada Mountains boast many superlative qualities. For example, they are the longest range with the highest mountain, Mt. Whitney, in the lower 48 United States. Home to the southernmost glaciers in North America, this range has received the most snowfall in a season: 86 feet on Donner Pass during the winter of 1983. The Sierras host two marvels: 8,240-foot-deep King's Canyon, which is several thousand feet deeper than the Grand Canyon, and 2,425-foot-tall Yosemite Falls, the third highest waterfall in the world. An area about the size of Maine, the Sierras comprise 19 wilderness areas, 9 national forests, and 3 national parks. And on their slopes grow the largest living thing ever to grace the Earth—larger than a blue whale, larger than any dinosaur, and larger even than the largest redwood—the giant sequoia tree.

And yet the soul of the Sierras is more subtle than stupendous. These are quiet mountains, a gentle wilderness, a mountain range of liquid days and languid nights. The quality of light that

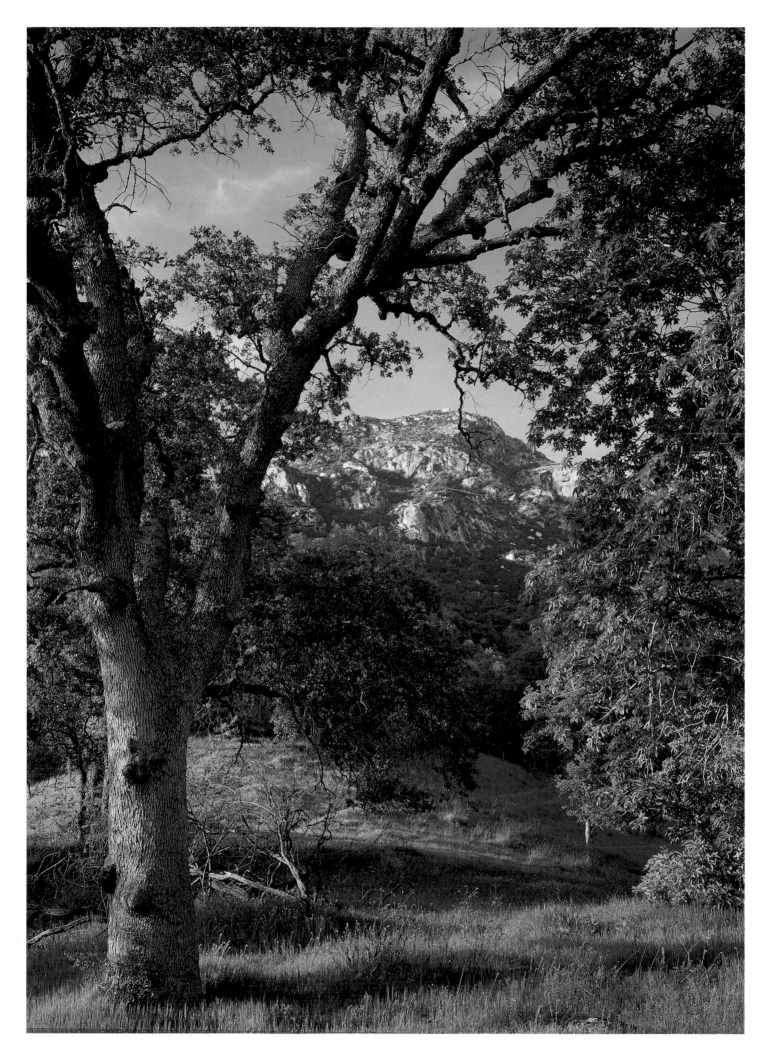

The Sierras are rock, water, and tree (above);
hard, flowing, and golden with aspens in autumn
(top right, both © Larry Ulrich). These moun-
tains are also the home to such animals as the red
fox (bottom right, © Kennan Ward).

falls upon the Sierras can't be found elsewhere. Is it the clarity of light washed by Pacific storms or the softness of light reflected

from glacier-polished rock that is so unique? Or are the eyes of the beholder, opened wider by the magnificence revealed, the real source of this magical light? Whatever the reason, the 19th-century Sierras beloved of John Muir, who was their greatest champion and founder of the Sierra Club, remain the Sierras of today: a range uncompromised, a Range of Light.

The most renowned region of the Sierras is Yosemite National Park. Yosemite was "discovered" in 1851 by accident when an army battalion chased 200 members of the Ahwaneechee tribe into the valley. Yosemite was first protected not because of its magnificent landscape but because of a grove of sequoia trees growing at the mouth of Yosemite Valley. This group of sequoias,

known as the Mariposa Grove, is one of just 75 sequoia groves in the Sierras. In 1852 when sequoias became known to the world, people marveled at their incredible size—and timber companies coveted the number of board feet each trunk contained. Luckily, sequoia wood is too light and weak to be commercially viable (however, this didn't stop loggers from testing their mettle by felling the giant trees). Sequoia National Park, south of Yosemite Valley, was in 1890 the second national park to be established (after Yellowstone) and the first to preserve a single species—the giant sequoia.

A sequoia rises from the ground like a rocky headland rises from the turbulent sea—suddenly, and without pretense or warning. Sequoias' bulbous bases remind me of stubby feet with under-curled toes. Other trees growing among the sequoias are also grand, even if dwarfed by the giants. Sugar and ponderosa pines that measure 6 feet across grow alongside immense white firs and incense cedars. Beneath them all, the ground is soft, littered with

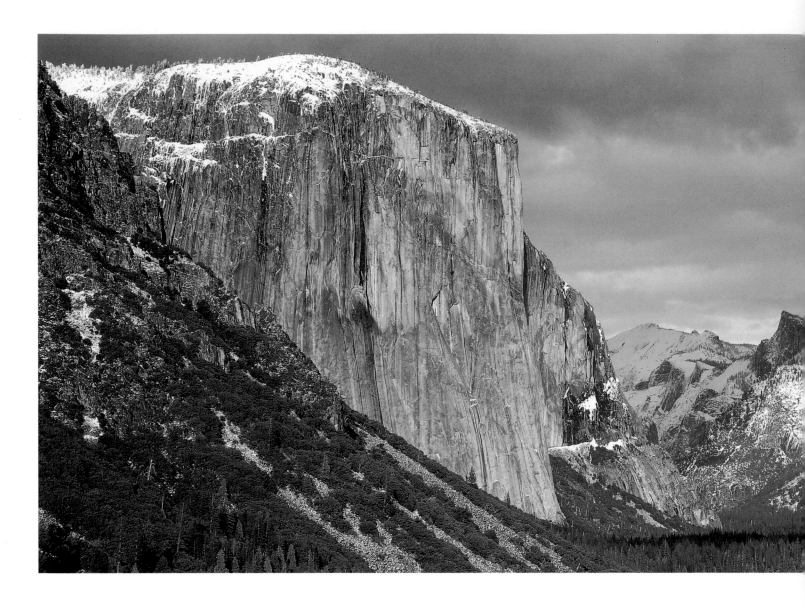

thin needles and long pinecones. Not much grows between the cones and the tree canopy save the occasional shrub and a wanderer's wonder.

Sequoias grow in a narrow, 260-mile band in the central Sierras. They are found only between 4,500 and 7,500 feet in elevation where rainfall is plentiful and winters are not too harsh. Most sequoias grow in shallow basins where snow accumulates and moisture lingers into the dry summer. There are about 13,000 sequoia trees growing in the 75 existing groves, each grove named but not all protected. The largest grove of about 3,600 trees and the largest tree, the General Sherman, are found in the southern part of the sequoias' range in Sequoia National Park.

Trying to describe in words the size of these giant trees is impossible. Only very long words—gargantuan, immeasurable, elephantine, hippopotamic—can begin to capture the size of these

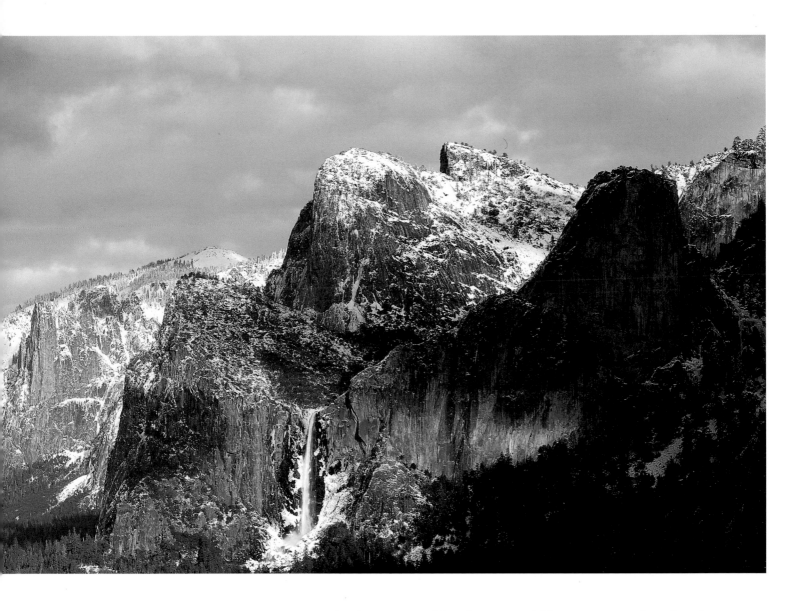

Mammoth El Capitan (left) and Bridalveil Falls (above) mark the granitic gateway to Yosemite Valley in Yosemite National Park, California. (© James Randklev)

very large trees. Numbers can aid in our comprehension, but to say that the General Sherman tree is 275 feet high, 36 feet wide at its base, weighs 1,385 tons, and has a trunk volume of 52,500 cubic feet is to reduce the tremendous to the trivial. Perhaps it is more useful to say that a big sequoia contains enough wood to build at least 50 two-story homes, or that a large sequoia branch has a greater girth than the biggest tree east of the Mississippi, but these words also fall short. Only a visit and a walk through a grove of these living miracles provides an accurate impression of just how massive the sequoias really are.

Sequoias are more than just big. A veneration for them rises in us when we are in their presence, an awe that can't be reduced to numbers. These trees are sometimes more than 3,000 years old, and anything that old that is still growing and reproducing deserves our respect and admiration. Still, the awe they inspire has

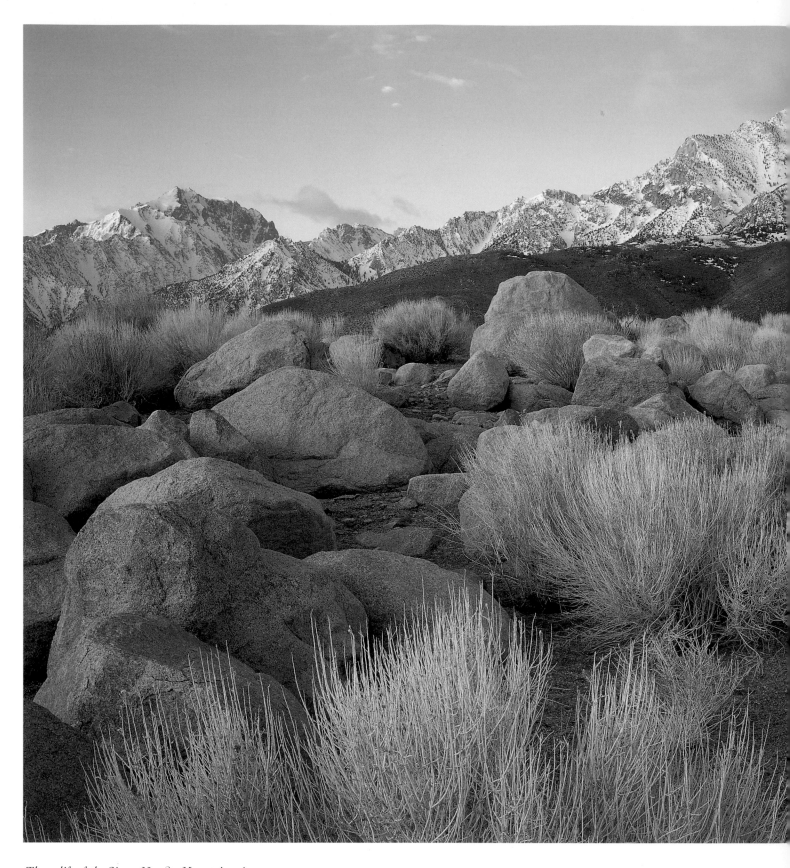

The uplift of the Sierra Nevada Mountains rises suddenly from the Owens Valley in eastern California (above, © Jeff Gnass). Fir trees in winter (right, © Kathleen Norris Cook) are draped in snow in Sequoia National Park, California.

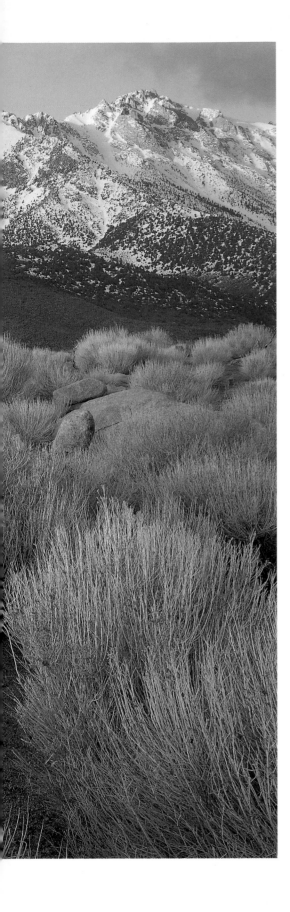

more to do with us as humans than it does with the sequoias themselves. These trees render us insignificant, belittling our day-to-day concerns and overwhelming our limited viewpoints. At the same time, sequoias encourage our imaginations to explore uncharted territory. Sequoias are surrogates for the unknowable, towering stand-ins for the fantastic, and bastions of strength and endurance that inspire wonder about life itself.

From the slopes above the sequoia groves, clear-water streams tumble down through them. Around these streams lives a little bird that is a cross between a mouse, a wren, a tennis ball, and a tenor—the water ouzel. The ouzel is a plump little bird, gray in color, with a round head, a stout bill, and legs that are black and long. Imagine a toddler's sketch of a "bird," and you have the essential shape of an ouzel.

The water ouzel was John Muir's favorite bird. His journals are filled with passages in praise of it. "Find a fall, or cascade, or rushing rapid, anywhere upon a clear stream, and there you will surely find its complementary ouzel, flitting about in the spray, diving in foam eddies, whirling like a leaf among beaten foam bells; ever vigorous and enthusiastic, yet self contained, and neither seeking nor shunning your company." He called it "the hummingbird of the blooming waters," for it dips and skirts and dances upon the ripples like a hummingbird flits among the flowers.

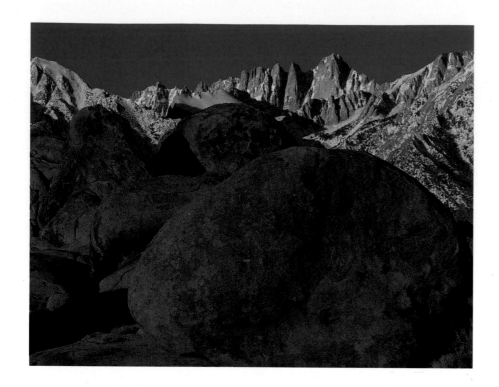

The ouzel is really an aquatic bird, always found within the roar of falling water, living in the shelter of river sounds. It hunts underwater, walking the eddies and plowing the backwaters, all the while tossing stones in search of aquatic midges, larvae, and nymphs. It does all this with astonishing ease, which is partly why ouzels are so engaging.

The other reason the ouzel is so well loved is its effervescent song. Singing year-round, ouzels have cheered me in January blizzards and August droughts alike. Their song is a ringing, cascading, tumble of notes that mimics the water world in which they live. Pitched from a mid-stream rock, an ouzel's song bounces downstream like a leaf in the current and rises above the water's notes like a breeze singing above the trees.

Twenty-five years ago on my birthday, I was given a book that opened my eyes wider than they had ever been opened before. A Sierra Club publication about the Sierra Nevada Mountains, the book was filled with bright photographs and the inviting words of John Muir. So gripped was I with the visions it offered of huge trees, towering waterfalls, and gardens of smooth rock, that I can still feel the strength of that book's impact. Visiting the Sierras over the years has deepened their hold on me. Wander the Sierras from afar or from within these photographs, and you, too, won't escape their embrace.

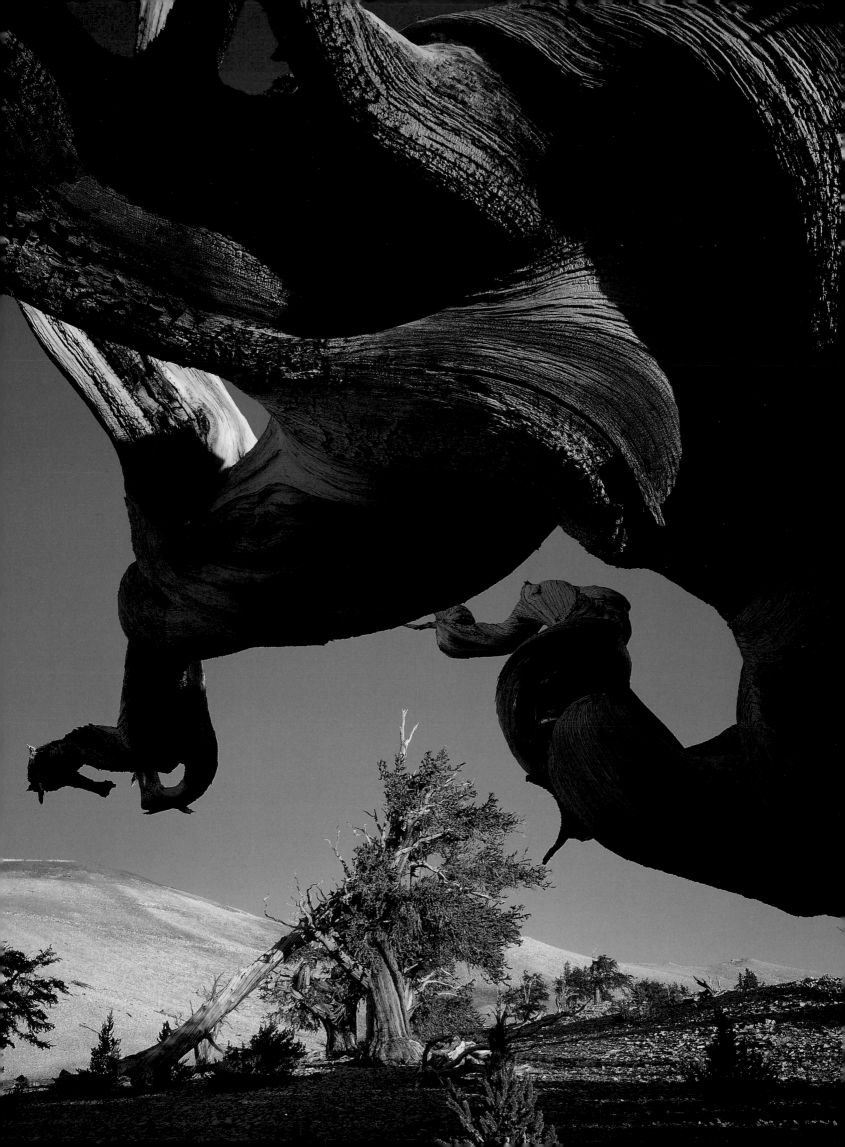

THE DESERT

"What good is a desert? It's good because it's so starkly,
stubbornly beautiful, a respite to the eye, a surcease
for the mind, a beginning on a beginning. A desert is good
because it holds the mountains apart."

— Ann Zwinger

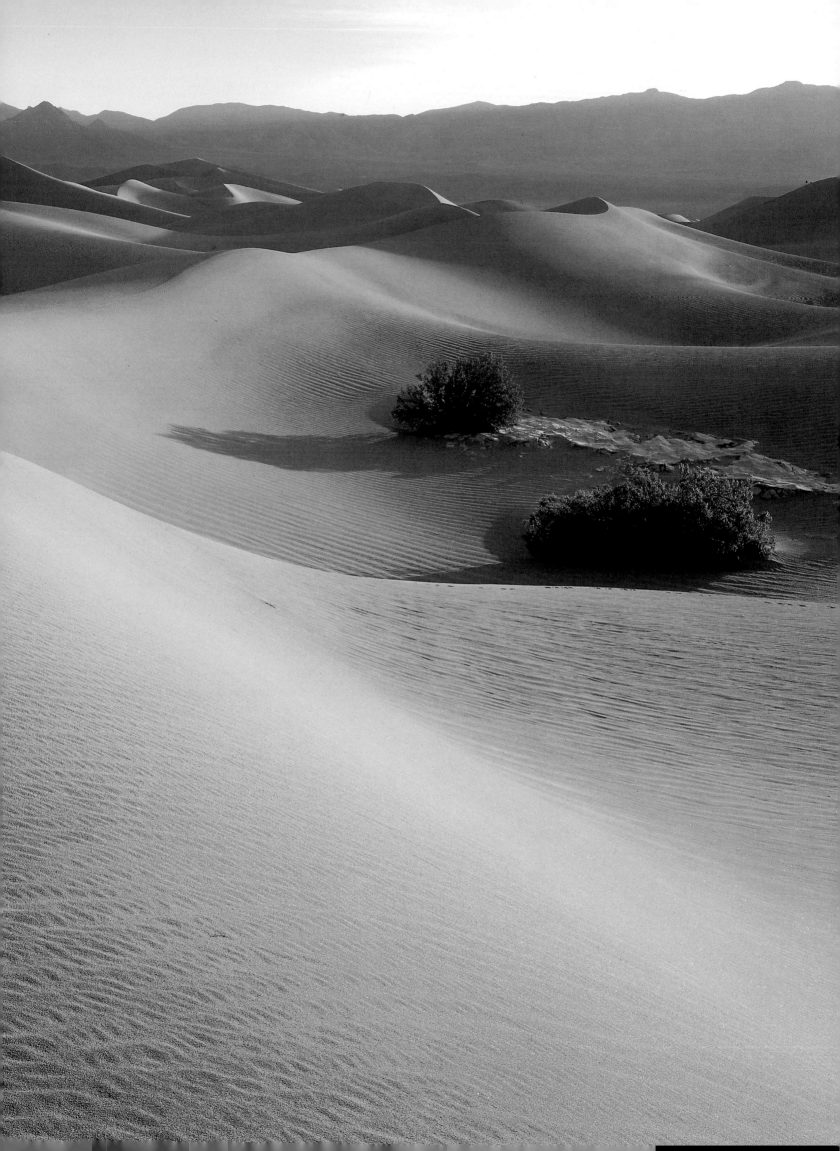

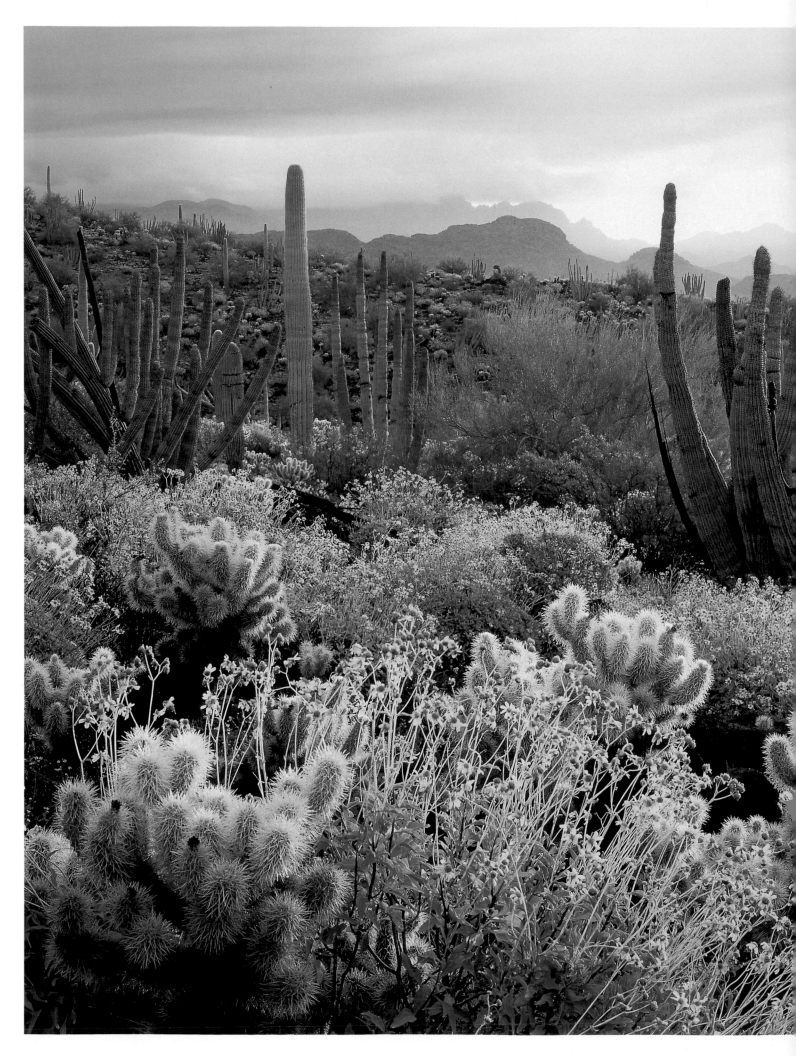

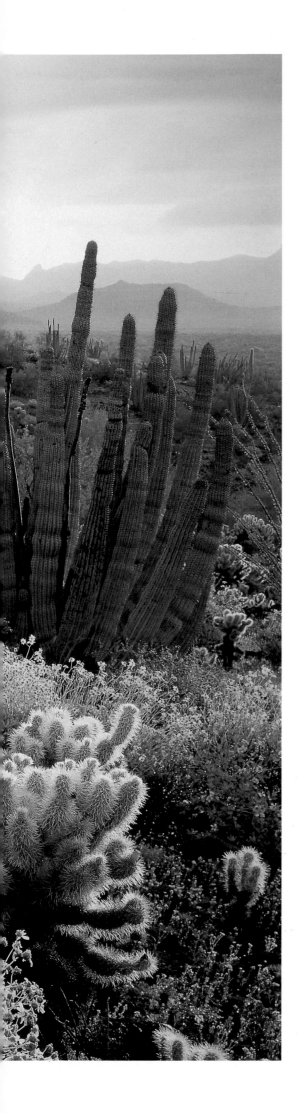

On the northern rim of the Superstition Mountains of Arizona hangs a little valley, like a kite in a hot breeze. This valley is so chock-full of cholla cacti that it appears to be impenetrable to anything other than sunlight and shadow. A cholla is all spines—long, intimidating needles—like a pincushion with arms and an attitude. These chollas are shoulder high, growing in a dense thicket, the top of each one a smaller, denser thicket of thorny arms. Littering the ground are broken chollas joints, a future generation waiting to hook rides to new cholla neighborhoods and the chance to grow thickets of their own.

Giving wide berth to these thickets is wise, although in my experience, backing up is when you are most likely to make a cholla's unexpected acquaintance. Not all creatures avoid chollas, however. Wood rats gather the discarded cacti arms and nibble past the needles to get to the chollas' flesh, where they find the water they need. White-winged doves build platform nests with spiny roofs and walls within these thickets. Cactus wrens construct tan-

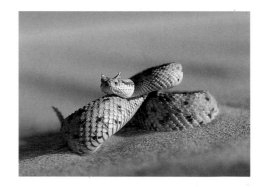

gles of twigs within the tangle of cholla spines, viewing the world from their nests as if from inside a dragon's mouth. To prick or protect? It all depends on how you land on the thorns of this cholla cactus dilemma.

(Previous pages, © Fred Hirschmann) Sand dunes are eternally shifting in the Mojave Desert's Death Valley National Park, California. They are home to the sidewinder snake (above, © Wayne Lynch). The Sonoran Desert (left, © Larry Ulrich) is known as the "garden desert" because of its thick cover of plants, especially the cacti and wildflowers shown here at Organ Pipe Cactus National Monument, Arizona.

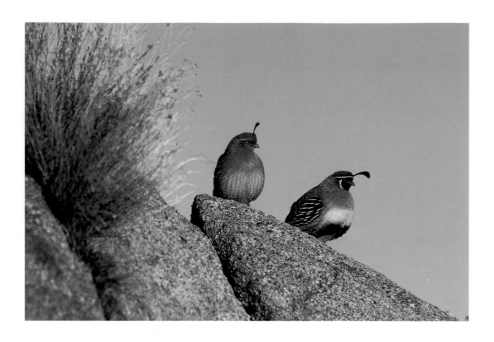

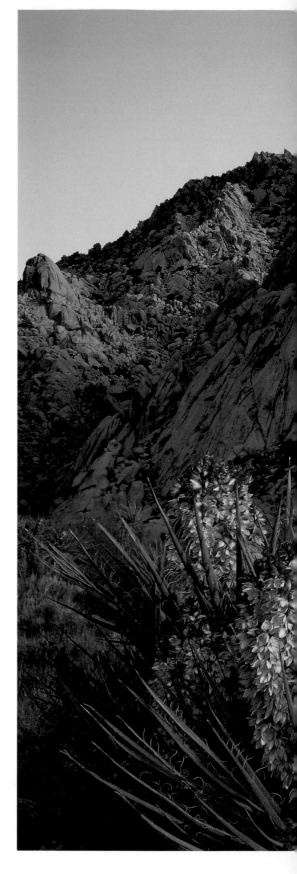

The desert ecoregion is a triptych, a three-desert design spanning the southwest borderlands of the continent, from the Sierras of California to the Rio Grande valley of Mexico and Texas. The Mojave is the westernmost and smallest of these deserts. It is also the driest, averaging less than 2 inches of rainfall in a year. The middle desert, extending from southern Arizona down into Mexico, is the Sonoran. It receives an intermediate amount of rain in two seasonal pulses, one in midsummer and one in winter. The easternmost desert, the Chihuahuan, is the wettest and largest of the three. Most of it lies in northeastern Mexico, invading only the Trans-Pecos region of Texas and New Mexico.

These deserts evolved about 40 million years ago when a ridge of high pressure formed off the Southern California coast and settled there permanently, like a huge boulder on a beach. Since then, this area of high pressure has diverted the path of Pacific storms churning east by sidetracking them northward, up the coast and away from the desert ecoregion. This bounding high pressure weakens from December through March, but even those storms that manage to break through it drop most of their rain on coastal mountains so that little precipitation is left for the deserts.

North America's deserts are unique because of their lush vegetation. There are 250 species of wildflowers found in the Mojave desert, and of these, 80 percent can be found nowhere else. There are more than 600 plant species in the Sonoran Desert, including 200 kinds of annuals, mostly wildflowers. And in the

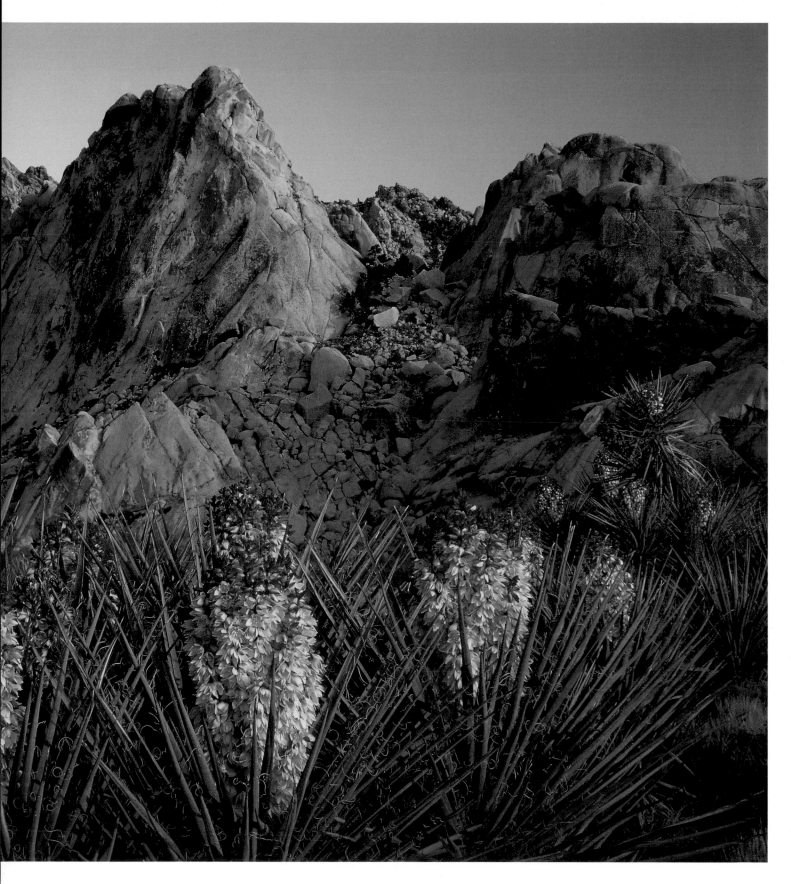

*Gambel's quail (far left, © Jeff Foot) and yucca
plants (above, © Larry Ulrich) appear on
rocky desert slopes from the southern Mojave,
through the Sonoran, and on into the western
Chihuahuan Desert.*

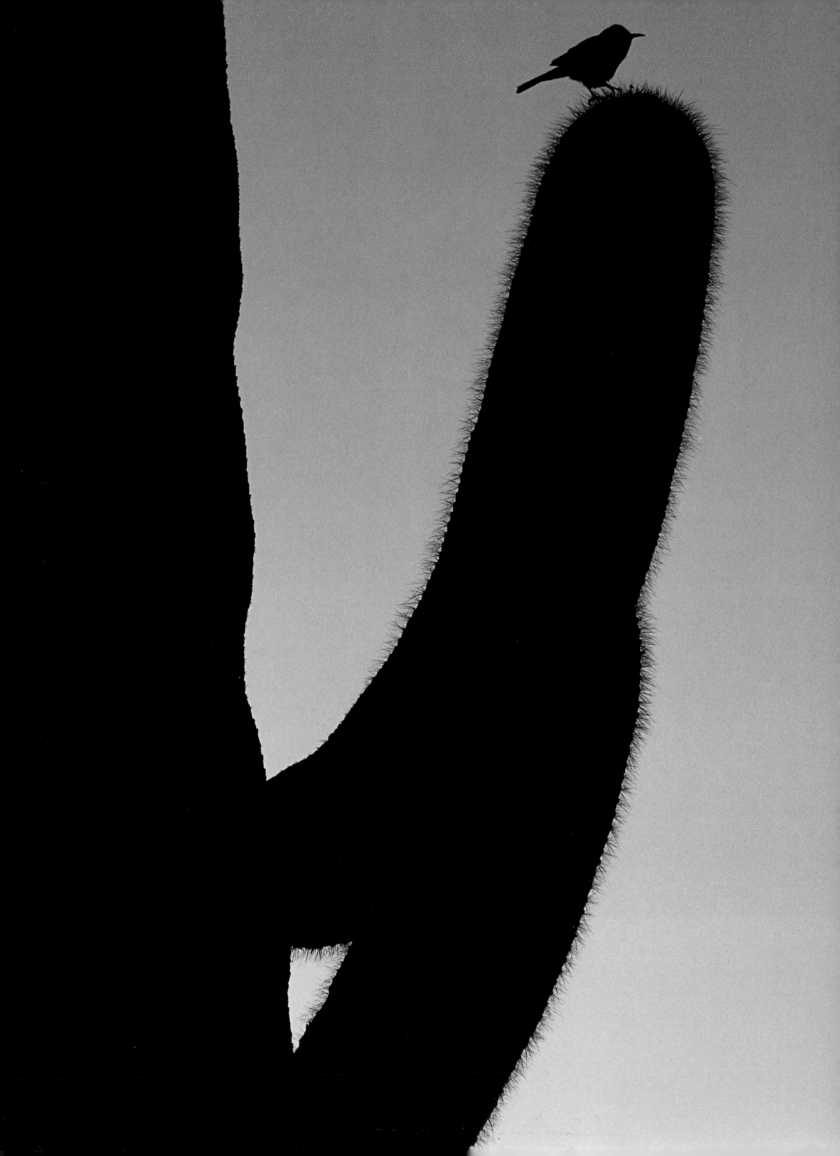

The spring bloom of paper flowers (right, © Fred Hirschmann) lights up the Chihuahuan Desert at Big Bend National Park, Texas.

Trans-Pecos region, the desert floor is thick with agaves, grasses, and almost 100 different cacti species. The giant agave, also called the *lechuguilla,* is the plant most characteristic of the Chihuahuan Desert. Its Spanish name means "little lettuce," which is faintly reminiscent of its shape but certainly not its demeanor—its leaves are as tough and ornery as the backside of a cowboy who has been too long in the saddle.

Many desert plants time their flowering to coincide with the coming rains. Brittlebush produces small, tough leaves during times of drought but broad, delicate leaves when it rains. Desert animals are attuned to this cycle as well. Hummingbirds coordinate their northward migration for arrival in the desert when their host flowers are in bloom. Spadefoot toads avoid summer's heat by entombing themselves underground. They must wait for temporary

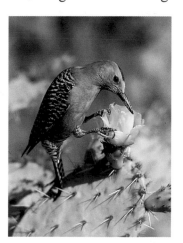

puddles left behind by passing storms before they can mate and lay their jellylike eggs. Seeping dampness from overhead storms rouses them to dig themselves out of the ground, the passing claps of thunder ringing their alarm.

Desert birds are exquisitely adapted to the sere landscape. Cactus wrens (left, © Pat O'Hara) build their nests within the spiny arms of cholla cacti for protection from predators. Gila woodpeckers (right, © Wayne Lynch) excavate nest holes in the saguaro cactus, looking for shade and insects attracted to its flowers.

The Lost Dutchman's Trail passes near the cholla thicket mentioned earlier, shuttling up the slope on its way past the

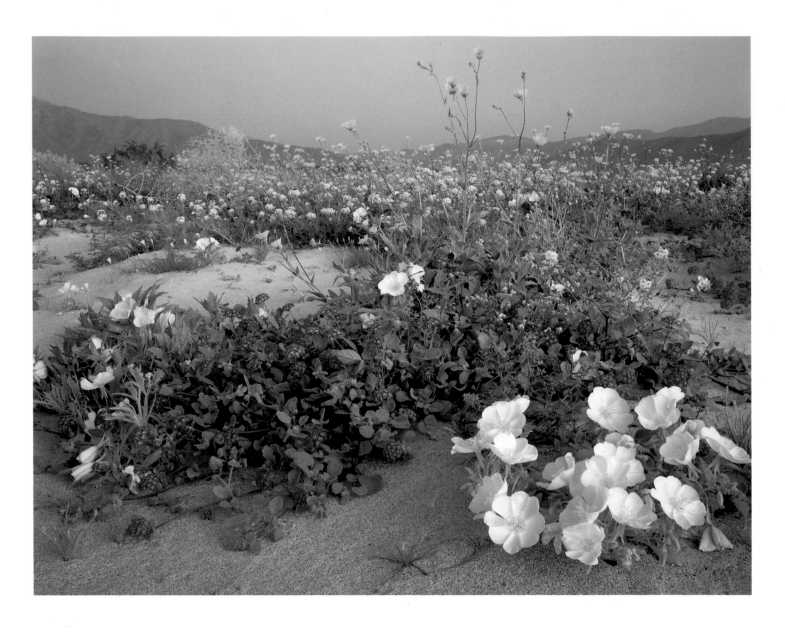

Weaver's Needle. In a valley below the thicket lies the trail head, surrounded by cacti and crawly critters washed in heat. All looks pale through the shimmering heat waves, and everything is baked to a fare-thee-well by the relentless sun. But the trail leads up to a ridge above the chollas where there are patches of snow and reminders of the northern forest: Douglas-fir trees, Steller's jays, and cool springs where peepers chorus in spring. Such are the changes wrought by elevation in the desert. A hiker can start in the desert, walk up to a northern-clime forest, and return to the desert in a single day.

All of the desert ecoregion is studded with mountains, not massive uplifts like the Rockies or the Sierras but individual ranges surrounded by desert. These desert ranges are known as "sky islands," for they are isolated rafts of green coolness in a sea of heat, and they harbor plants and animals—such as bears, bighorn sheep, and bobcats—that couldn't survive the dryness below.

Dune evening primroses and other spring flowers (above, © Fred Hirschmann) bloom sporadically in the Mojave Desert. Winter storms in the desert are not uncommon and generally not catastrophic to the native plants and animals (right, © Jack Dykinga). Often, by afternoon, the snow is gone and life returns to normal.

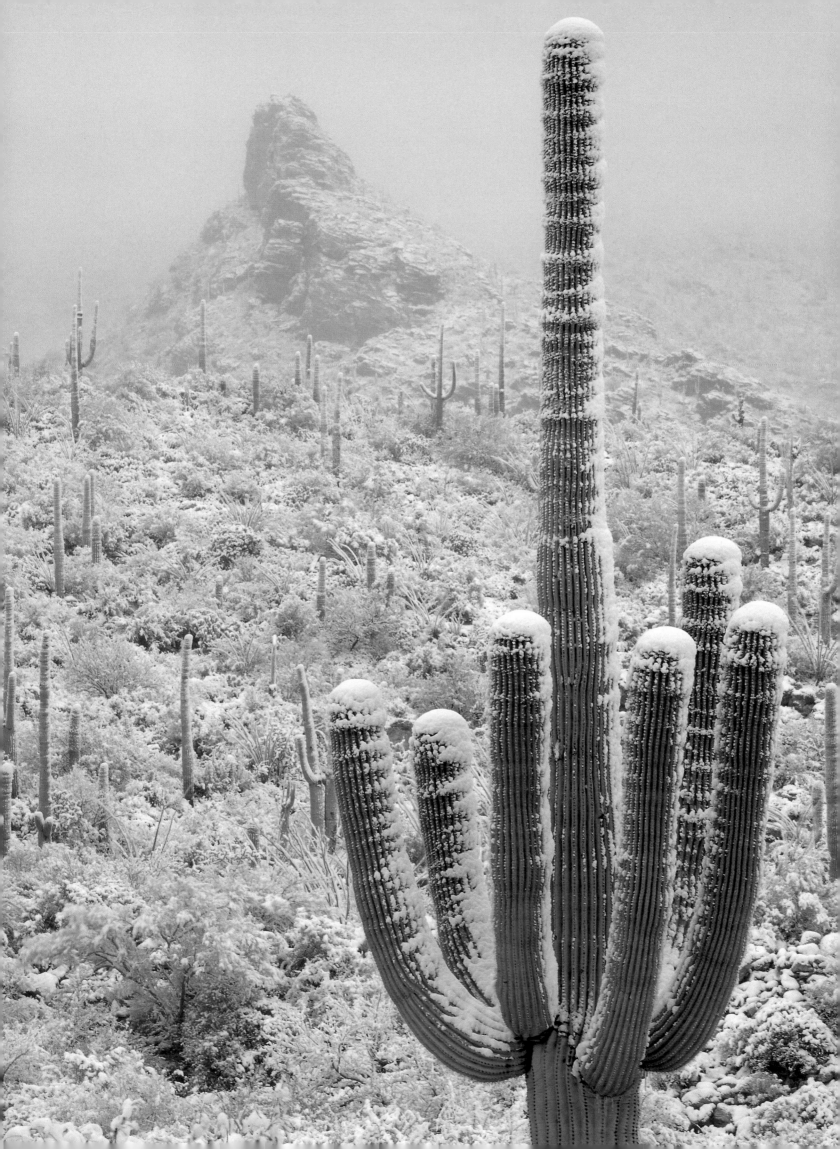

There is so much difference between the mountain-top and desert climates that it isn't uncommon to see snow at mountain elevations of 10,000 feet from sidewalks in Tucson, Arizona, where it is too hot to stand barefoot.

In winter, snow occasionally covers the desert floor. These freezes are rare, but they leave their mark. For example, very old saguaro cacti often have rings of constriction around their trunks, which are scars leftover from a particularly bad freeze in 1848. Overall, however, such chills bother the wintering visitors and the plants introduced from other areas more than they do the natives, who know how to adapt to coldsnaps.

The land surrounding the sky islands looks oceanic—a wavy landscape of grasses, awash in breaking agave whitecaps that roughen the rolling sea. This landscape disappears into the desert proper as grasses give way to hardscrabble flats, and life finds shelter on minimal edges. Where land and water meet, one such edge appears, an edge that traces a green line around shallow lakes and slack river waters. On this edge lives the desert's most ferocious predator, a six-eyed creature with crunching jaws that hides in a burrow, ready to ambush unsuspecting prey. I speak of the tiger beetle, 25 species of which live in the desert ecoregion. Its lurking larvae are important hunters of bugs, ants, flies, grasshoppers, and anything lingering within their mandibles' reach. The adult beetles also prey on insects, stalking them on the wing and then running down the slow-footed quarry.

Tiger beetles are one of the few beetle species with tympana, ear-like organs located under their wings. The tympana are sensitive to the ultrasound clicks of foraging bats. If heard, this sound will send a flying tiger beetle to the ground and running to safety. A beetle with ears, a nest of thorns, a flower with varying leaves, a piece of Idaho lost on sky islands above the desert floor. When the day is done, come what may, desert life endures.

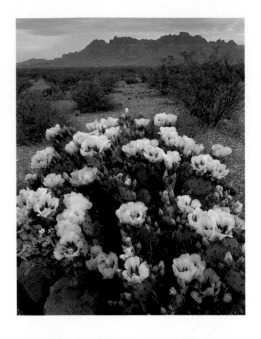

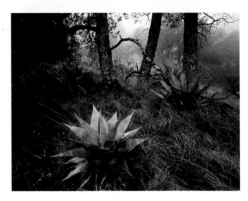

Desert mountain ranges are called "sky islands." While prickly pear cacti bloom on the desert floor (top, © Willard Clay), Mexican pinyon pines and agaves (bottom, © Carr Clifton) thrive up above in the cool mountain climate. In October the colors of these mountain forests (right, © Jack Dykinga), filled with sycamores and maples, rival New England's autumn foliage.

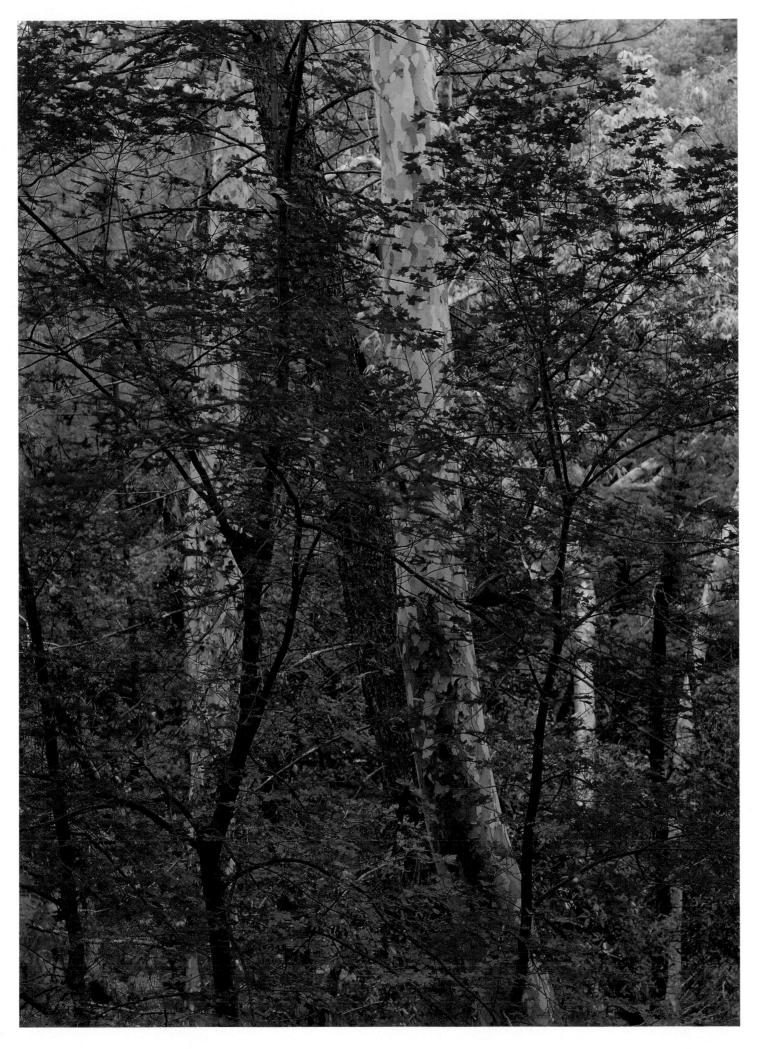

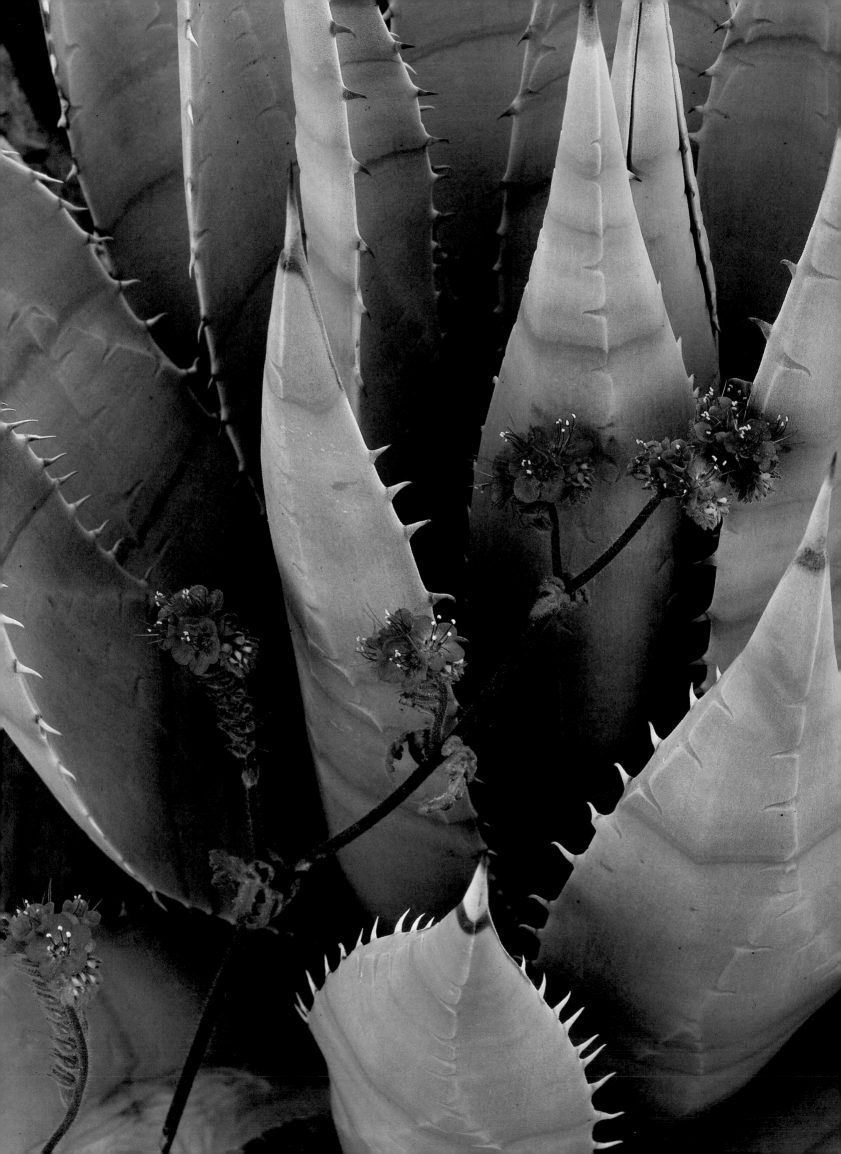

(Left, © Jack Dykinga) Wild heliotrope blooms across an agave plant.

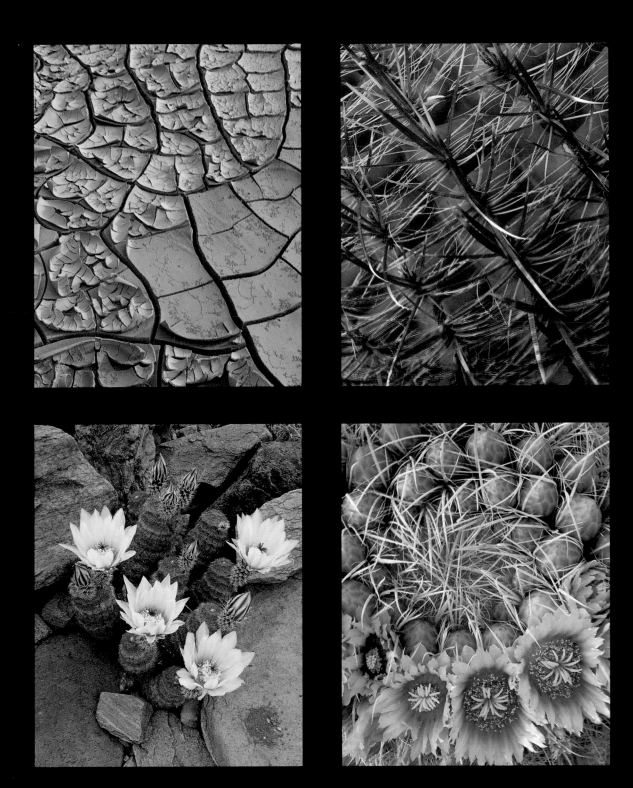

Rainfall in the desert may not occur for many months, causing water beds to dry out and mud to crack (top left, © William Neill). Cacti conserve water beneath their thick skin and protective spines (top right, © Fred Hirschmann), and by growing very slowly. When rain does come, rainbow cactus (bottom left, © Willard Clay) and barrel cactus (bottom right, © Fred Hirschmann) produce surprisingly showy flowers.

Joshua trees are characteristic of the Mojave Desert,
growing tall where all else hugs the dry desert floor.
(© William Neill)

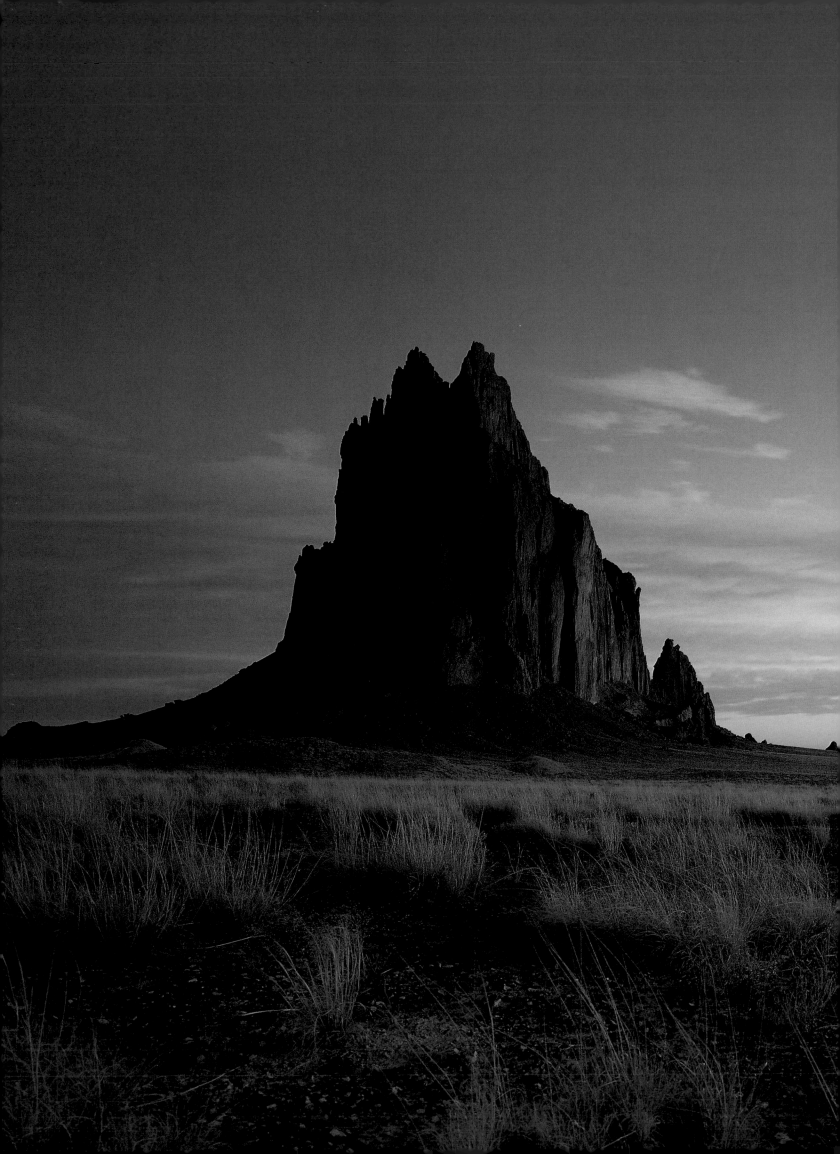

THE BASIN AND PLATEAU

"Its rivers run nowhere but into the ground; its lakes are probably salty or brackish. Its snake population is large and its human population small. Its climate shows extremes of temperature that would tire out anything but a very strong thermometer. It is a dead land, though a very rich one."

—Wallace Stegner

There is a place southwest of the Great Salt Lake in Utah where, at ground level, I've been able to see more of the earth than anywhere else I've ever been. At the edge of Route 50, "the loneliest road in the USA," south of the Sevier Desert near the little town of Abraham, on a day when the wind is not blowing great clouds of salt silt into the air, I've seen an area encompassing 30,000 square miles. This huge vista, six times the size of Connecticut, unfurls around this lonely place in a grand panorama.

To the south, I can see 150 miles to the Pine Valley Mountains lying just east of Zion National Park. To the east 70 miles away stretches the Wasatch Plateau, which is the western edge of the Colorado Plateau. To the northeast 90 miles away are the Wasatch Range and 11,750-foot Mt. Timpanogos, the sentinel that overlooks Salt Lake City. To the north 150 miles away, past the Great Salt Lake Desert and the western arm of the Great Salt Lake, lie the Goose Creek Mountains at the triple junction of Nevada, Utah, and Idaho. And 80 miles to the west, between Marjum and Skull Rock Passes, rises Wheeler Peak, the highest point in Great Basin National Park. So, with Abraham close by

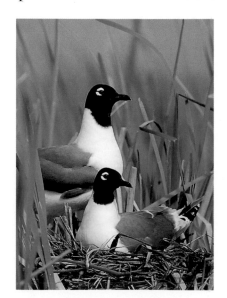

and Zion at my back, I stand and wonder, how grand might be the panorama from Wheeler Peak?

The Basin and Plateau ecoregion combines the Great Basin and the Colorado Plateau. Both areas are defined by rock, wind, and lack of water. The Great Basin (so named because no rivers flow out of it, and water is held hostage until lost to the

Water, while often unnoticed in the Basin and Plateau, is never unappreciated. Downpours wash through gullies like this one in Escalante Canyon in Utah (right, © Jack Dykinga), seeping into cracks to nourish yellow evening primroses (above, © Rod Planck) and collect in shallow basins where Franklin's gulls nest (left, © Wayne Lynch).

(Previous pages, © David Muench) Shiprock is an eroded volcano in the northwestern corner of New Mexico.

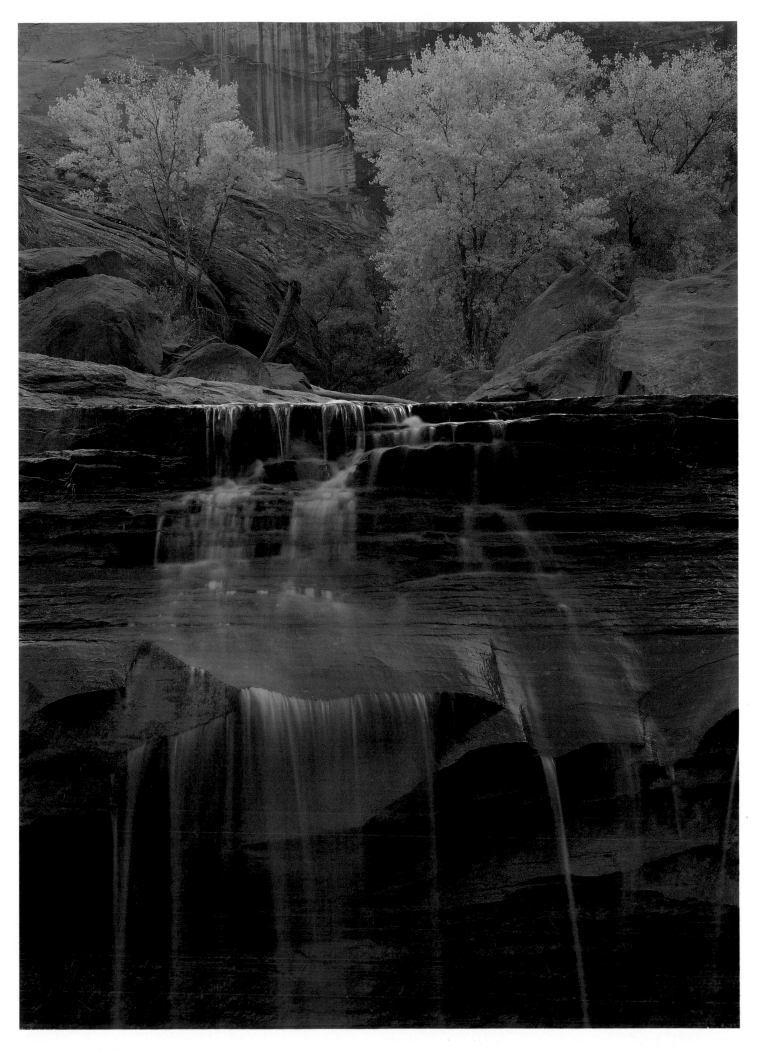

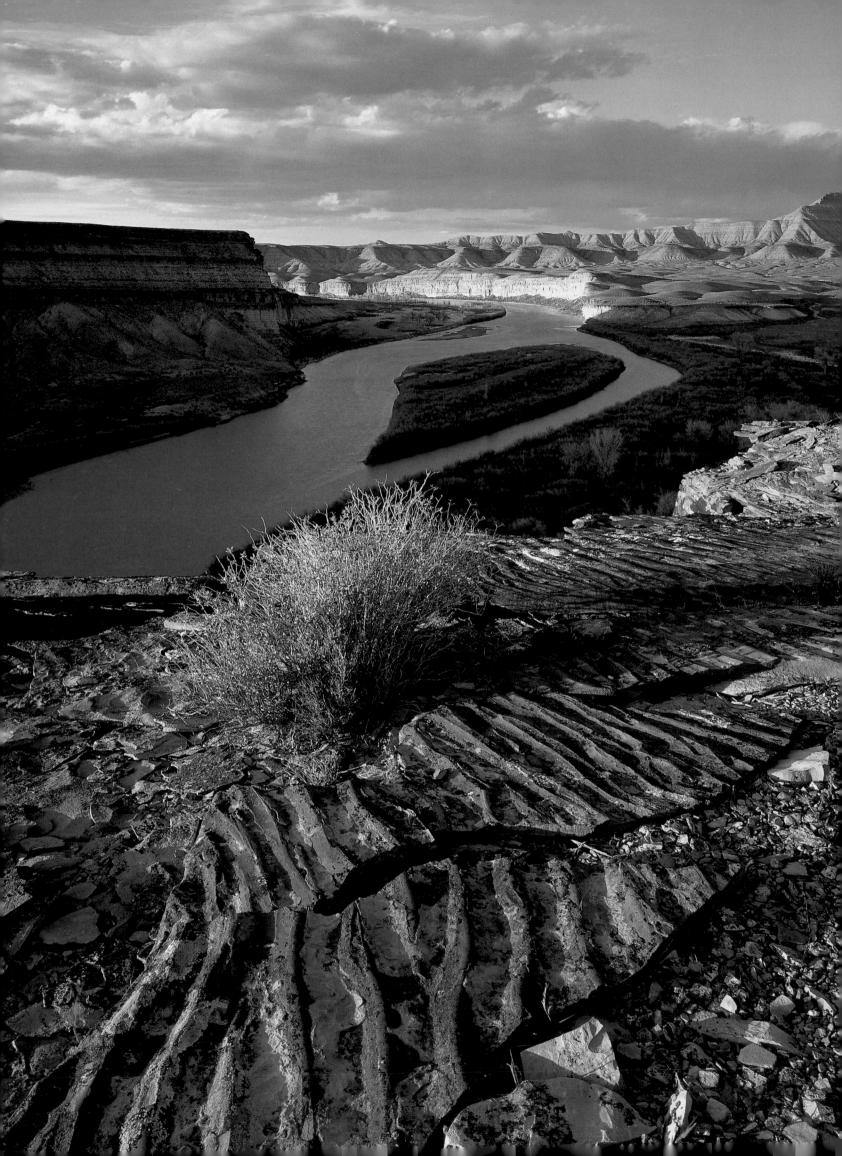

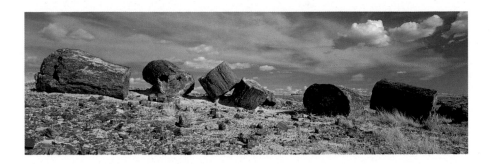

The effects of wind and time on the Basin and Plateau are often clearly exposed to the eye. Frosted ripples in the dunes at Monument Valley Tribal Park, Arizona (below right, © Kathleen Norris Cook), and fossilized ripples in sandstone above Desolation Canyon, Utah (left, © Carr Clifton) are evidence of the wind's erosional powers. A trunk of petrified wood (top right, © John Shaw) in Petrified Forest National Park, Arizona, reminds us of the eons of time that have shaped this landscape.

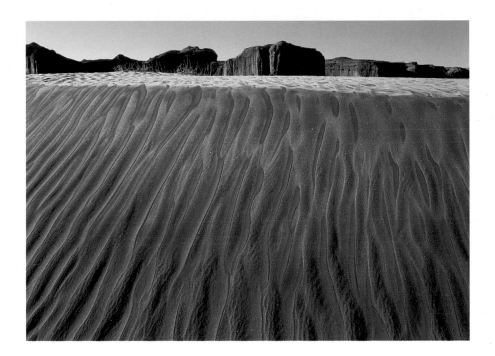

(Overleaf, © Art Wolfe) The Alabama Hills bump into the Sierras in eastern California, marking the western boundary of the Basin and Plateau ecoregion.

sky) and the Colorado Plateau (named after the uniform, layer-cake geology revealed by the Colorado River) cover an area of more than 300,000 square miles. The Great Basin, roughly heart-shaped, is centered on Nevada, although the Basin spills into the southern corners of Oregon and Idaho, western Utah, and bumps hard into the Sierras of eastern California.

The Colorado Plateau is canyon country, a landscape of sandstone cliffs and dry washes. Here the play of water and wind on rock has sculpted the land into bowls, folds, mesas, and arches. The Colorado River drains most of the region, carving canyons in the process and etching great swirls into the land. This has made the Colorado Plateau into a slickrock and slot canyon playground, now home to many great North American parks: Capitol Reef, Canyonlands, Petrified Forest, Arches, Bryce, Zion, and Grand Canyon National Parks, and Monument Valley Tribal Park.

The Basin and Plateau have had a manic, almost schizo-phrenic geologic history. Over the last 2.5 billion years (the age of its oldest rock), the ecoregion has been compressed, soaked, dried,

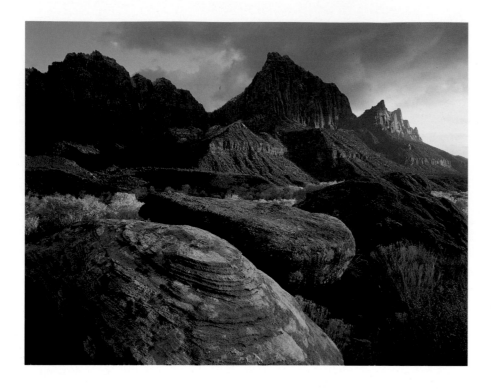

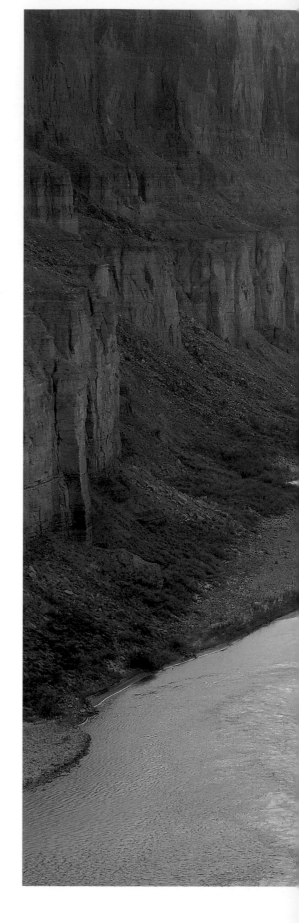

split north/south, reassembled, split east/west, heated, stretched, tilted, rotated, and thinned. As northern California is being pulled to the northwest by the motion of tectonic plates, this is stretching the Great Basin east to west. Evidence of this motion can be found in the swarms of north/south-running faults in the Great Basin, geologic stretch marks common throughout the region. After more than 8 million years of being pulled like taffy, Nevada is twice as wide as it once was, and the distance between Reno and Salt Lake City has increased by 50 miles. During the next several million years, this stretching will work its way north, further elongating southeastern Oregon as the Cascades rotate west into the Pacific.

Not as old as the land but certainly as venerable, ponderosa

and bristlecone pines cover the Basin and Plateau mountain ranges. Ponderosa pines grow throughout the Colorado Plateau in open, parklike forests that invite impromptu picnics and afternoon strolls. In the Great Basin, the ponderosas' need for moisture restricts them to high mountain slopes, where they form a green ring around the mountains like a high tide line around a rocky island. Between the pines, sagebrush, and creosote bushes of the valley

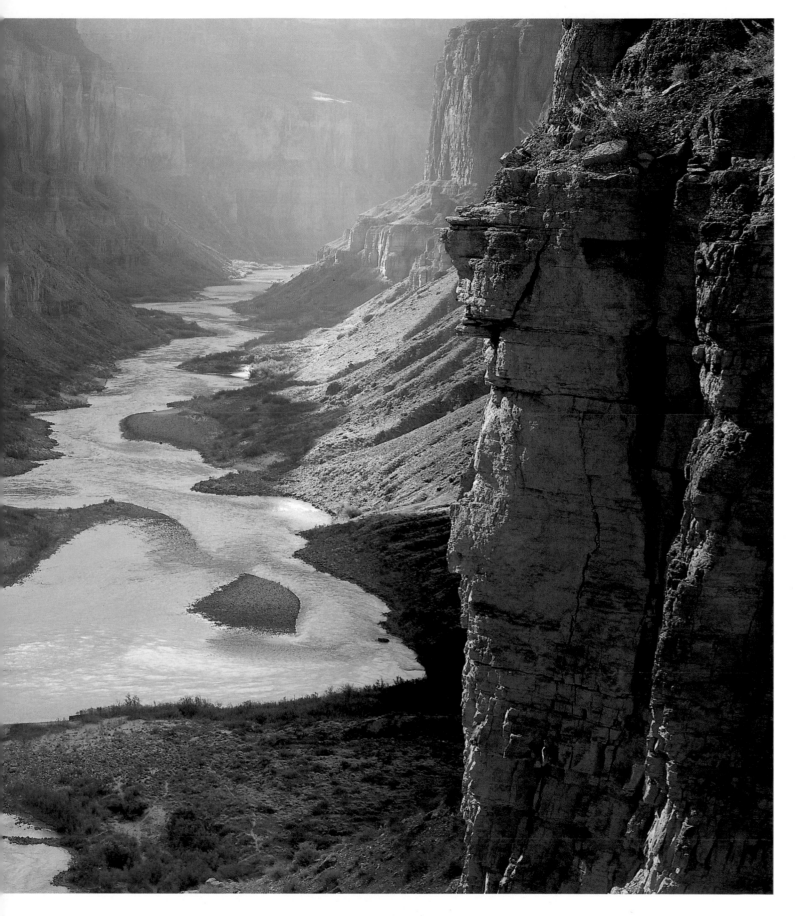

The Basin and Plateau area in the Southwest is a rocky tableland, sliced throughout by wind and water into great eroded blocks of land. The Watchman rock formation (top left, © Carr Clifton) in Zion National Park, Utah, is wind carved, while the Grand Canyon (bottom left, © David Muench) in Arizona has been worn away over 2 million years by the Colorado River. The Grand Canyon (above, © Kathleen Norris Cook) is more than a mile deep and exposes rocks that are 1.7 billion years old.

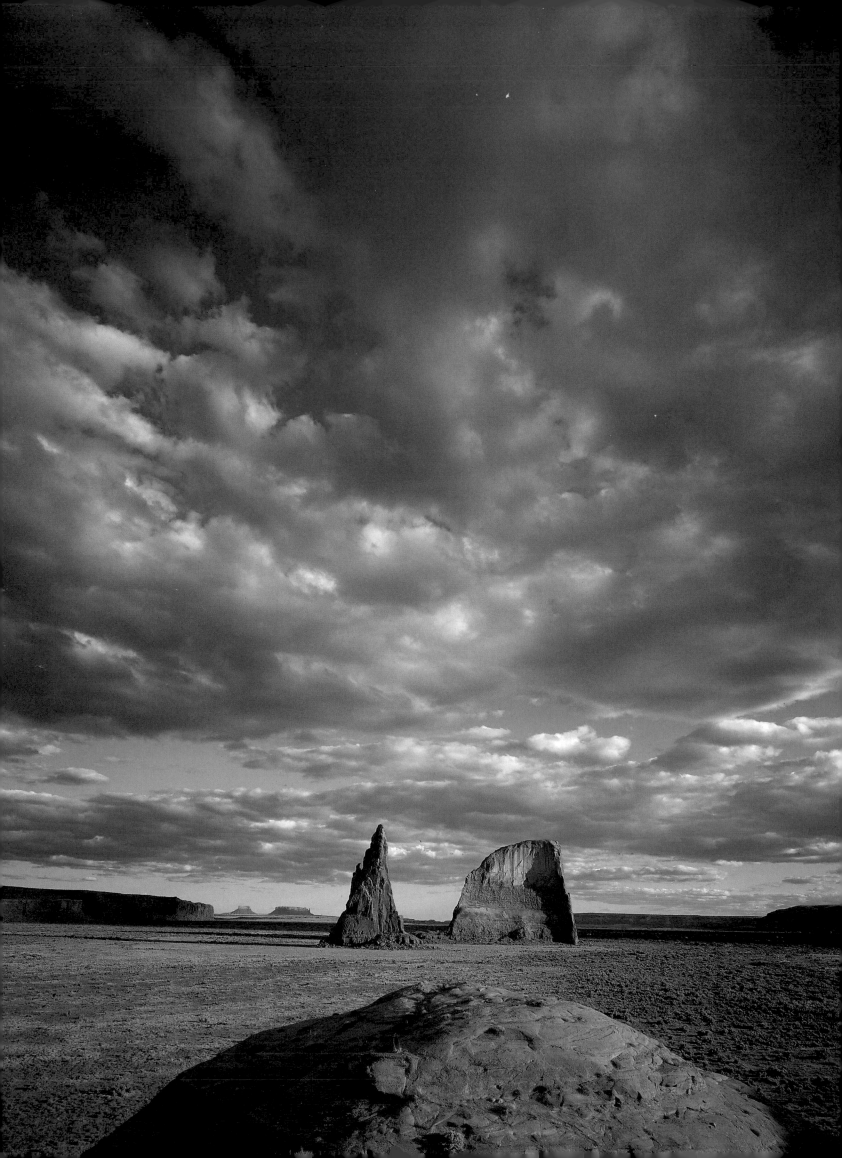

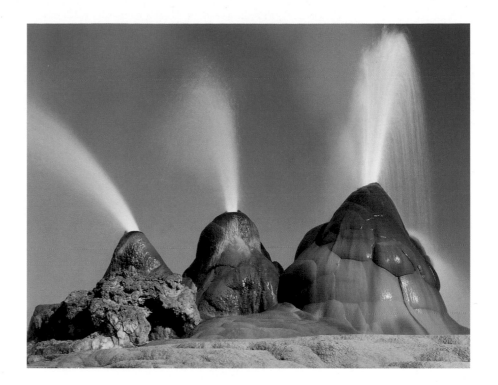

floors grow an uneven margin of junipers. They thrive wherever wildfires don't burn because junipers, rich in resins, explode when touched by flames. Where valleys have been developed and wildfires suppressed, junipers creep downhill like a slow green shadow, eventually occupying entire valleys.

By the time a ponderosa is 40 years old and has a trunk a foot or so thick, the ground around it is littered with pinecones, needles, and puzzle-piece flakes of bark. Not many wildflowers seem to grow in this thick pine mulch other than lousewarts and Easter daisies. These tiny plants with oversized flowers cling to the needle mats, blooming on the first warm days of spring, but as soon as the soil dries, little else blooms around the ponderosas.

Groves of ponderosas may be my favorite kind of forest because their floor is always soft underfoot, and the whisper of wind in their boughs is kind to the ears. Plus, a ponderosa forest is sweetly scented with exotic aromas. If you put your nose into a fissure in a ponderosa pine and inhale deeply, the scent of vanilla—some say butterscotch—will reward you. Overhead, woodpeckers' staccato taps underscore the tiny tinhorn notes of pygmy nuthatches that flit through this wonderous, seductive forest.

Above the green belt of the ponderosas grow the most gnarled and weather-beaten trees of North America, the bristlecone pines. Pushing the sky out of their way, bristlecones grow at tree line, an environment so harsh that it is shunned by all lesser

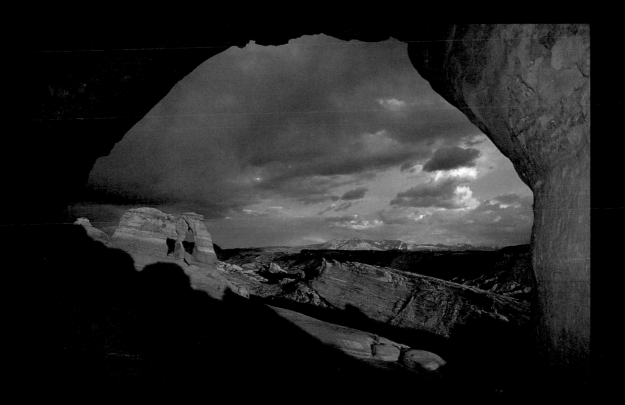

Delicate Arch, Arches National Park, Utah. (© Galen Rowell)

Antelope Canyon, Arizona. (© John Shaw)

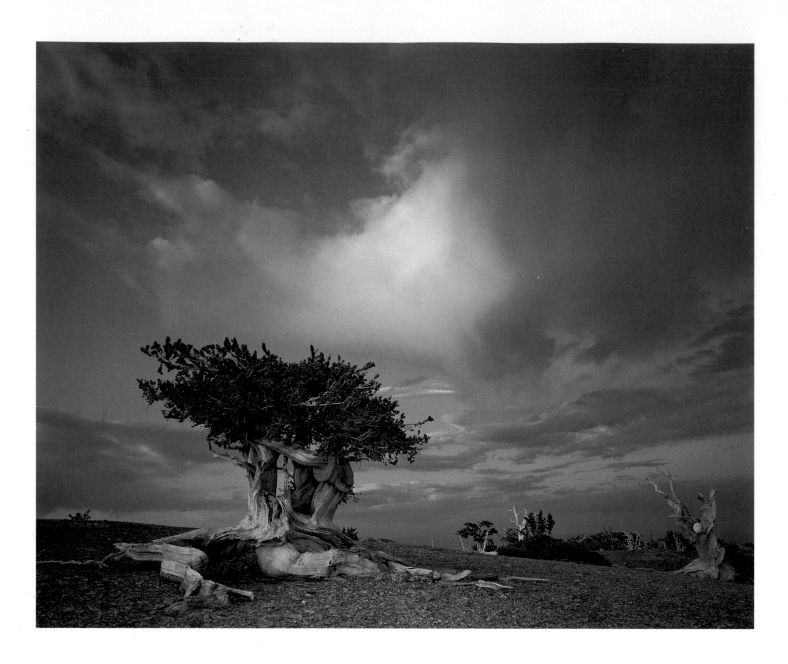

trees. Gripping the mountain with twisted roots and shouldering their limbs against storms, bristlecone pines seem to live on wind alone, for they can grow in such a harsh environment only during the summer months when temperatures rise above freezing. And yet bristlecone pines are the oldest living trees in the world; several have been living for nearly five thousand years.

Bristlecones pines are grandfather trees, riding the ridges in groves of wind-carved timber and gathering the stories of the land in their wood. The rings of a dead bristlecone might reveal a millennium—or five millenia—of Basin and Plateau history. Where the rings are thin, the climate was cool, meaning the tree, the coyote, and the cactus just endured. Where the rings are wide, the sun warmed the earth, meaning the tree, the deer, and the sagebush prospered. What better way is there to know the land than to find a tree with stories to tell?

The trees of the Basin and Plateau vary as much as water and sky. While riparian cottonwoods (right, © Kathleen Norris Cook) endure winter by Oak Creek in Sedona, Arizona, ancient bristlecone pines (above, © David Muench) survive in the arid Great Basin National Park, Nevada.

(Overleaf, © William Neill) Mono Lake National Scenic Area, California.

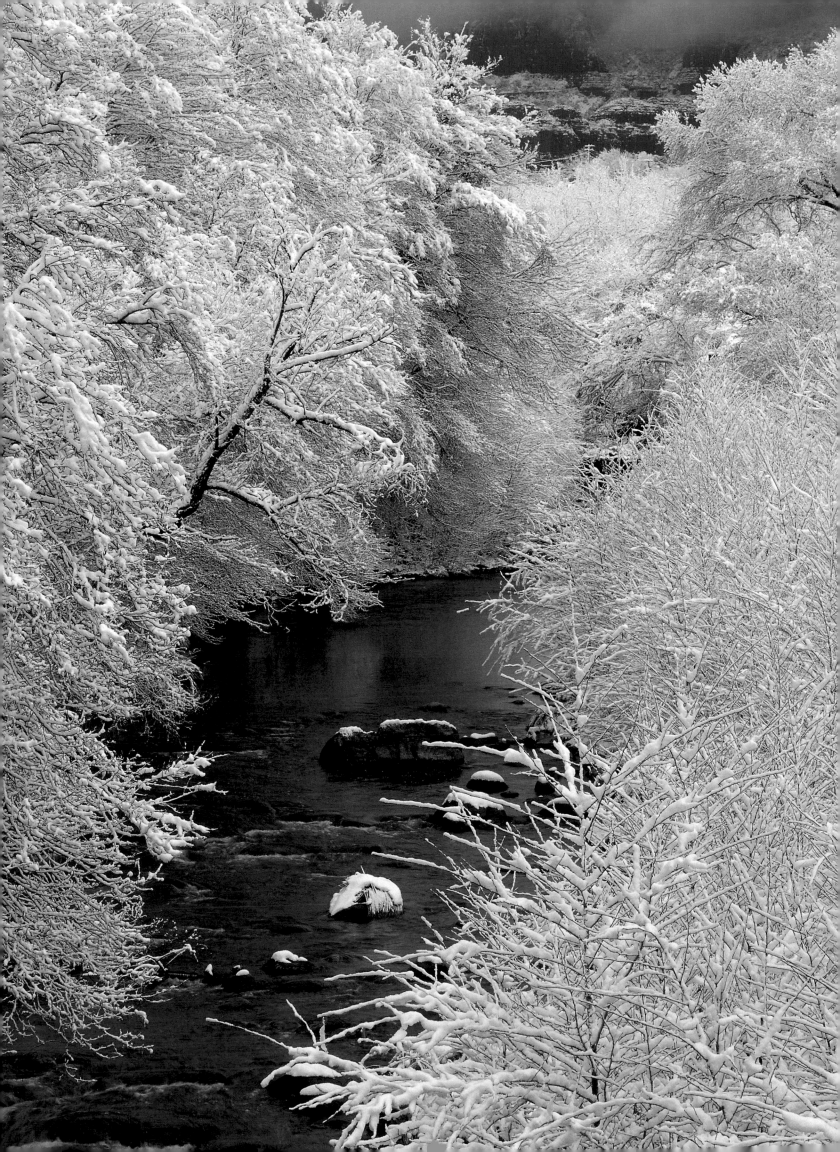

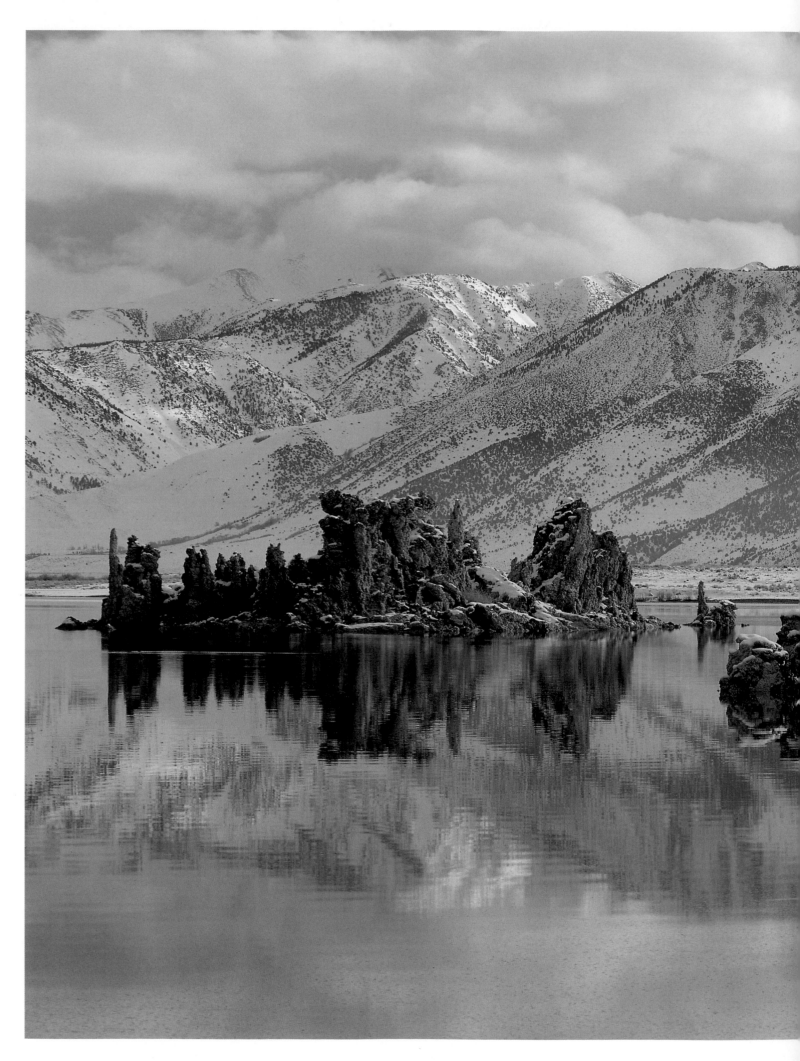

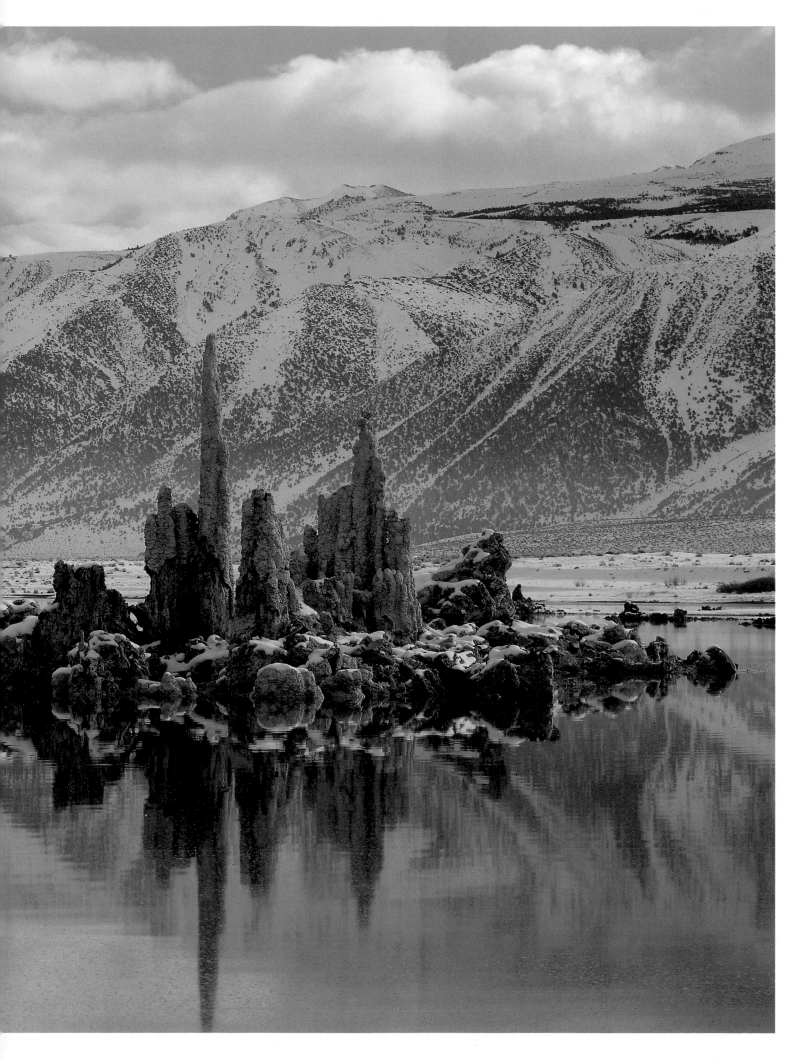

THE ROCKY MOUNTAINS

"Those who have packed far up into grizzly country know that the presence of even one grizzly on the land elevates the mountains, deepens the canyons, chills the winds, brightens the stars, darkens the forest, and quickens the pulse of all who enter it. They know that when a bear dies, something sacred in every living thing interconnected with that realm . . . also dies."

—John Murray

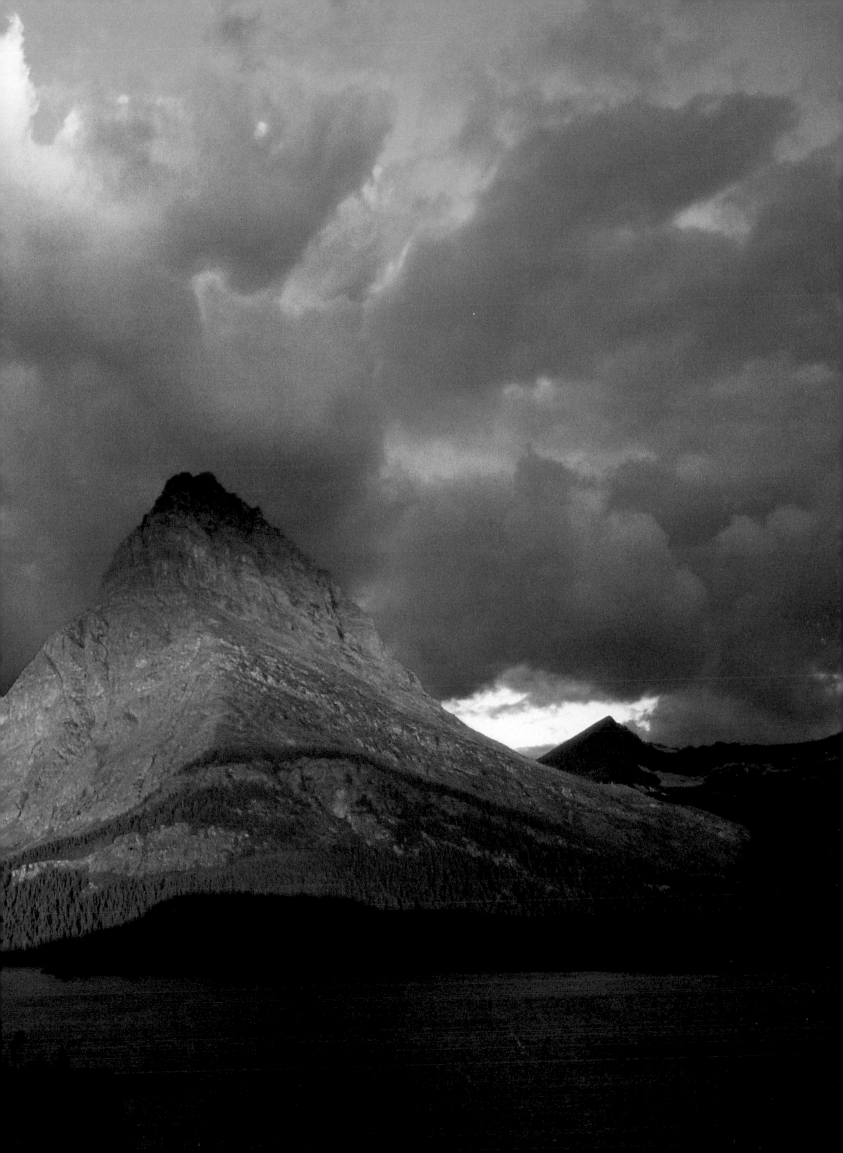

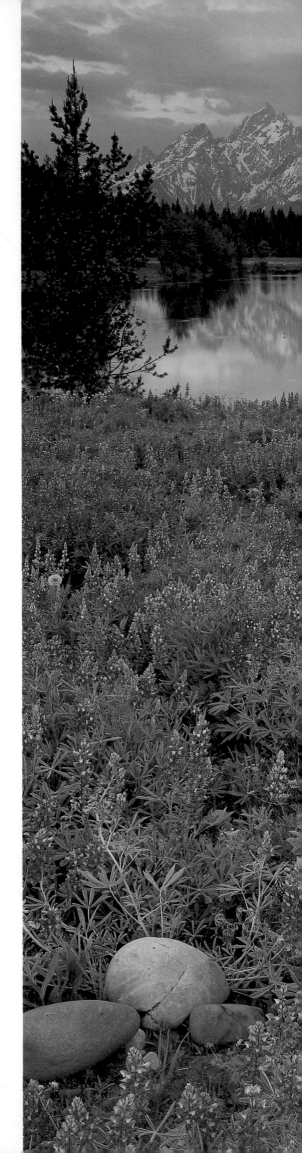

The Rocky Mountains are most
noticeably rocky—rock hard, rock solid, mountains of rockiness.
No overburden of sediment softens
their contours to lessen their impact.
The Rockies are not clothed in thick
vegetation like the Appalachians or
hidden under tall timber like the
Cascades; the Rockies' lithic bones lie
exposed and bare. They loom without
pretense sharp and hard against the
blue western sky, a stony fortress of

continental proportions. The Rockies are solid and formidable,
parallel lines of north/south ranges
piled up like breakers waiting to crash
upon the rising Great Plains.

The Rocky Mountains are
North America's granitic hinge, bend-
ing the geologically older and more sta-
ble East to the younger and more
unpredictable West. Extending from
central Mexico through all of North

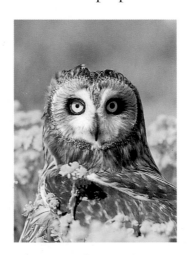

America, the Rocky Mountains are the signature mountain range
of the continent. While their appearance varies from Alberta to
Albuquerque, their origin is the result of a single, sustained, moun-
tain-building push. The Rocky Mountains we see today rose over
a period of 60 million years, as the growth of the Atlantic Ocean

*Summer flowers, such as meadowbright (top), dot lush meadows where a short-eared
owl might hunt at dusk (bottom, both © David Middleton). Such is also the case
along Pilgram Creek (right, © Willard Clay) where lupines bloom in Grand Teton
National Park, Wyoming. (Previous pages, © Art Wolfe) Grinnell Point, Glacier National
Park, Montana.*

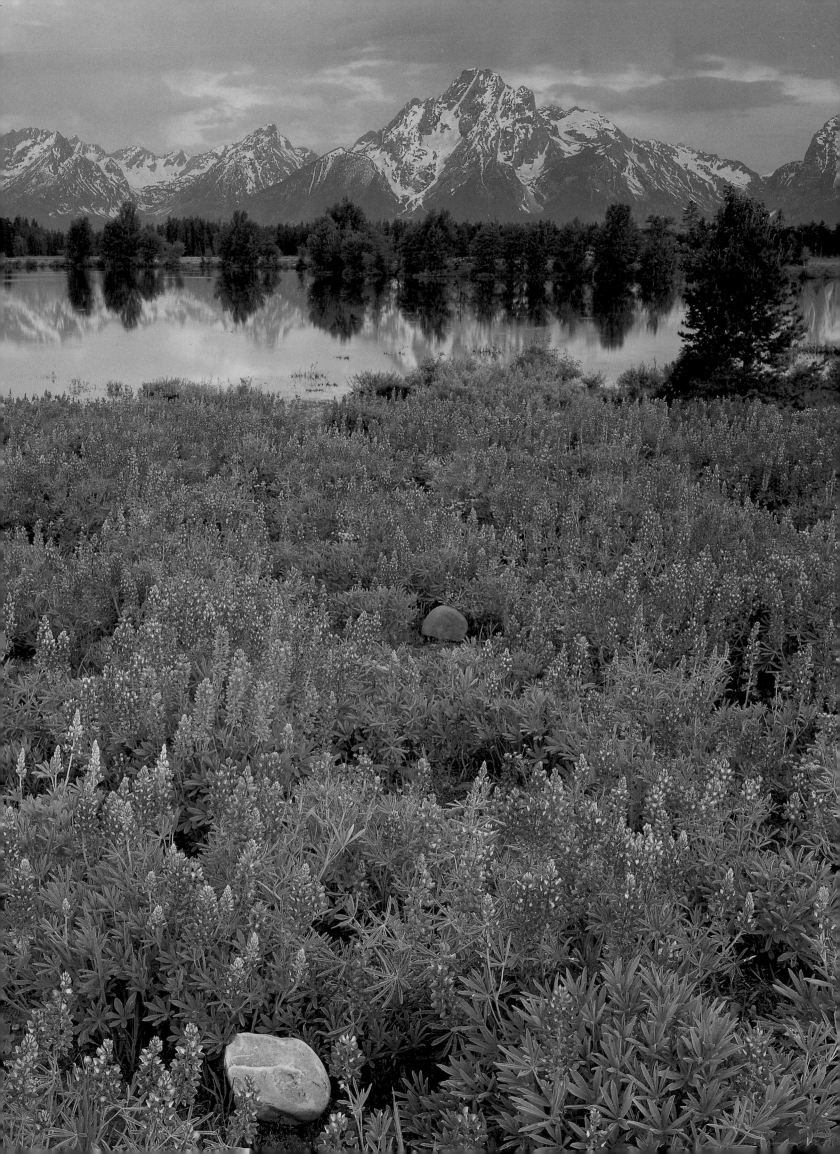

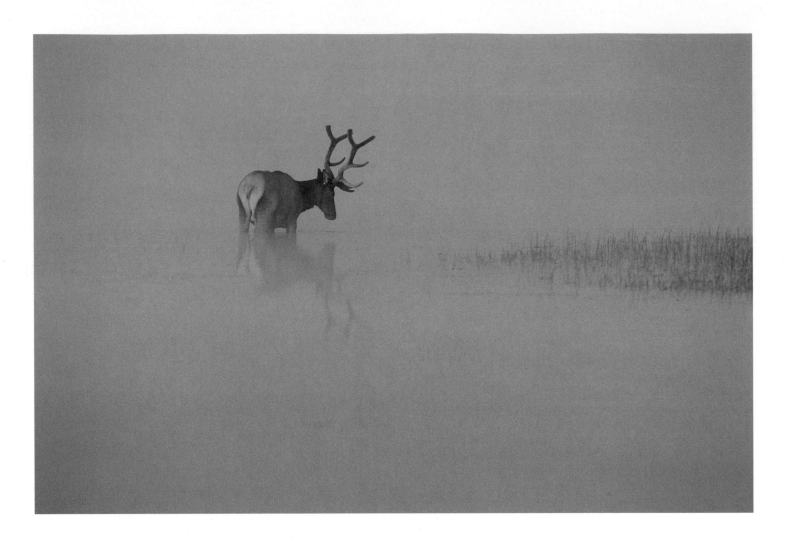

accelerated the drift of North America away from Europe and westward over the Farallon tectonic plate in the Pacific. As the Farallon plate disintegrated deep within the Earth, it caused the crust of North America above to tear and buckle, and the Rocky Mountains emerged.

Because much of this mountain building occurred in a relative fingersnap of the Earth's recent lifetime, the geologic features of the region are still unworn and hence impressive. Many of our best-loved national parks (Yellowstone, Glacier, Grand Teton, Jasper, and Banff) and famous landmarks (Pikes Peak, Carlsbad Caverns, Old Faithful, and Lake Louise) are found within this ecoregion. Because the Rockies are still largely untamed, they stir the imagination perhaps more than any other ecoregion does in North America.

No season grips longer nor leaves a deeper impression than winter in the Rocky Mountains. Countless winters long ago once filled the region's valleys with ice that, in turn, filled its rivers and basins with meltwater. Both ice and water have sculpted the ridges and canyons of the Rockies. Where these glacial waters pooled,

Even when tourists are thick, stillness can be found on quiet mornings, when elk feed in Yellowstone National Park (above, © Tom Mangelsen) and fog shrouds the Snake River in Grand Teton National Park (right, © Carr Clifton).

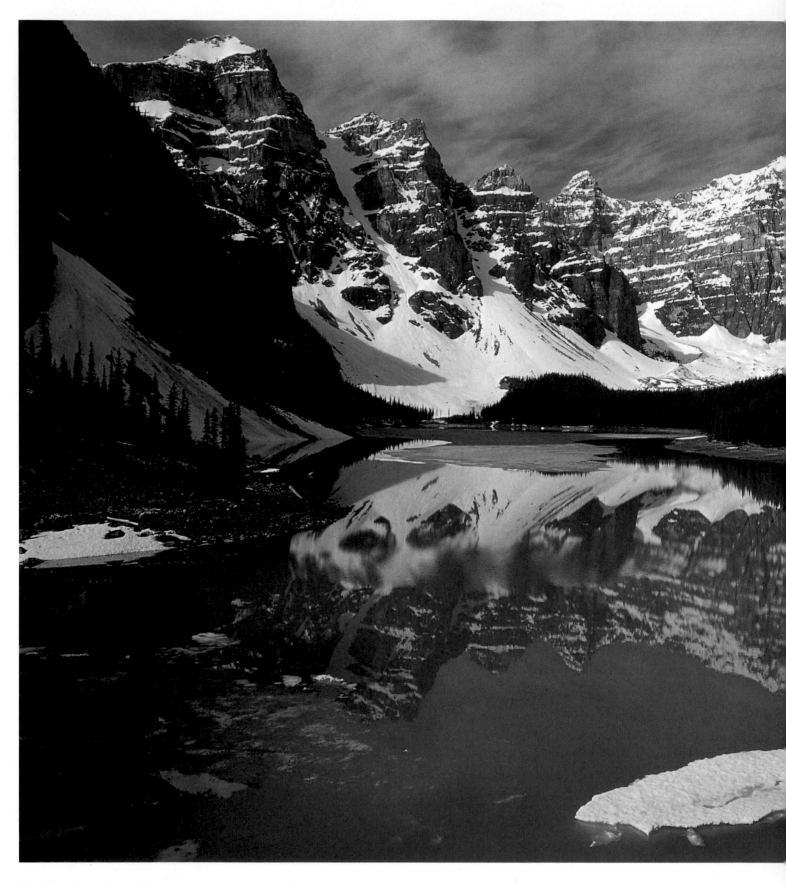

*In July, winter reluctantly eases into summer at Moraine
Lake, Banff National Park, Alberta (above, © John Shaw),
as beargrass blooms (right, © David Muench) in
Glacier National Park, Wyoming.*

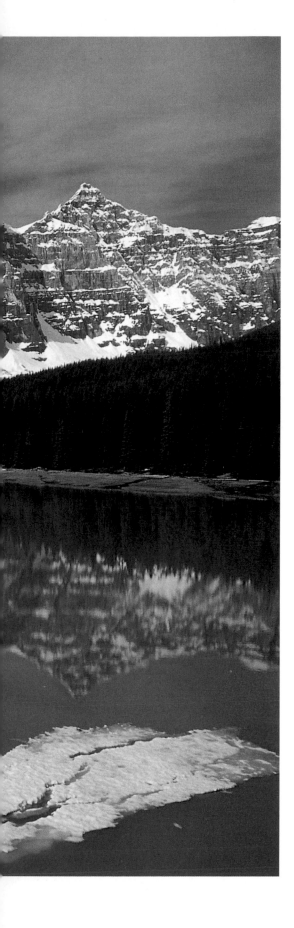

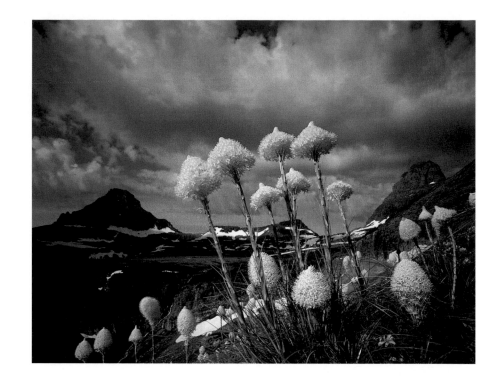

Pleistocene lakes arose. These lakebeds, now dried, are the well-known "parks" and "holes" (for example, South Park and Estes Park in Colorado, and Jackson Hole in Wyoming) of the Rocky Mountain landscape. Winter still shapes all life within this snowy realm. Starting in autumn, winter begins with the first winds that fell the golden aspen leaves in October, lasting until early summer when snow squalls often postpone nest building in June (and sometimes fireworks in July).

Snowfall in the mountains ranges between 30 and 40 feet annually, knitting a dense, white blanket that is deeper than a shovel is tall. For many plants and animals, this blanket is truly an insulating comforter that shelters delicate roots and warm-blooded bodies from winter's extreme temperatures and biting wind. Beneath the snow, there is much activity. Pikas and pocket gophers—both small, furry balls of life with short ears and stout personalities—dig mazes of tunnels in order to munch frozen plants and tend to their piled pantries of dried grass. During the winter, these little rodents are protected from most avian predators by a snowy roof, but other dangers remain. Short-tailed weasels, in their winter white coats with black-tipped tails, plunge through snowfields in pursuit of warm shadows. Overhead, coyotes with antennaelike ears zero-in on unseen squeaks, and then pounce with stiff legs and arched backs on unseen prey. This drama is lost on the marmots and ground squirrels, professional sleepers that

retreat from winter's dangers in contented curls of hibernation.

In the winter forest, a multitude of animals stay active year round. Chickadees and nuthatches scour branch and bole, probing for insect larva and eggs. Overhead, pine siskins and crossbills tear apart cones and catkins in search of overlooked seeds. Elk and porcupines find sustenance in the aspen's pale green bark, leaving gnawed teeth marks behind as calling cards. The nutrition they get comes from the aspen's unique ability to photosynthesize through

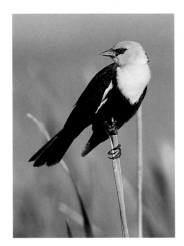

its bark, thereby producing food (sugars) without risking delicate leaves to the vagaries of late winter/early spring weather. Aspen bark spiced with willow buds may be the only food available to such browsers as mule deer, moose, and elk during long winters.

The first sign of spring in the Rocky Mountains is the temporary thawing of something long frozen—usually mud. Spring overlaps so much with late winter and early summer that it is often dismissed as being just a "too warm day for winter" or a "too cool day for summer." The season is as fleeting as the passing of northbound geese. A rumor of spring surfaces in the repetitive, hollow hoot of courting boreal owls in mid March. By the beginning of April, thick snow still covers the meadows, but ground squirrels emerge from their seven-month hibernation to sit in the sun and remember greener times. By early May, quaking aspens blush green with the first patter

of leaves, sending whispers on the wind that spring has come. But not until the burbling gossip of bluebirds is heard can it be said that winter's tide has finally ebbed.

Winter's hand leaves its mark on summer's meadows. Without enough of the snow's sustaining run-off, the land is sere,

The colors of the Rockies are strong on a yellow-headed blackbird (above left, © John Shaw), subtle on Colorado blue columbine (above right, © Jack Dykinga), and eerie in a fading storm above a beaver lodge in the Crooked River, Alberta (right, © Tim Fitzharris).

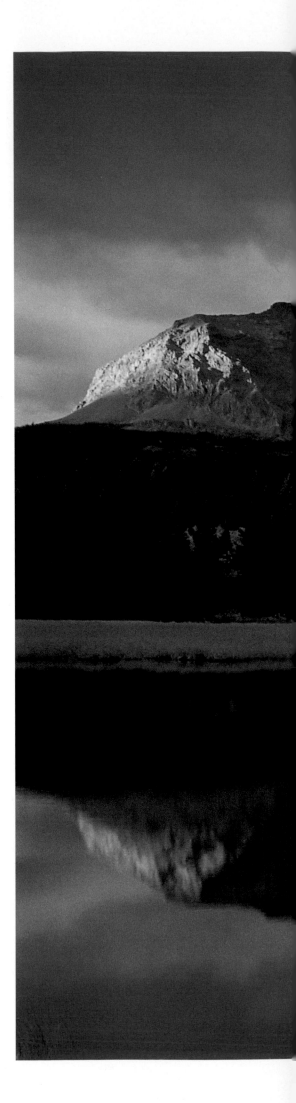

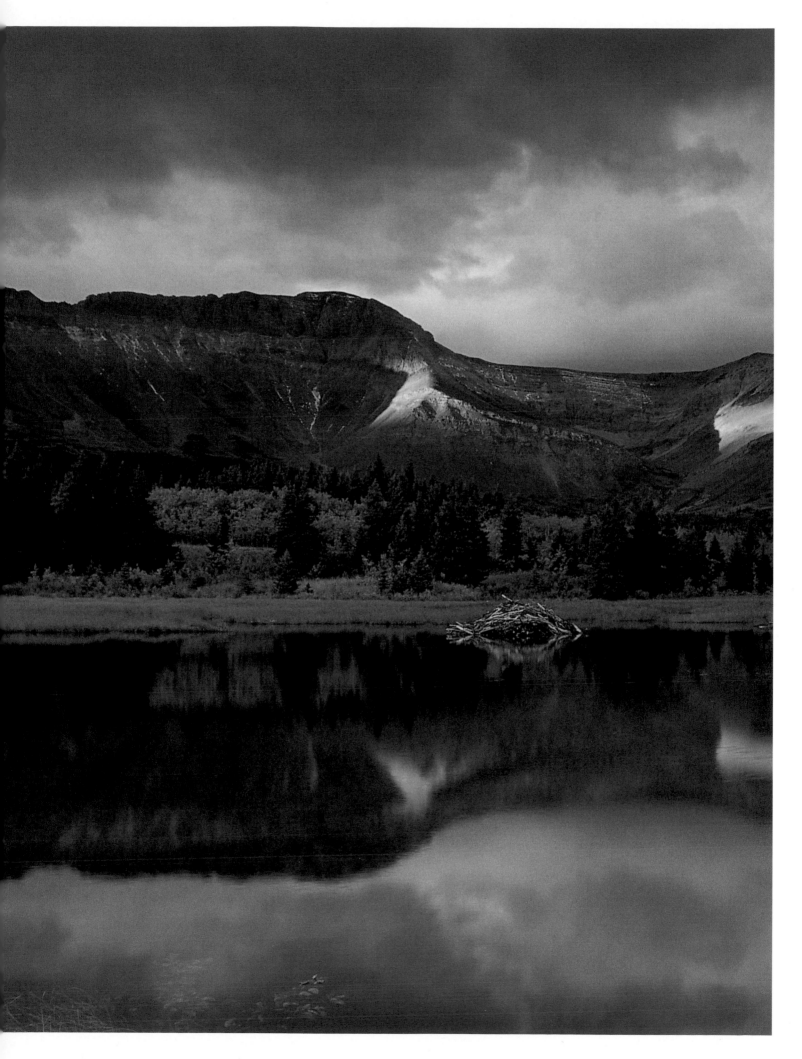

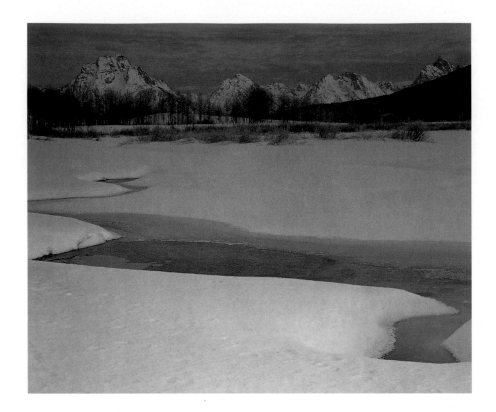

and plants wither and die. With too much snow, summer never really comes and flowers must wait another year. But when the snowmelt is generous and warmth is sufficient, the high meadows of the Rockies blaze with summer blossoms. The growing season may last for just a few weeks, but its abundance nourishes nesting birds and foraging bears alike. Six weeks to grow, flower, pollinate, set, and shed seeds; plants and animals have no time to dilly-dally when the next winter looms on the horizon.

Chief among the diligent are the broad-tailed hummingbirds. Broad-tails dart among the meadow flowers, all dash and no doubt, their buzzing wings announcing them as they fly. Hummingbirds are like flying explosions, so hot do their metabolic fires burn. The resting heart rate of a broad-tailed hummingbird is about 600 beats per minute; in flight, this can rise to 1,000 beats per minute. To keep its heart going, it must feed all day long, gathering nectar and tiny insects from inside flowers. If the temperature drops too much, hummingbirds go dormant, waiting for the sun to rekindle their flame. If summer is late, broad-tails will forage but not nest, waiting like the flowers they feed upon for next summer to raise a family.

In the Rocky Mountains, autumn is the season of the tree. Almost all of the trees that cloak the valleys are cold, drought, and fire tolerant. Most are conifers because these can best survive the

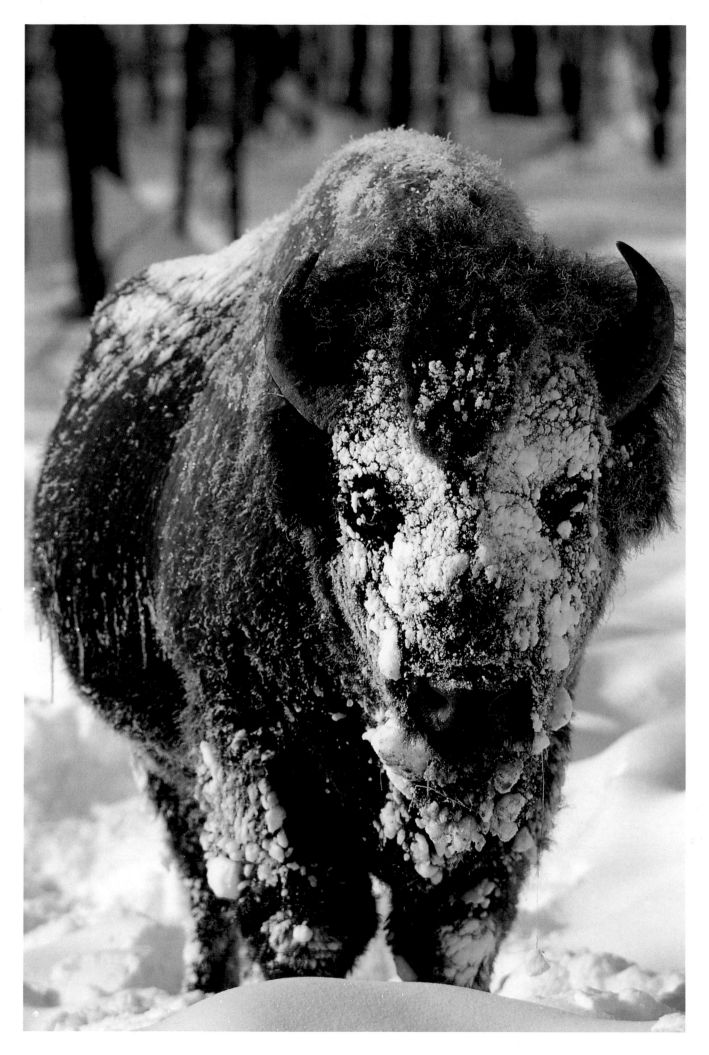

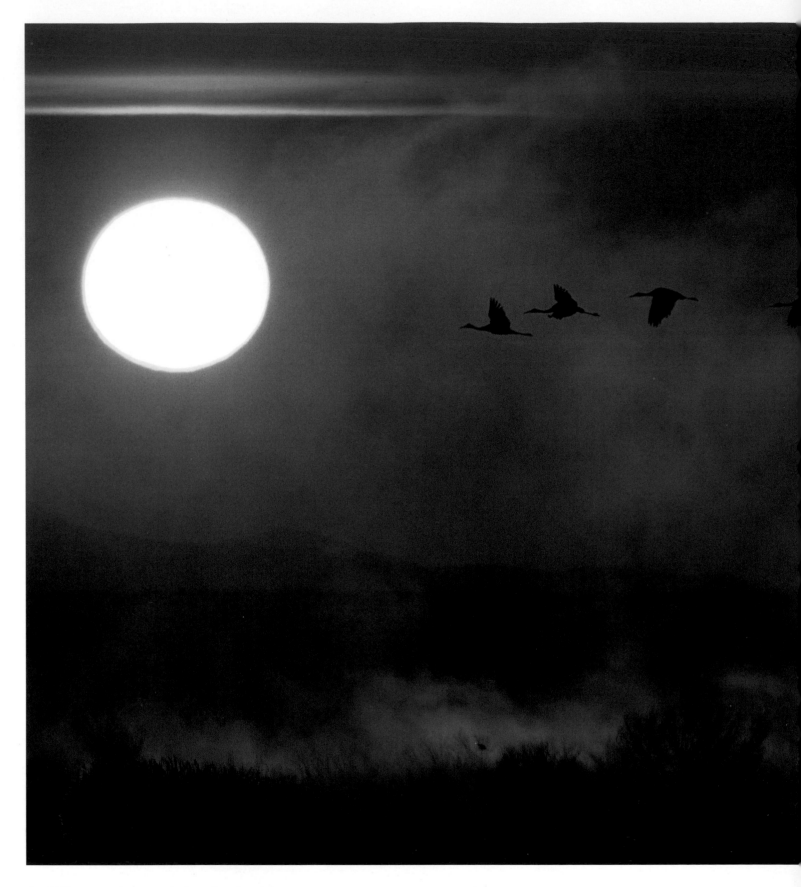

Sandhill cranes migrate south along the spine of the Rocky Mountains (above, © John Netherton) to winter in great trumpeting flocks in Bosque del Apache National Wildlife Refuge, New Mexico. Today, gold in the Rockies is more often associated with the aspen's autumn leaves (bottom right, © David Middleton; top right, © Carr Clifton) than with precious metal underground.

dry summers. Engleman spruce and Douglas firs live on the high mountain slopes, where the snows are deepest and the summers are cool and damp. Below, lodgepole pines drape most of the mountainsides and valley bottoms, taking the greatest beating and benefit from wildfires. Without the heat from nearby flames, the serotinous cones of the lodgepole pine would

never fully open. But activated by the heat of passing wildfires, the cones release thousands of seeds and the forest begins anew. Conflagration equals regeneration.

The most renowned tree in the Rockies is its most diminutive: the innocent quaking aspen. Small in stature but vivid in memory, the golden aspens of autumn are one of the continent's great natural spectacles. Ten thousand years ago, aspen forests covered far more territory then they do now. Since then, global warming and the drying of the soil has caused the aspen forest to retreat into the mountains. Now the weather is typically too dry for their tiny seeds to survive, so aspens spread by root sprouts. A neighboring tree is probably the same tree; it is a

clone. The aspen forests we see today are but large family gatherings, and like T-shirts at a reunion, each clan can be distinguished by its own leafy shade of green and, later, gold.

Enter this forest of shimmering light, where every breeze is broken into a thousand quivers and quakes. Each shimmer and shake gives voice to the wind, and with each breath the forest murmurs. Listen . . . the Rocky Mountains are calling.

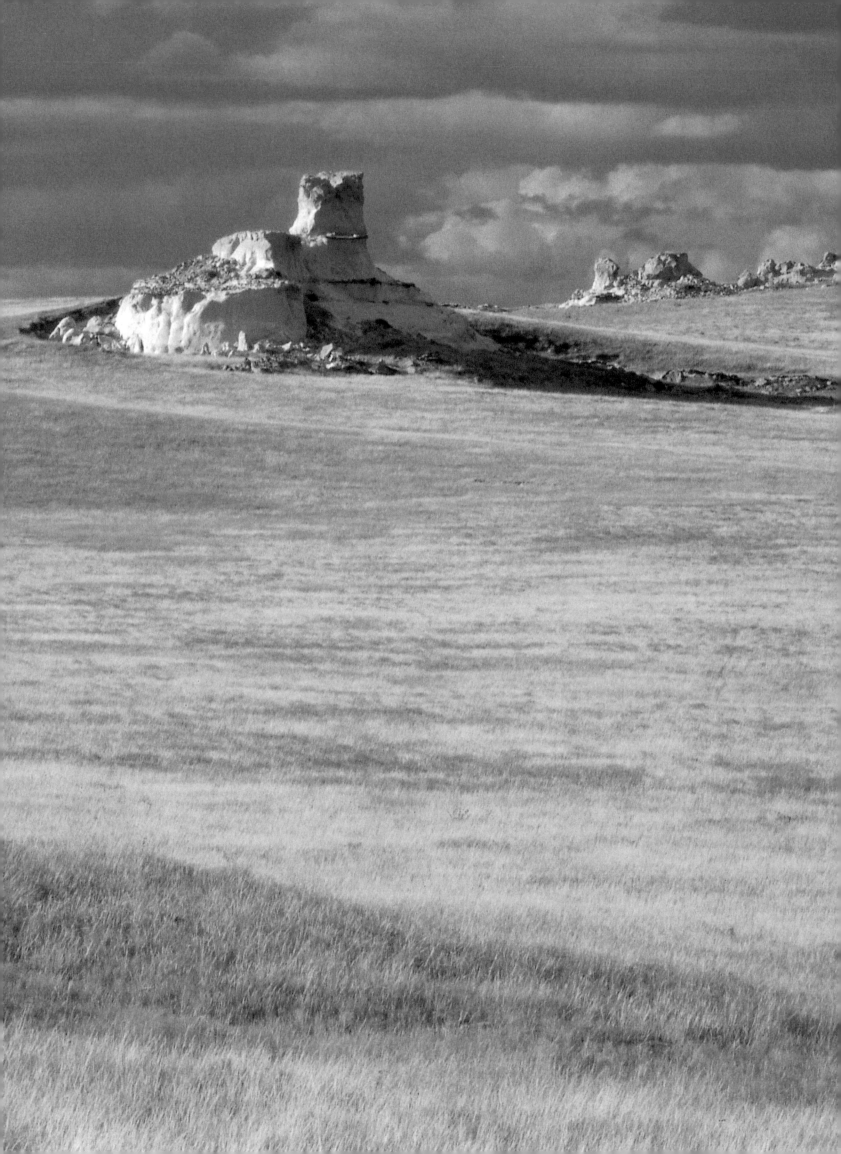

THE GRASSLANDS

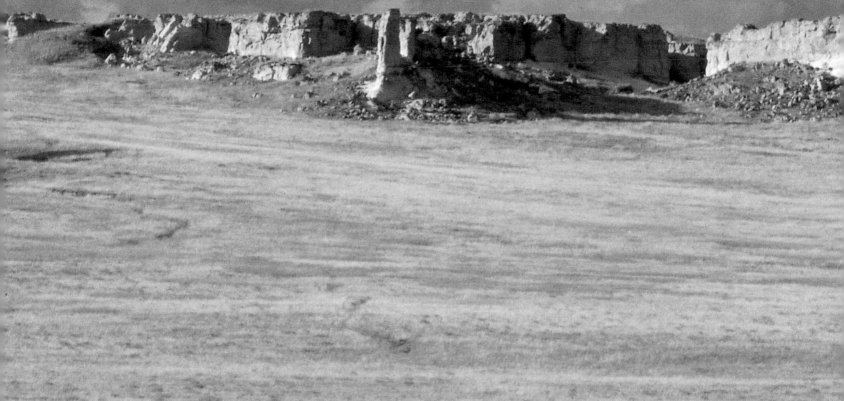

"To make a prairie it takes a clover
and one bee,—
One clover, and a bee,
And revery.
The revery alone will do
If bees are few."

— Emily Dickinson

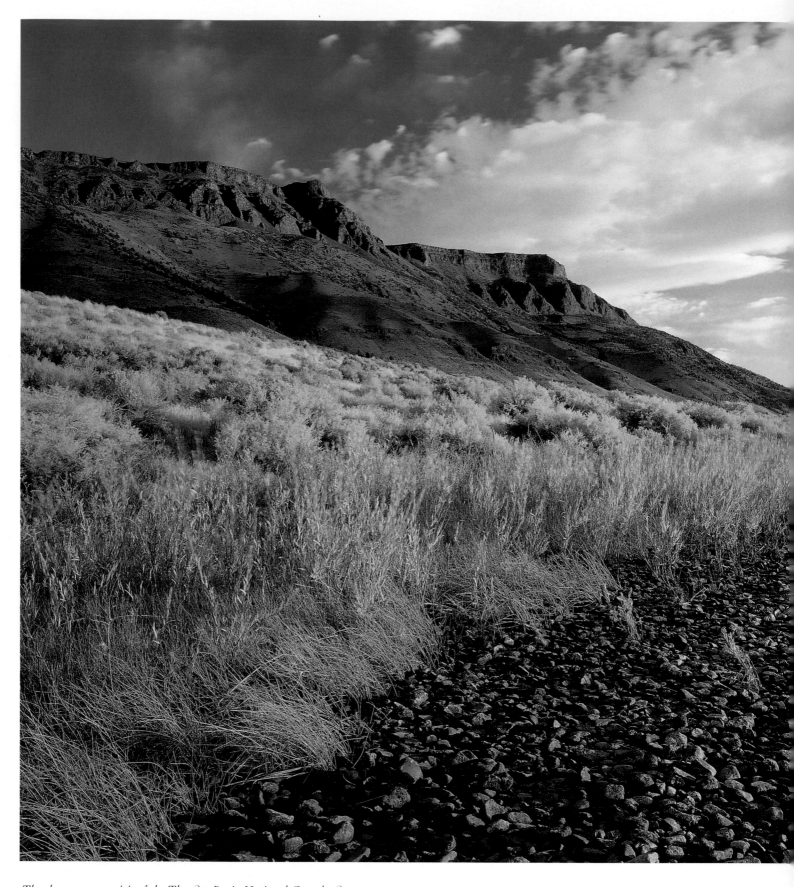

The short-grass prairie of the Thunder Basin National Grasslands,
Wyoming, (previous pages, © David Middleton) lies hard in
the rain shadow of the Rocky Mountains. In eastern Oregon and
Washington, there is an outlier of the grasslands (above, © Steve
Terrill) formed by the rain shadow of the Cascade Mountains.
The redwing blackbird (right, © Wayne Lynch) surveys prairies
across the continent.

From an airplane, the middle of North America looks like an endless grid of backroads and super-highways, surrounding mosaics of irregular fields and growing crops. Superimposed upon this agricultural checkerboard are squiggles of forests along rivers and jagged patches of untamed pastures. Like scattered strands of chromosomes cast randomly across the landscape, these remnants of wild lands carry within them the natural histories of times past when the landscape amounted to just prairie, sky, and wind. The sky and wind are still there, but most of the prairie has been turned over for crops, and the legacies of wildness are broken and overlooked, condemned to a life at the edges. But that doesn't mean the grasslands are dead— no, strong farmers still bust the sod, or "prairyerth," and the prairie wind still sings to the sky. And grasses still whisper in sibilant sighs about a land where "all flesh is grass."

The Grasslands east of the Rockies is the second largest ecoregion in North America, originally covering more than 800 million acres of the continent. Like the Desert, the Grasslands is really a three-part realm, arranged east to west: the eastern tall-

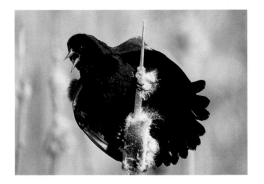

grass prairie, the western short-grass prairie, and the mixed-grass prairie in between. There is also a western-outlier short-grass prairie, called the Palouse, that lies east of the Cascade Mountains, created by their rain shadow.

Where and how the grasses grow depends largely upon how much rain falls. Rainfall, in turn, is affected by how close a prairie lies to the the Rocky Mountains, the dividing crest of the

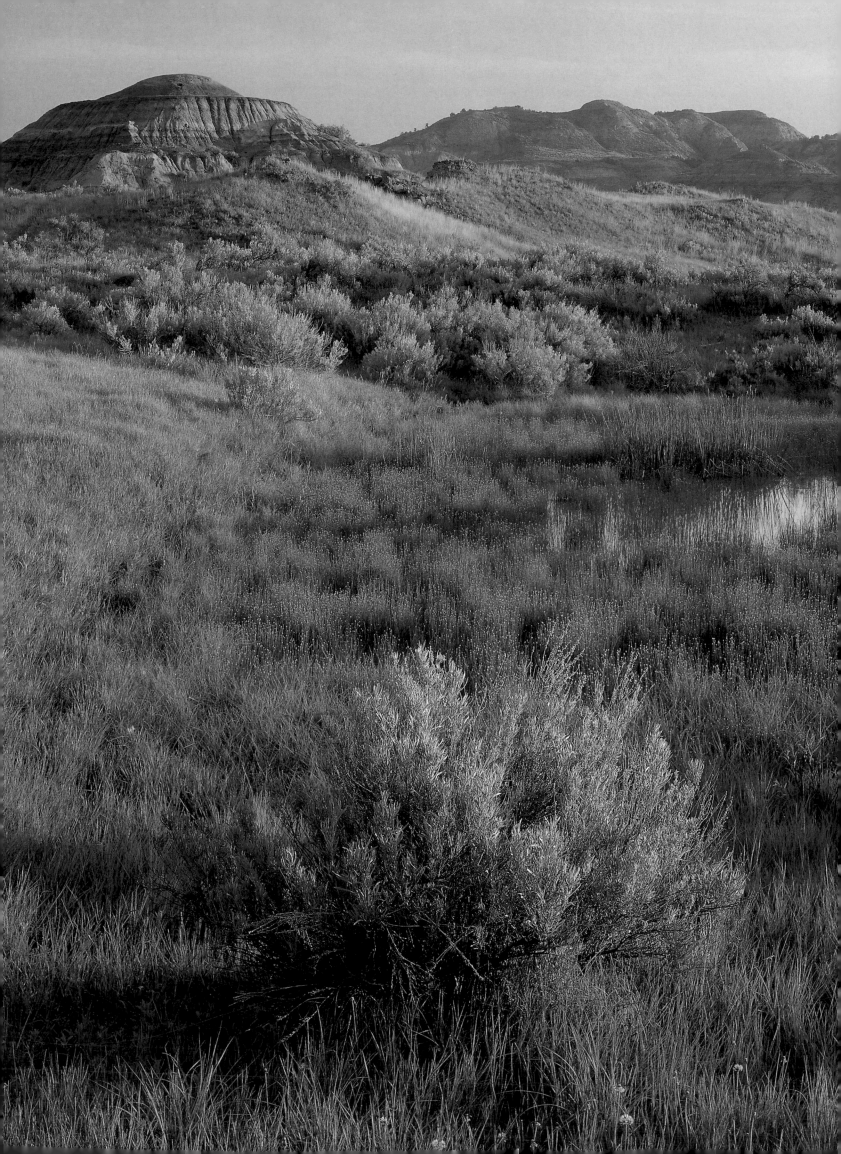

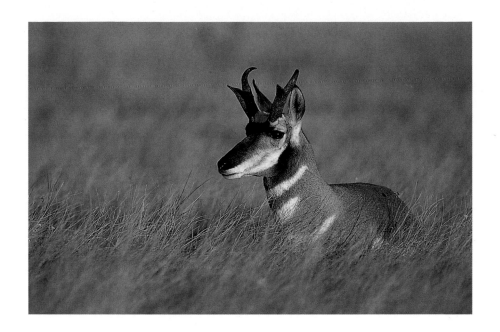

A male pronghorn rests in the short-grass prairie (right, © Rod Planck) of Badlands National Park, South Dakota.

continent. Storms pushing east out of the Great Basin drop most of their rain on the western face of the Rockies, depriving the Great Plains beyond of moisture. Denver, lying on the eastern front of the Rockies, receives less precipitation than Wichita; that city, about five hundred miles east of Denver, receives less than St. Louis, which is a thousand miles east of the mountains. Consequently, the short-grass prairie, which is closest to the Rockies, typically grows in the driest part of the grasslands; and the tall-grass prairie, which is farthest from the Rockies and gets supplemental rainfall from Gulf Coast storms, grows in the wettest part of the grasslands.

Annual rainfall is only part of what defines the grasslands as an ecoregion. Other factors include wildfires and temperature. For example, if the climate cooled and rainfall increased, the trees of the eastern forests would invade the tall-grass prairie like dandelions sneaking across a lawn. If rainfall decreased or the climate grew warmer, the deserts of the Southwest would invade the short-grass prairie like a dune spreading across a saltmarsh.

Fire is an essential part of the tall-grass prairie and maintains it much like waves shape a beach. Native Americans called fire the "red buffalo" for the way it stampeded across the plains. In its rush, fire kills invading trees and rejuvenates the soil. Fire also patterns the landscape into a quilt of affected and unaffected areas, providing diverse habitats for sustaining the prairie animals.

Tall- and mixed-grass plants are cleverly adapted to the run of the red buffalo. The 150 species of tall grasses are perennials, producing annual green stems (what we call grass, but what

Winter's demise brings a vernal pond (left, © Larry Ulrich) to the short-grass prairie in Theodore Roosevelt National Park, North Dakota.

botanists call tillers) in springtime that flower in the summer. They then die back in autumn, leaving behind nothing but unnutritious thatch. The important parts of the tall-grass plant are protected underground, ready to send up more tillers if they are able. This is why you can cut your lawn like you cut hair—as long as the roots are healthy, the grass will grow back. So when wildfires once rushed over the tall-grass prairie, the main part of the grass plant was protected and only the easily regrown tillers were burned.

Short-grass plants are also perennials, but they store their food above ground, ever-ready to take advantage of favorable growing conditions in a climate too severe and unpredictable for an annual lifestyle. Fire is less of a problem in the short-grass prairie because the vegetation is sparse, so fires are harder to start and harder to sustain. This difference between the short-grass and tall-grass prairies was instinctively understood by the millions of bison that once roamed the grasslands. In spring and summer, they grew fat on the lush grass buffet of the tall-grass prairie. But in autumn, they migrated to the short-grass prairies of the Great Plains where they could sustain themselves on the still nutritious plants.

It has been estimated that 60 million bison once ranged over the grassland ecoregion. At the turn of the century, that number had been reduced to 300 animals. Now there are healthy herds in several preserves, and the population has grown to over 200,000 animals. Elk, grizzly bears, and wolves were also once prairie animals. Today, they are confined to the Rockies, refugees in remote mountain valleys far from the rising tide of civilization that has flooded the prairies and washed them west.

Prairie birds still flush suddenly from thickets and fly up to fence wires to cast their songs to the wind. Most prairie birds have weak, lispy songs that are sung from the grass, and many imitate the dry stridulations of insects. In a world of little protection from predators, a song that draws too much attention to the singer may not be such a good idea. This thriftiness is lost on meadowlarks, for they sit with bold yellow breasts on fence posts for all to see and sing loudly to the passing wind. The song of the meadowlark brings back grassy memories to anyone who has lingered in the prairies, for this sudden and liquid sound is as much a part of the prairies as the grass is.

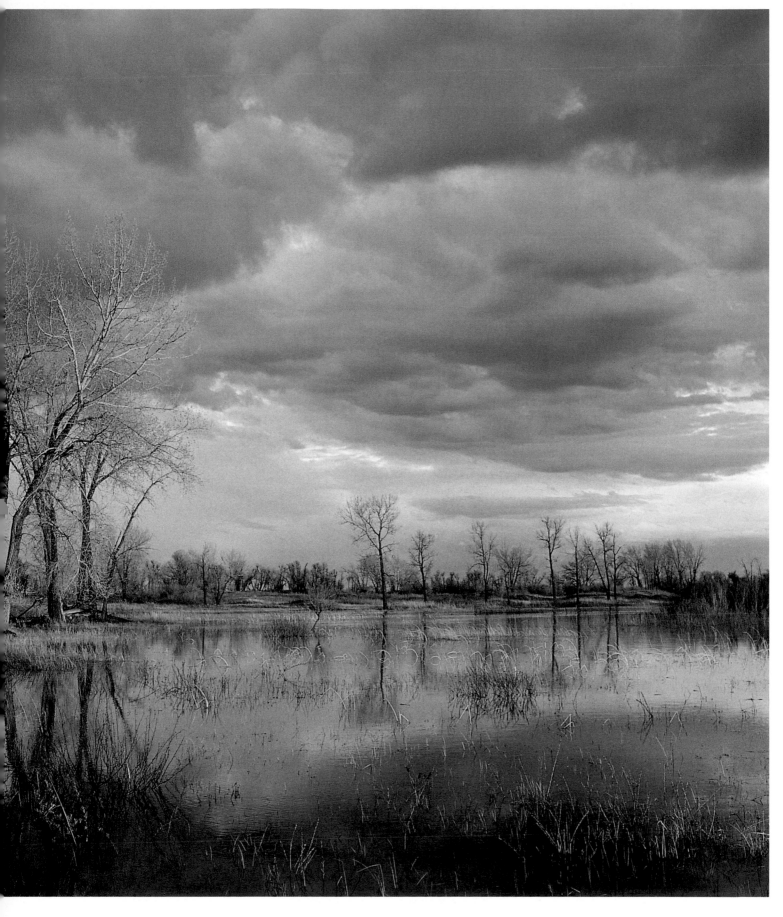

A prairie wetland reflects an April sky in
Sheyanne National Grasslands, North Dakota.
(© Wayne Lynch)

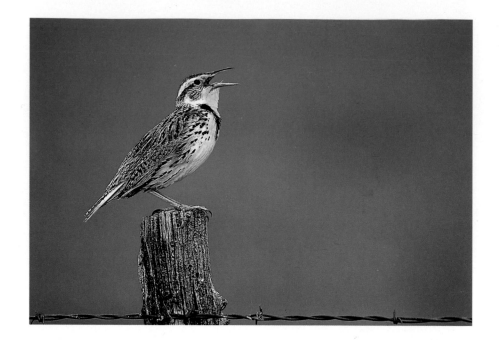

Other compelling images of the prairies must include the wildflowers of Texas. In a good year, they cover everything — roadsides, fences, yards, trails, fields, and pastures — during April and May. In a dry year, the Texas landscape is khaki and dull, and wildflowers can only be found where water settles or in the spring shadow of a late winter thunderstorm. But during a wet year, the countryside from the Edward's Plateau in central Texas down to the Gulf Coast is brushed with broad strokes of color — paintbrush red, bluebonnet blue, winecup burgundy, mustard yellow, and phlox pink. In many places the colors are dribbled together like a Jackson Pollack splatter, but in some areas the same color congregates in startling, head-turning displays.

Walk into the prairie, and the cultivated world disappears so suddenly that you can almost hear a grassy green door slam behind you. Sit down, and you are likely to lose the rest of the world entirely as, overhead, grasses nod and dip downwind like one-handed applause to the passing breeze. Underground in a chaos of tunnels, prairie dogs live, rising up into sunlight to frolic and harvest grass. A few feet below the entrance of their burrows, prairie dogs build listening rooms, mid-level cubbies where they can safely gather news of the season and of predators from the telling wind. Prairie dogs live with their noses to the wind and their ears to the ground, a life cradled by the "prairyerth."

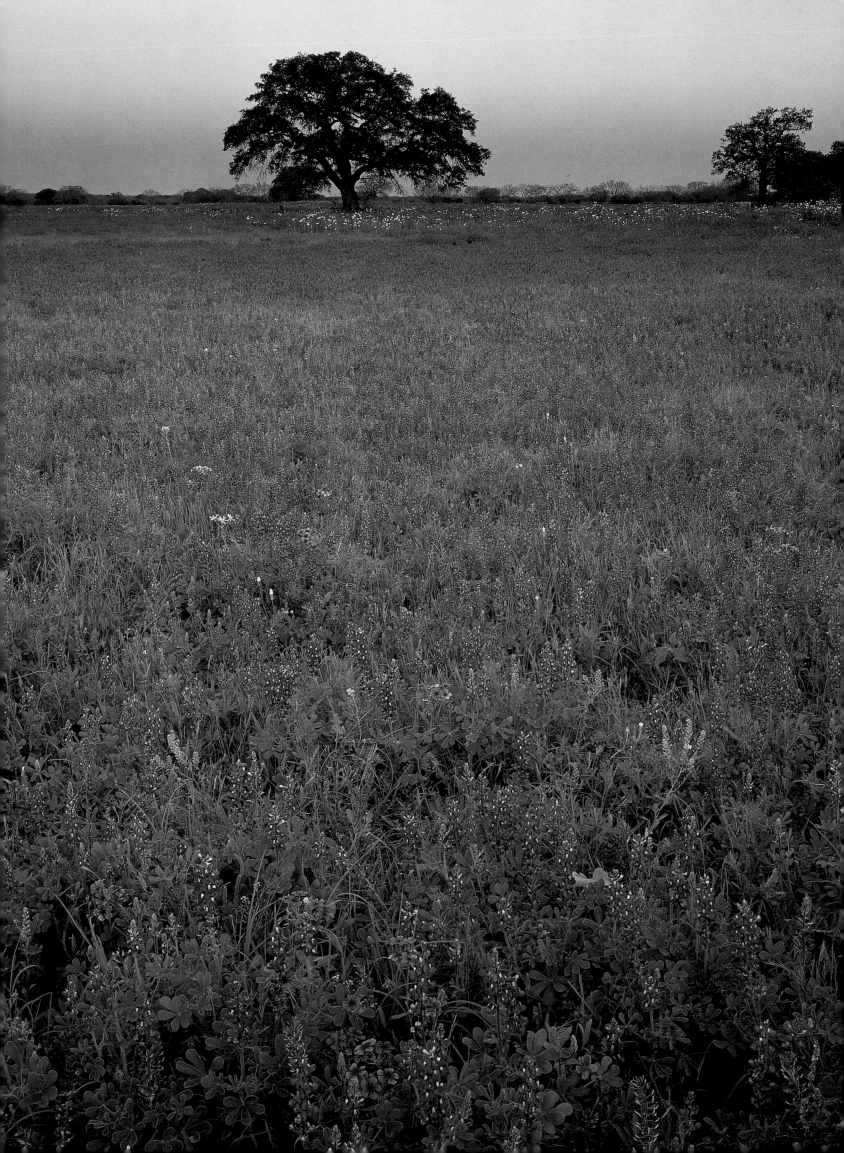

Winecups, phlox, and bluebonnets, central Texas.
(© John Shaw)

Paintbrush, flax, and bluebonnets, central Texas.
(© John Shaw)

Prickly poppies, phlox, and bluebonnets, central Texas.
(© David Middleton)

Blazingstars and sunflowers, Gensburg Prairie,
Illinois. (© Cliff Zenor)

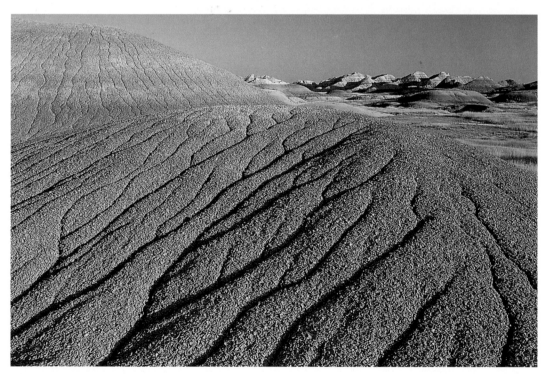

Badlands National Park in South Dakota is a landscape of rock, earth, and sky. Here the changing light on eroded bluffs reveals subtle colors and textures in the Colored Mounds (top, © Carr Clifton) and the Banded Buttes (bottom, © Rod Planck).

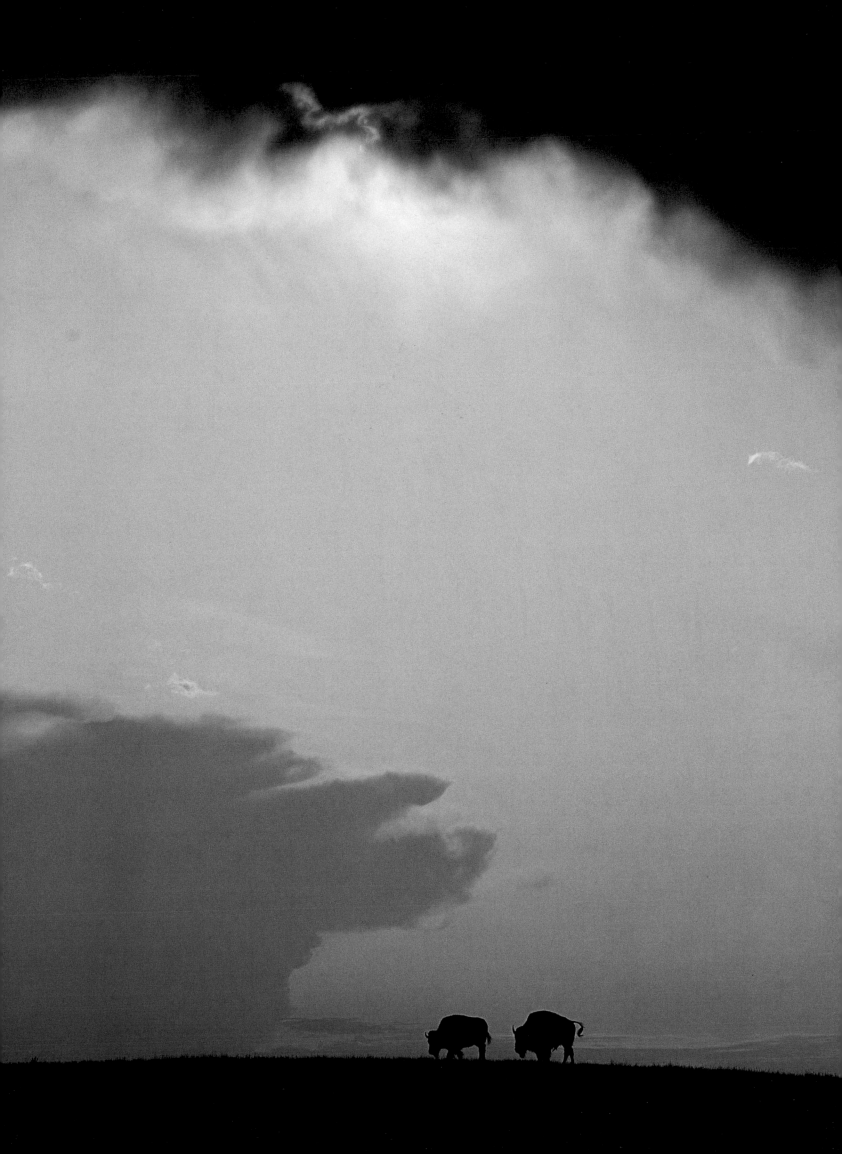

THE SOUTHERN APPALACHIAN MOUNTAINS

*"Spring is all things to all men. It is the bleating of lambs,
the sound of the carpenter's hammer. It is the yellow of
dandelion and the green of new grass. It is cumulus clouds
and the smell of new-turned soil, brimming ditches and
miles on miles of fruit trees in bloom."*

—Edwin Way Teale

The Southern Appalachians are a rumpled bedspread of old unmade mountains, their soft ridges and rounded valleys jumbled between the Atlantic coastal plain and the Midwest. They are the wrinkled remnants of ancient mountains that rose 300 million years ago when Africa first bumped into North America. Bound by the forest and stitched by innumerable

rivers, this lush mountain quilt hides unfathomable secrets tucked within its river creases and rocky folds.

If you listen closely, you might still hear the trees whisper tales of mountain men, pioneer families, and other walkers of forest paths. This is the land of John Henry, Daniel Boone, and Davy Crocket, whose tall tales grew out of the tall trees. And here too lies the spirit of the Cherokee Nation, who still sing of the "trail of tears" they were forced to walk and whose people still grace the woods. Every gap and every stream has a long human history, for the forest has been cut and stripped, and the land laid bare, more than once. Felling the forest raised houses and barns for those who cleared the land. Needing more from the land, they also reached into the ground

Spring arrives at the Clarion River (left) in Pennsylvania, sending the dame's rocket beneath a white ash tree into flower. Fringed polygala (above left, both © Larry Ulrich) blooms on the forest floor while a mockingbird (above right, © David Middleton) sings from the canopy. (Previous page, © Bill Fortney) Sunset, Great Smoky Mountains National Park, Tennessee.

The cove hardwoods of the Southern Appalachians are forests of astounding diversity. Protected in deep, fertile valleys, giant yellow poplars (left) tower over yellow trilliums and white phacelia (bottom right, both © David Middleton) as a green tree frog (top right, © John Netherton) clings to a damp leaf. The barking tree frog (below, © Joe McDonald) is less shy.

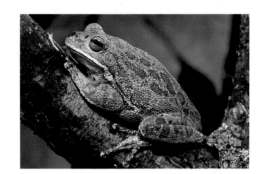

and restacked its rocks into chimneys, foundations, and fences. No mountain range has been woven so tightly into the fabric of our history.

Unlike the West, where the biggest trees are conifers, the Southern Appalachians' largest, oldest trees are hardwoods. Cove hardwoods, so named because they live in protected valleys, reach their pinnacle in Great Smoky Mountains National Park and on the slopes of Grandfather Mountain, a UNESCO Biosphere Reserve. No other ecoregion of comparable size in North America has so many champion trees: a red maple 7 feet wide, a yellow buckeye more than 5 feet across, a white pine almost 5 feet in diameter, and a tulip tree that is 7.5 feet wide. All of these trees are more than 150 feet tall, and it is usually more than six stories up to their lowest limbs, so it is easy to understand why the cove hardwoods are so impressive.

The cove hardwoods are more than just big trees, they are part of an astonishingly diverse ecoregion. The central part of the Southern Appalachians is the most biologically rich, temperate environment in the world. In the Great Smoky Mountains National Park alone there are 1,200 species of flowering plants, 2,000 species of fungi, and 350

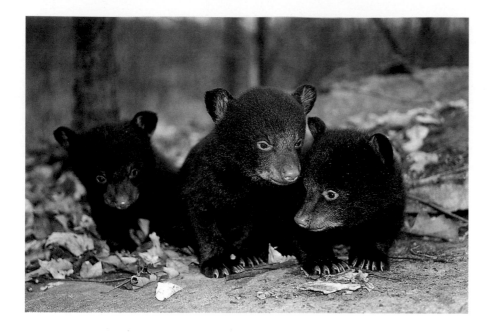

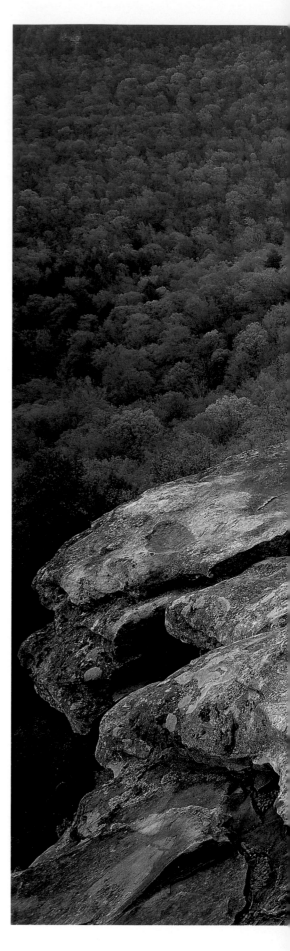

kinds of mosses. Of the 130 types of trees, more variety is found on an acre of land here than in all of Europe. And with 25 species of salamanders in the Smokies, it is the largest assemblage of these animals in the world.

The biological richness of this ecoregion explains why the black bears of the Southern Appalachians are so populous. Compared to black bears anywhere else in North America, these bears are the largest, they mature the earliest, they have the biggest litters, they have them more frequently, and the population is growing the fastest. This is all due to the abundant food for bears — mostly acorns and beech nuts — easily found in the Southern Appalachian forest.

Autumn is when black bears put on as much weight as they can to sustain themselves through the four winter months of hibernation. With a good nut crop, black bears can gain 180 pounds in just three months of foraging. If the mast crop (nuts on the forest floor) fails, as it does every five to seven years, black bears disperse in search of food, often wandering 30 to 40 miles from home. This dispersion is called "the fall shuffle" by scientists who study bears. It explains why black bears sometimes show up where they don't belong, for instance, in suburban neighborhoods or inside backwoods cabins. The fall shuffle is not a random movement. A black bear remembers exactly where it last shuffled off to, even if it was years ago. The bear will make a beeline to that spot and feed until it is fat. But when November's chill settles upon the forest, the bear always returns to its home range to den for the winter.

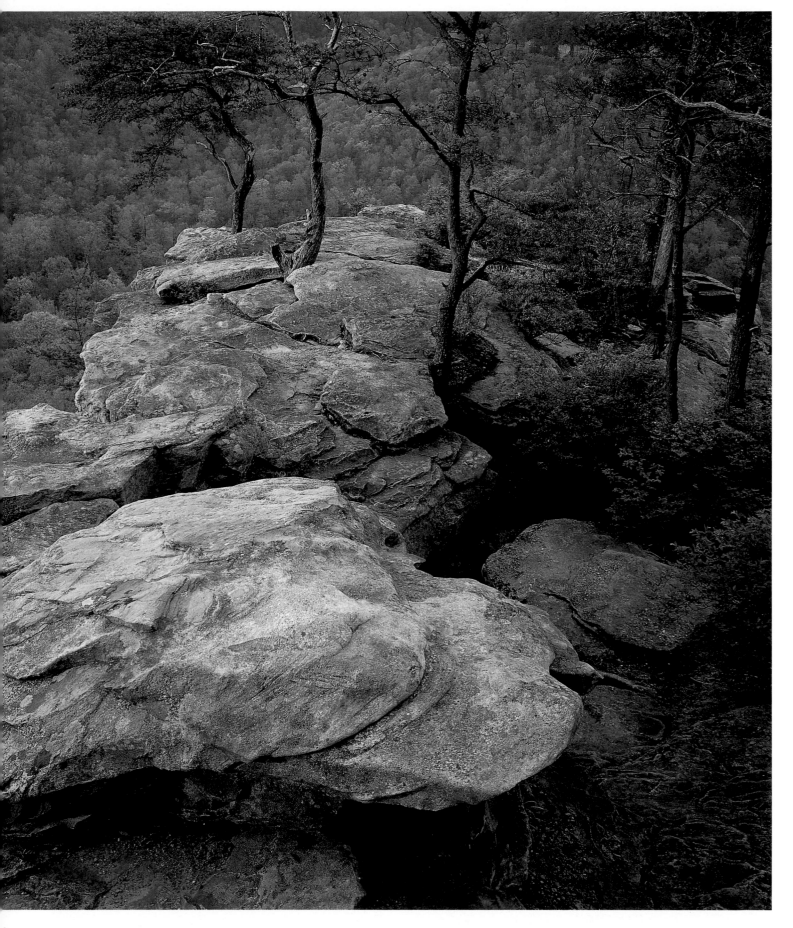

Black bears are quite common in the Southern Appalachians.
Pregnant females often den in rocky outcrops like this one
(above, © Carr Clifton) in Fall Creek Falls State Park, Tennessee.
They emerge in early spring with a pile of cubs (left, © Wayne
Lynch) eager to explore the world.

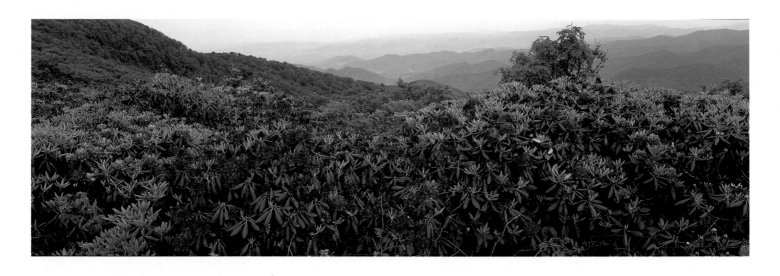

Spring comes very early to Lake Tombigbee State Park (left, © Larry Ulrich) in Mississippi. Low in the wooded hollows, a riot of wildflowers blooms, including the slender iris (right, © John Netherton), a splash of unexpected color on the forest floor. Overhead, an opossum (© John Shaw), born in early March, makes its first tentative steps out on a limb. As the months progress, spring climbs the mountain ridges throughout the Applachians until the Catawba rhododendrons (top, © John Shaw) of Craggy Gardens in the Blue Ridge Mountains of North Carolina bloom in June; then spring rests for another year.

Like their sister bears all across the continent, pregnant black bears must maximize their weight gain before they begin hibernating in late October, or their body will terminate the pregnancy. The rigors of pregnancy, birth, and nursing are too energy-demanding for a thin bear to risk her life. If a bear is too small, she won't be able to produce enough milk for her cubs, and if a cub doesn't weigh three pounds by the first of April, it will usually not make it through the summer. Typically, older bears have more experience finding food, and thus are heavier and have larger litters with more surviving cubs. In the Southern Appalachians, there are lots of heavy bears; three cubs in a litter is most common, but five cubs are as common as just one.

Bear cubs emerge from their den in early spring, as the forest first blushes green. By mid-April, a flood of green arrives, starting on the forest floor and gradually rising through the understory to the beech and tulip-tree canopy above. Generally, the forest floor is a monotonous pattern of leaves—the brown detritus of last year mixing with the new green of the year to come. But during the wildflower weeks of spring, the ground is so covered with blossoms—yellow, red, and white trillium, trout lilies, lady's slippers, mayapples, hepatica, Dutchman's britches, columbines, violets, squirrel corn, baneberries, anemones, and phacelias—that following a trail without being

distracted by the flowers is difficult. Still, by the time the first leaves appear overhead, spring's ephemeral wildflowers have finished blooming and have cast their seeds to the ground.

Spring color not only rises within the forest itself, it also creeps up the valleys and climbs into the ridges. In autumn and winter, the flow reverses, as color and cold sink from the ridgetops to the valleys below. This phenomenon is due to changes in elevation; the difference between a valley floor and a ridge crest may exceed 4,000 feet, a span equivalent—ecologically speaking—to traveling from Newfound Gap in the Smokies to Newfoundland in Maritime Canada. To a naturalist it means it is possible to walk through an entire season just by wandering the ridges. In spring, walking uphill is like going back in time, and walking downhill is akin to previewing things yet to come. In autumn as the season sinks into the valleys, climbing higher is like walking into approaching winter, and walking down is like sliding back toward summer.

I once wrote that "over the years, the forest we see as unchanging is, in fact, dancing to the slow tune of opportunity and adaptation, waltzing with time to the rhythms of change." No forests better illustrate this than those of the Southern Appalachians. In no other region is the past so present; in no other region is the present so abundant; and in no other region is the abundance so wild.

THE
ATLANTIC
COAST

"A phoebe showed up from South America, wagging its tail,
pretty much on time . . . and seemed to say, in its dry
little voice 'Here I am, ready to nest in your eaves, let me stay.'
And I felt that any fool would who knew how much we stood
in need of directions from such a reliable partner."

—John Hay

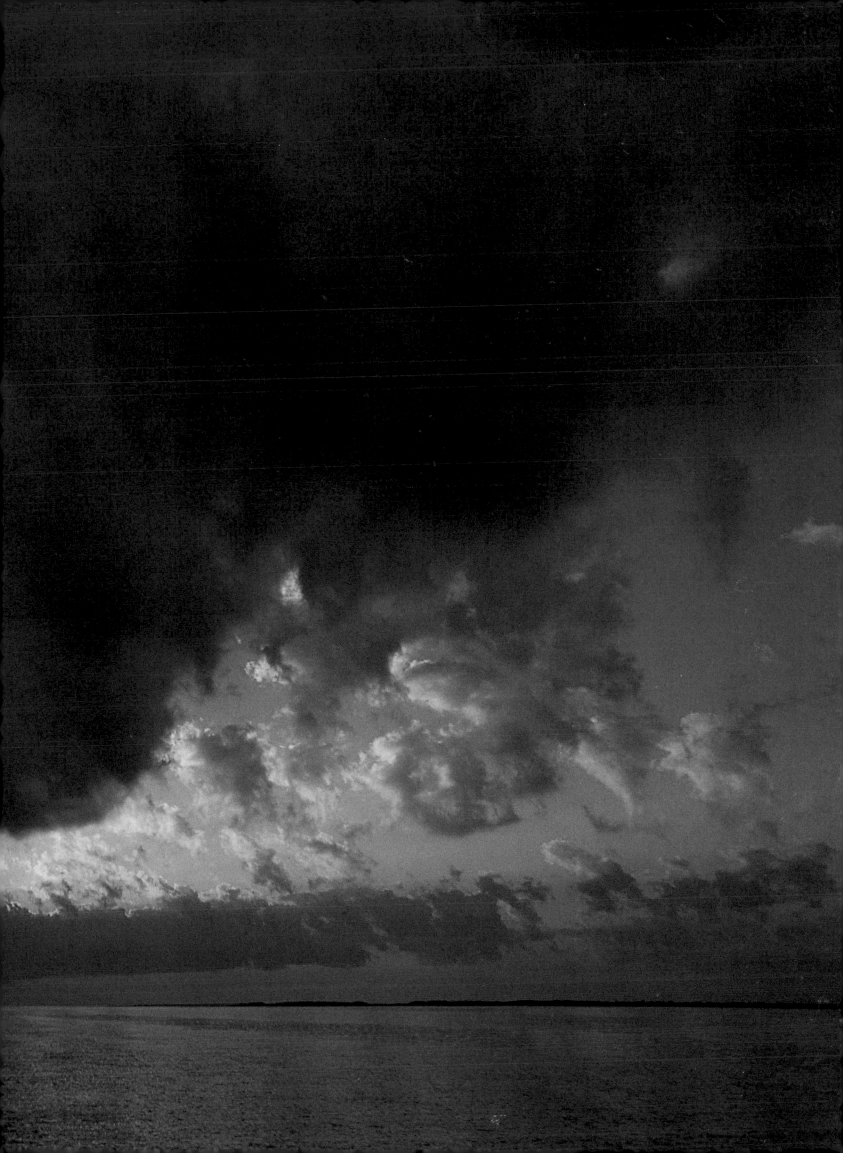

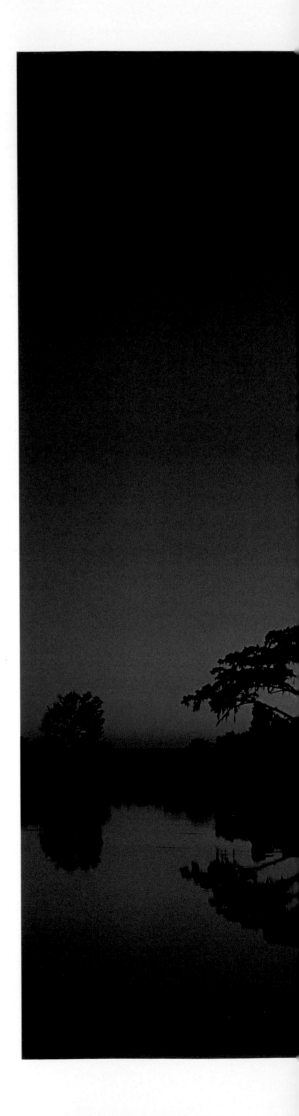

Midnight in mid-channel, midway along the Maine coast, and I am adrift between two tides. One carries my small boat away as I pull to shore against its tidal tug. The other also washes through the starry darkness, but I cannot pull against it. Thus caught in the middle with raised oars, I drift . . . listening. "Churrs," "cheeps," "tinks," and "seets," rain down upon me, the notes of swift birds slipping through the night. As the water gently holds me to the coast, another unseen current carries me

away to places I can't row to. Overhead flows a river of wings, a river of heartbeats, pumping strong, pumping south. It is the flow of migration. It is the passage of place.

The Atlantic Coast ecoregion extends from the Gulf of St. Lawrence through the Gulf of Mexico, a distance of more than

6,000 miles. To the north, the landscape is fresh and clean—and still recovering from glacial ice. Once buried under more than a mile of ice, the maritime coast of Maine and Canada is literally rising from the sea as it rebounds from the weight of its recent icy burden. Now a topography of rocky headlands and granite ledges, dressed in spruce caps and skirts of green seaweed,

Cypress swamps (right) are common along the southern Atlantic coast. They are a haven for wildlife, including many kinds of birds such as the least bittern (above right, both © Tom Blagden), and reptiles such as the alligator (above left, © Joe McDonald). (Previous pages, © John Netherton) Florida Bay, Florida.

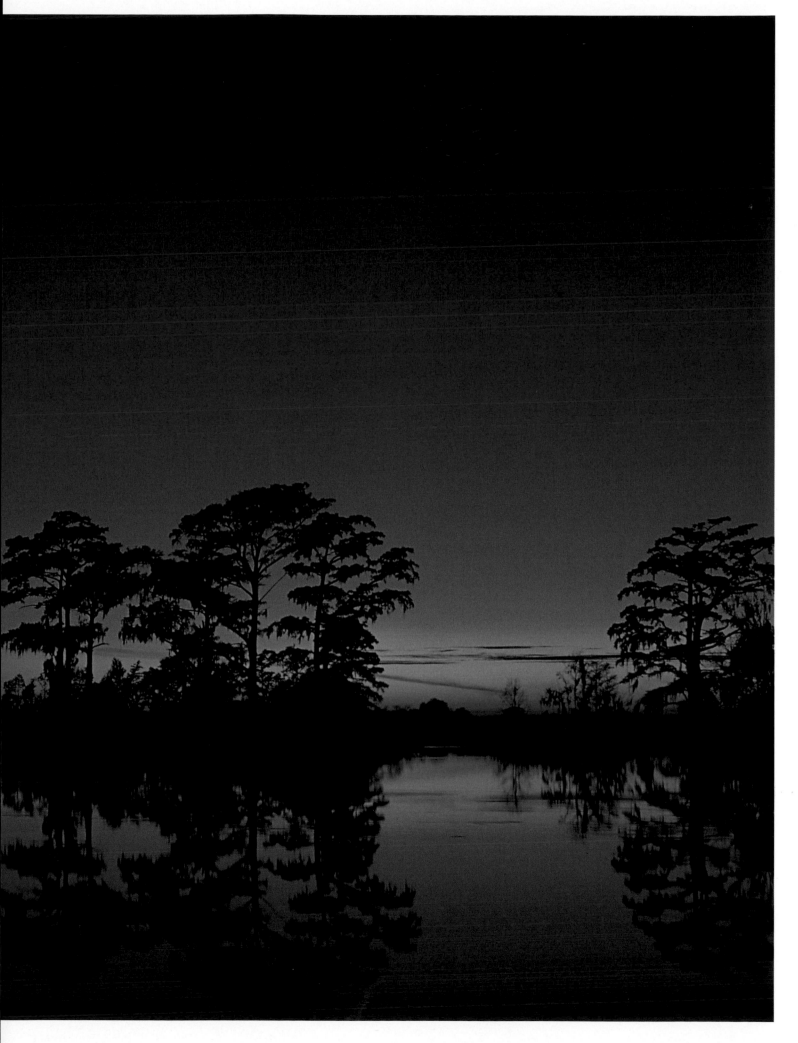

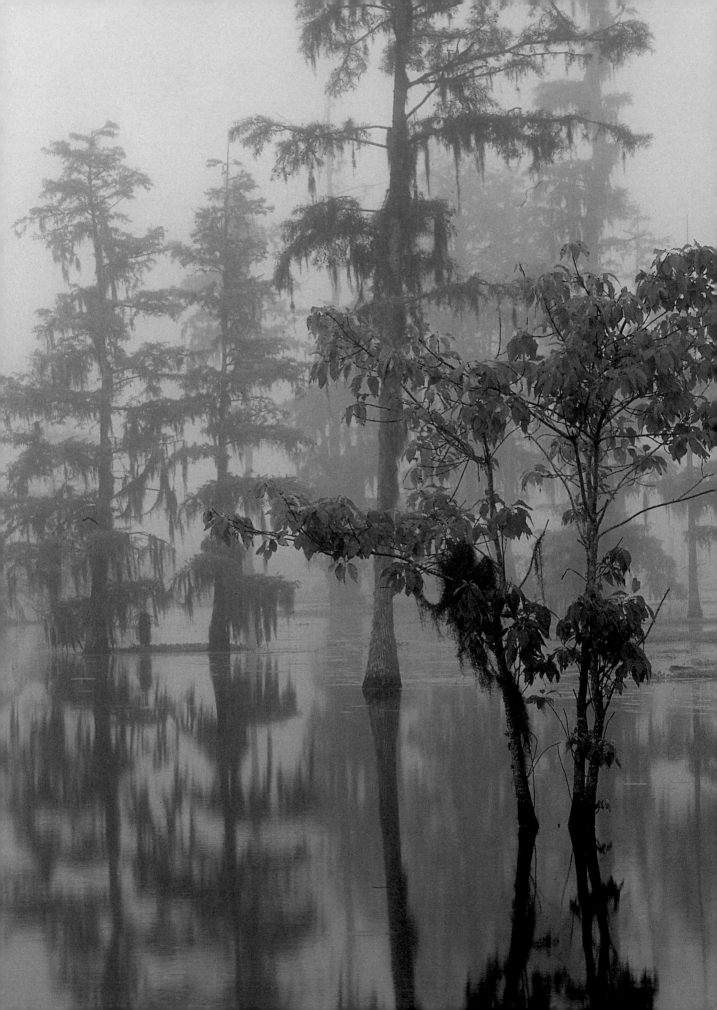

the northern Atlantic Coast quickly gives way to the spruce-fir and hardwood forests that press against it from the north. Only the small beaches tucked along its rocky coast, like forgotten hammocks slung between rock walls, are reminders of the softer southern Atlantic coast.

Cape Cod and the islands of Martha's Vineyard, Nantucket, and Long Island are deposits marking the path of the most recent advance of glacial ice through the region. Beyond this eastern push of islands, the coast turns south. Then soils thicken, headlands diminish, and beaches decorate the coast like long sandy ribbons. South of Long Island, barrier-island beaches wrap the coast all the way down to the Gulf of Mexico, attracting hordes of sand-crazed people. Yet beyond the reach of dune-front bungalows stretch sandy slivers of wild lands, beaches where harrier hawks still hunt and sanderlings still tease the waves.

What ties together this most ecologically varied ecoregion is the pulse of migration that annually swings north and then south along the broad reach of the Atlantic. Caught between the mountains and the shore, the Atlantic Coast is a natural corridor for animals traveling with the seasons. In fact, migration never ceases along this path. Somewhere, some kind of animal is always on the move here. And occasionally in some places, some species will be going north while others are going south.

A calendar of bird migration for the mid-Atlantic Coast is a chaotic amalgam of arrivals and departures. In January, the earliest kestrels and red-tailed hawks arrive from the south, usually

Manatees (left, © Jeff Foott) are endangered mammals who live along the south Atlantic coast. In winter, they seek rivers with warm-water springs, returning in summer to the open coast.

males first, to stake out breeding territories. Pintails, the first of the northern-bound waterfowl, arrive in late January followed by swans, loons, and cormorants in early March. Bluebirds appear at this time as well, encouraging reluctant Spring to come north with their song.

In April and May, the river of wings overflows as birds flood the coast. First come the blackbirds. Then sparrows, hawks, gulls, terns, herons, swallows, thrushes, warblers, seabirds, and sandpipers drop out of the sky to rest and feed before again moving northward. If, perchance, a storm collides with these birds migrating over the ocean, their fallout onto nearby land is an incredible sight. Enter a coastal Texas oak grove, or motte, on an April morning after such a storm, and you'll find songbirds, exhausted and hungry, adorning every branch. In two weeks they will be home far to the north, but for a little while, they rest and feed among palm trees and live-oak leaves.

By autumn, the migratory flood reverses, swollen by juvenile birds born in early summer. Fleeing cold weather and diminishing food supplies, these birds push south with a deliberateness unlike their northward migration in the spring. Driven to find high-quality food to fuel their southward journey, many birds make dangerous, long-distance flights across the ocean to get to their winter homes in South America. Usually only adult birds who are experienced migrants and in peak physical condition take these

At night, white ibises and great blue herons (right, © John Netherton) roost communally in a tangle of branches and a squabble of voices. At dawn, they disperse to hunt the marshes of Everglades National Park, Florida.

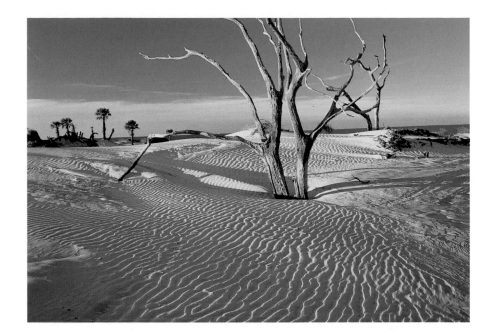

routes. Less adept at collecting food, juveniles generally avoid the treacherous journey over water and instead fly the longer, but safer, land routes.

Guided by the autumn stars and the Earth's magnetic field, tiny birds fly far south before they rest. Prior to migration, their metabolism changes, allowing them to deposit layers of flight-prolonging fat. For example, a blackpoll warbler can fly 125 miles on one gram of fat, which is not so important when it is crossing a New England lake but imperative when it flies nonstop between Nova Scotia and the north shore of South America. Departing on the winds of a passing high front, the blackpoll rides along to the southeast, correcting its course over Bermuda, where the northeast tradewinds blow the tiny birds back to a safe landing in South America. With a tail wind, they have a nonstop journey of at least 40 hours. Without a tail wind, their flight becomes a fatal journey left unfinished.

Birds are not the only migrants that hug the sheltering lee of the coast. Humpback whales winter in the Caribbean Sea and migrate to the rich banks off Cape Cod to feed and sing whalesongs. Right whales winter off Georgia's shores and then migrate to the Gulf of St. Lawrence to gulp schooling herring. More than a million shad and an increasing number of Atlantic salmon run the lower reaches of the Connecticut River every year.

The salt marshes of the Southeast (left, © Tom Blagden) are important sources of food and shelter for nesting birds. On Cumberland Island National Seashore, Georgia, (above, © James Randklev) an oak tree slips into the dunes.

Sea turtles glide out of the Sargasso Sea onto Carolina nesting beaches. Horseshoe crabs rise out of Delaware Bay to mate by the tens of thousands on narrow strips of sand. And even monarch and fritillary butterflies waft south in fluttering waves on blue autumn days, draping trees and weeds with their papery wings.

For humans, witnessing migration awakens senses long diminished. Migrating birds have historically heralded news both desired and desperate. Who hasn't been cheered by the wren's first spring song or chilled by the winter's hoot of an owl? Peter Mathiessan writes: "Both curlews and whimbrels were known as harbingers of death, and in the sense that they are birds of passage, that in the wild melodies of their calls, in the breath of vast distance and bare regions that attends them, we sense intimations of our own mortality, there is justice in the legend. Yet it is not the death sign that curlews bring, but only the memory of life, of a high beauty passing swiftly, as the curlew passes, leaving us in solitude on an empty beach, with summer gone, and a wind blowing."

Who wouldn't don wings, if possible, and follow the curlew's cry? Who can watch a warbler cast to the sea, and not wonder if the winds will draw it to shore? And who can watch a whale plow the waves, and not wonder what worlds it travels below the surface? Wonder is the beating heart of migration and, like it, takes wild flights to visit unknown shores. What directions might a phoebe give, fresh from the starry sky?

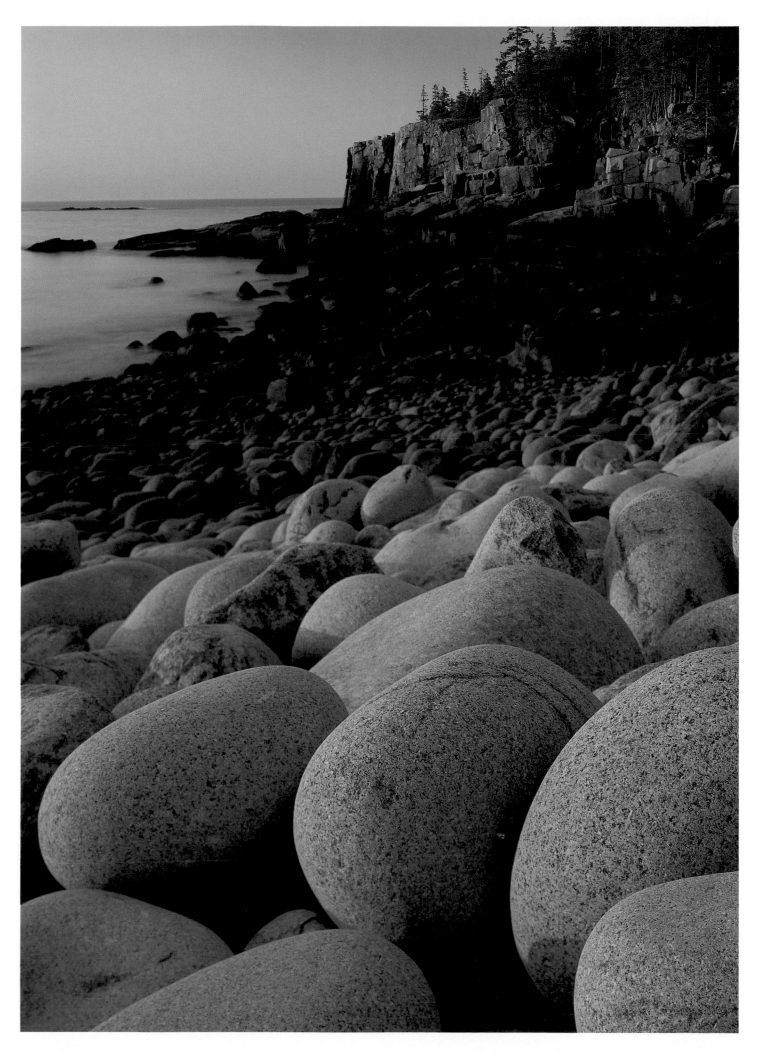

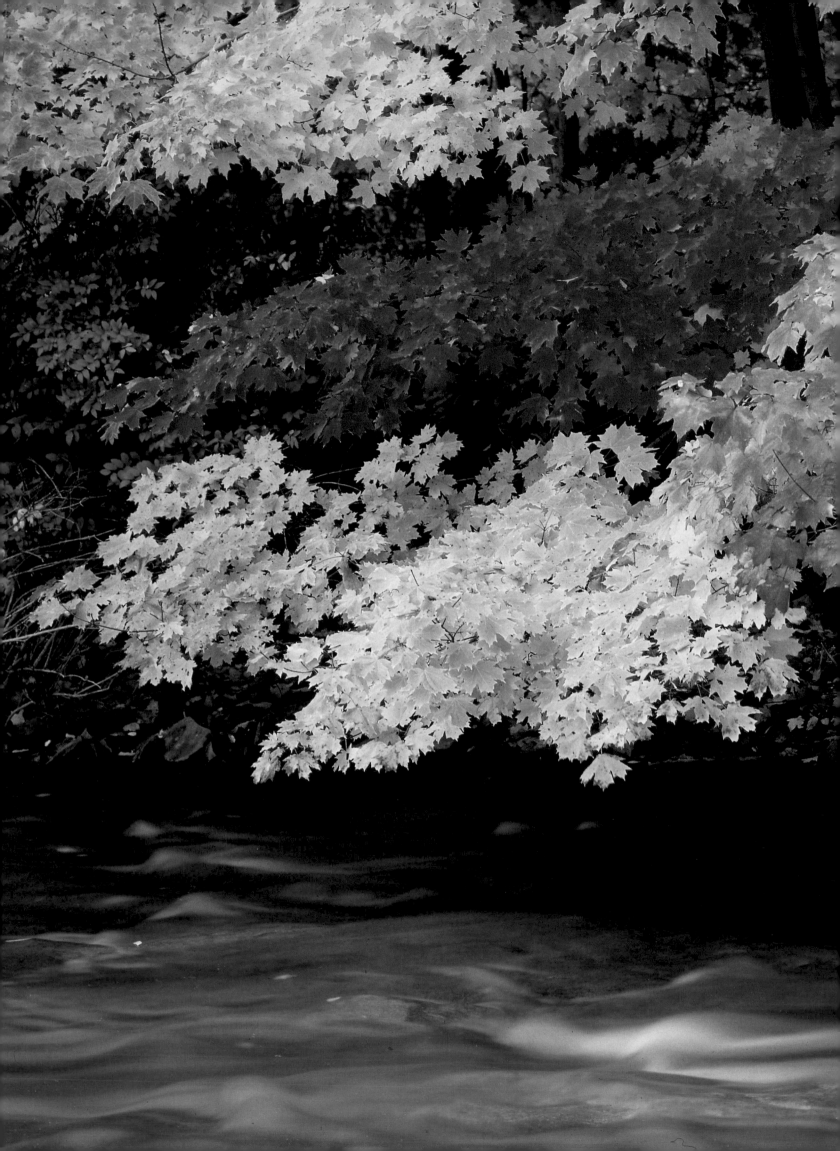

THE NORTHERN HARDWOODS

"Wherever you live, wherever you tramp or travel, the trees of our country are wondrously companionable, if you have a speaking acquaintance with them. When you have learned their names, they say them back to you—and very much more, for they speak of your own past experience among them, and of our nation's forest life."

—Donald Culross Peattie

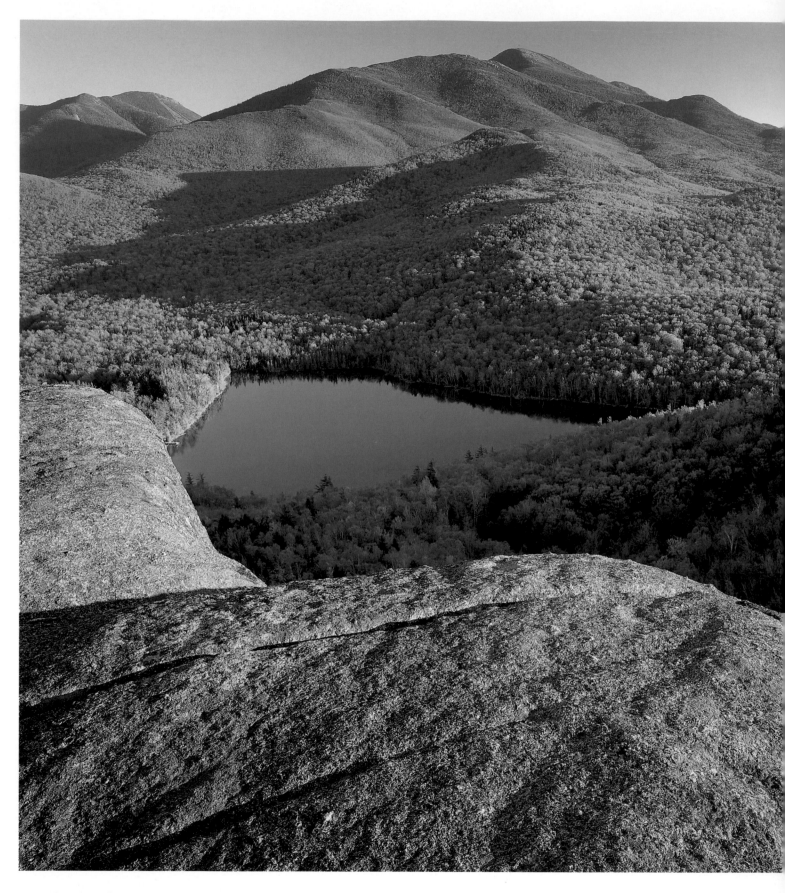

*From the sugar maples of the Ohio Valley (previous pages)
to the beeches, oaks, and maples surrounding Mt. Marcy
and Heart Lake in the Adirondacks (above, both
© Larry Ulrich), autumn turns the hardwood forests into
vivid collages of colors. Luminous green cinnamon ferns
(right, © Carr Clifton) are found throughout the northern
hardwoods.*

The Northern Hardwood ecoregion encompasses the broadleaf, deciduous forests of New England, the Ohio River Valley, southern Ontario and Quebec, and the upper Midwest. It is a catch-all ecoregion, sandwiched between the Taiga to the north, the Grasslands to the west, the Appalachians to the south, and the Atlantic Coast to the East. These northern forests sit on an ecological fence, neither too cold, too wet, nor too dry. If the region experienced a longer winter and thus a shorter growing season for hardwoods, the evergreens of the north (capable of photosynthesizing during the hardwoods' cold offseasons) would invade and dominate. If the summers were drier, the grasslands would spread east like a shaggy carpet creeping under living-room furniture, for grasses are superior to forests at withstanding drought and its companion, wildfire. And if the climate were just a bit warmer, the smooth-talking, good-living trees of the south would sneak in, like a drawl among the noisy cheers at Yankee Stadium.

This is not to say that the northern hardwoods lack character or distinction. Within their realm, these forests vary tremendously, as they stretch east to west for 1,500 miles. On a grand scale, the tree species change composition above and below an east-west line that halves the ecoregion. To the north, New England and the Great Lakes are dominated by forests of sugar maple

and beech, although they were once blanketed by white pines before they were logged. To the south in the Ohio River Valley, oaks and hickories are dominant.

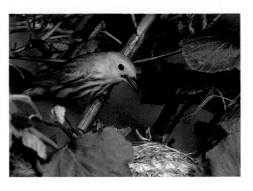

Despite the human tendency to define permanence as anything lasting longer than its expiration date, hardwood forests are, in fact, newcomers to the north. Pushed far south by the repeated incursions of glacial ice, oaks, maples, beeches, and hickories hid during the Pleistocene in temperate sanctuaries where sub-tropical forests now grow. As the ice back-stepped to the Arctic 12,000 years ago, plants spread north with the warming climate. So the northern hardwoods are young forests, still unpacking boxes, spreading their roots, and learning how to get along with their new neighbors.

The hardwood forest has an unfair reputation for being a tad monotonous, a bit uniform, just so . . . regular. This point of view results from a limited perception of the forest as being a dull set of gray trunks, topped by a boring green roof. But if you see the forest for its trees and leaves and ferns and flowers, if you participate in the forest, if you acquire a "speaking acquaintance" with it, you'll find out differently. I used to be able to tell the names of trees just by touching their bark. Every species feels unique, and my hands were often more clever than my eyes at identifying trees. But either my fingers have forgotten the rub of old corduroys, or my mind has misplaced the name associated with it: white oak. You may have to peer closely at the trees, or sniff around a bit, or be led by the hand as I once was, but there are friends to make here, enough to last a lifetime.

Every kind of tree has a different kind of flower and seed that are characteristic of a life out on a limb. Birches have tiny pendulous flowers and seeds, the better to catch rides on the wind. Maples hang their flowers out on long stalks and endow their

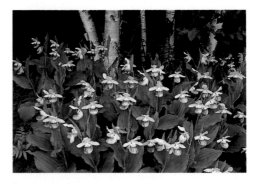

seeds with papery wings. Oaks make little green flowers and seeds that are fat, while beeches make seeds that are square. Pines pro-

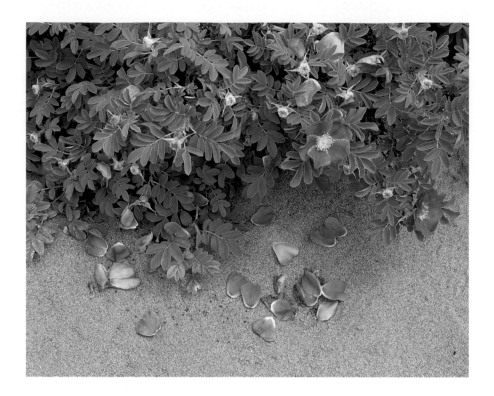

duce pollen that can color the wind and put their seeds in thorny old cones. Poplars create tuliplike flowers, and their seeds thunk down to the ground, while dogwoods have perhaps the prettiest flowers of all and seeds that are autumnal red.

While we may not notice the flowers on hardwood trees, we adore the blossoms that grow below them. Every spring, beneath gray tree limbs, grows an ephemeral garden of wildflowers. Blooming after the frosts have tip-toed north and before the shading green canopy unfurls overhead, these flowers, like their alpine and arctic cousins, must take advantage of a precariously short time to grow, flower, fruit, and send off the next generation. Many of our most beloved wildflowers—trilliums, lady's slippers, mints, and violets—bloom at this time.

Perhaps the most beloved of all northern wildflowers are the violets. There are at least 80 natural hybrids among the several dozen violet species in the Northeast alone. Despite their name, most violets are not violet but more commonly are yellow, white, or blue. Violets sprout from an underground stem that can produce plants even when broken into many pieces (a fact familiar to any gardener of wild beds). The first violet flowers of the season nod shyly, perhaps unsure of their beauty. As the season progresses, the

If only for a short while, flowers adorn these forests from head to toe, appearing on redbud trees (right, © Willard Clay), as well as on the forest floor, such as these wild roses (above, © Nadine Blacklock).

Large-flowered trilliums (above, © Rod Planck)
are a rare woodland wildflower of the northern

flowers raise their heads skyward. Each position presents the flower to a different set of pollinators—ants prefer the nodding flower, flies and bees like the level form, and butterflies land on blossoms that have opened to the sun—a come-one-come-all approach to ensure pollination.

If pollination hasn't occurred by the time butterflies are fluttering by, violets have a back-up plan. Under the litter of leaves, on thin pale stems, closed buds are formed, called cleistogamous blossoms. Cleistogamy means "closed marriage"; the bud will never open. To a violet it means the surety of self-pollination. While not as viable as fertilization from another plant, the bud at least produces some seeds for future plants before fading to ground.

Fritillary butterflies are also violet devotees. They lay their eggs on violet roots so that their larvae can munch violet meals. Does this make the larvae mostly violet and the adult fritillaries more violet than not? When I see a new fritillary butterfly spreading its wings, I think of a violet flower opening to the sun. Where does the butterfly end and the violet begin? To see a fritallary in the northern forest is to see a butterfly with violet wings; rising to the treetops, it is a fluttering, breeze-held violet.

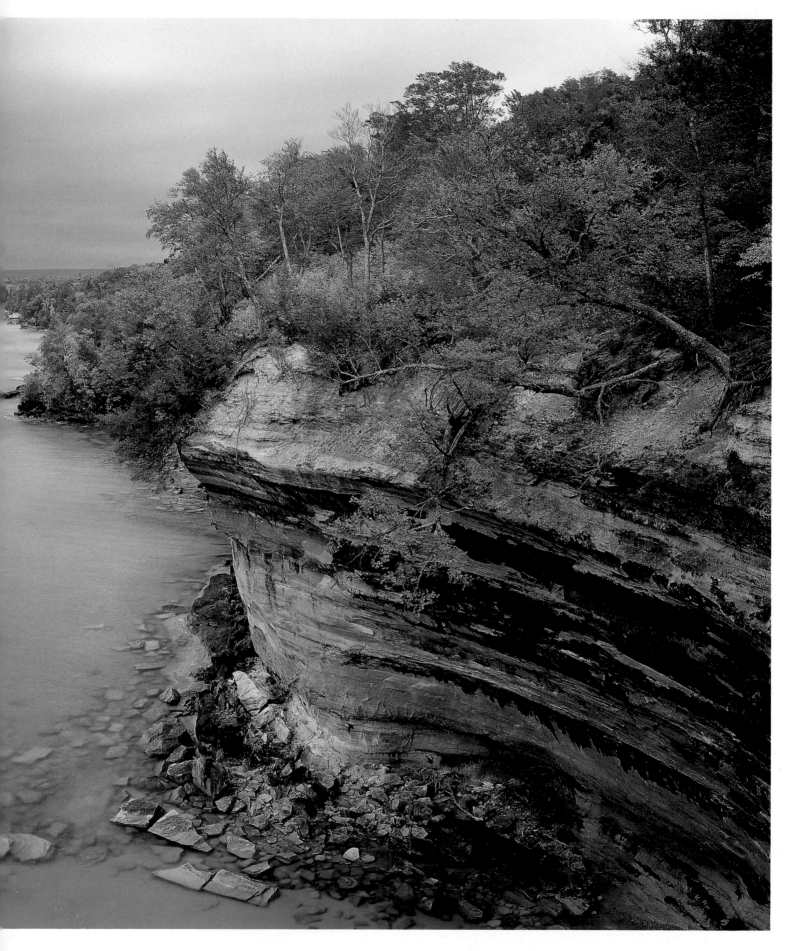

*The shoreline of Lake Superior is dramatically wild. Pictured
Rocks National Lakeshore (above, © Carr Clifton) in Michigan
is as hauntingly beautiful as the watery caves of the Apostle
Islands (left, © Craig Blacklock).*

Summer quickly melts into autumn's splendor. Northern lakes, such as the Lake of the Clouds (left, © Larry Ulrich), are blue oases in the Porcupine Mountains on Michigan's Upper Peninsula. Millions of individual beauties, such as this red maple tree in Ontario (above, © Charles Krebs), are annually woven into a carpet of color across northeastern America.

*Winter wind sculpts the snow with icy gusts near
a frozen woodlot in central Michigan (right, © Rod
Planck). This time of year, the northern forest
provides meager shelter for any raven happening by
(above, © Jim Brandenberg).*

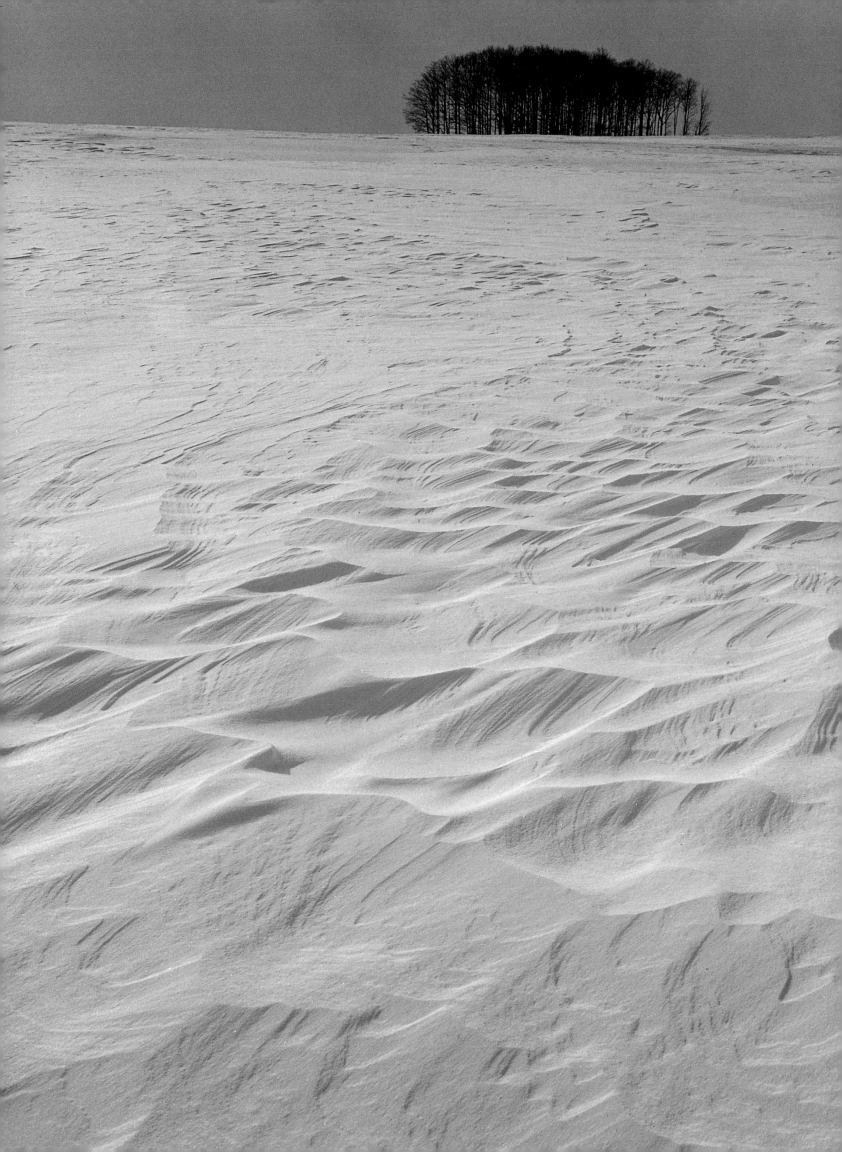

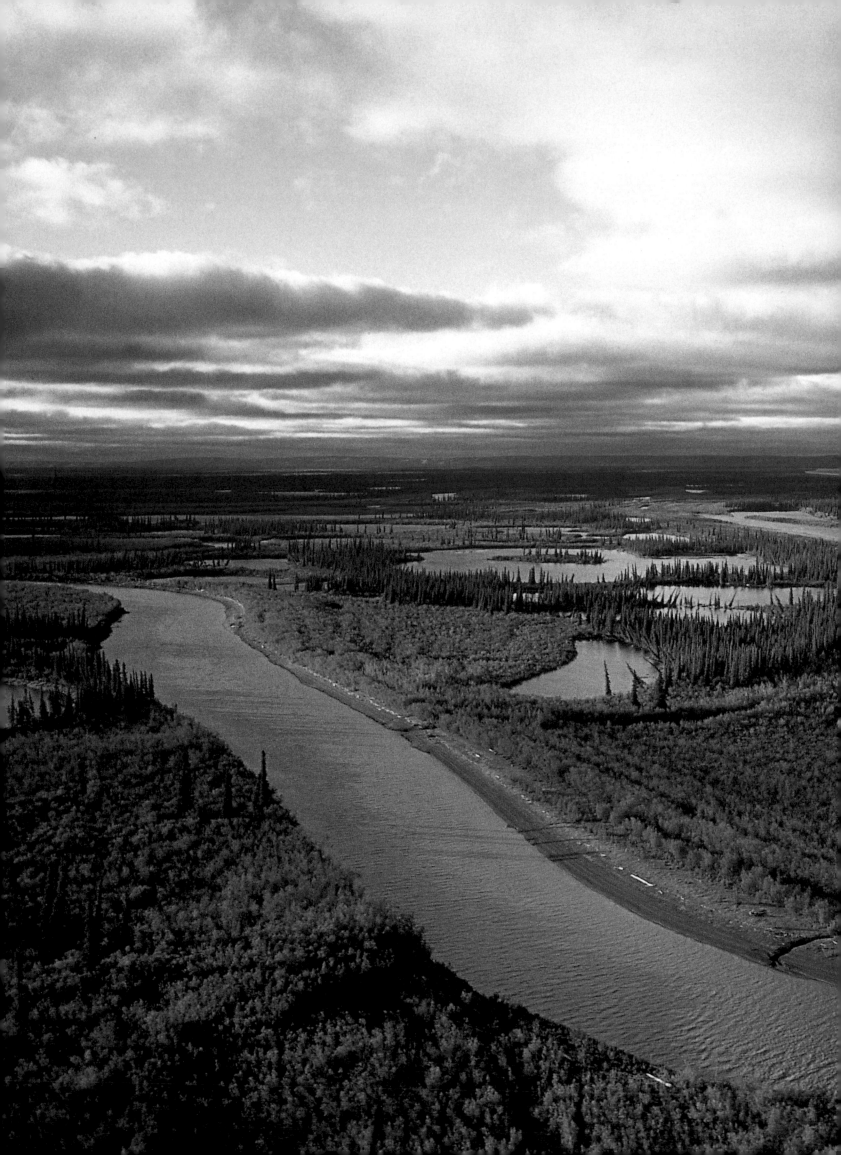

THE TAIGA

"Only the mountain has lived long enough to listen
objectively to the howl of the wolf."
 —Aldo Leopold

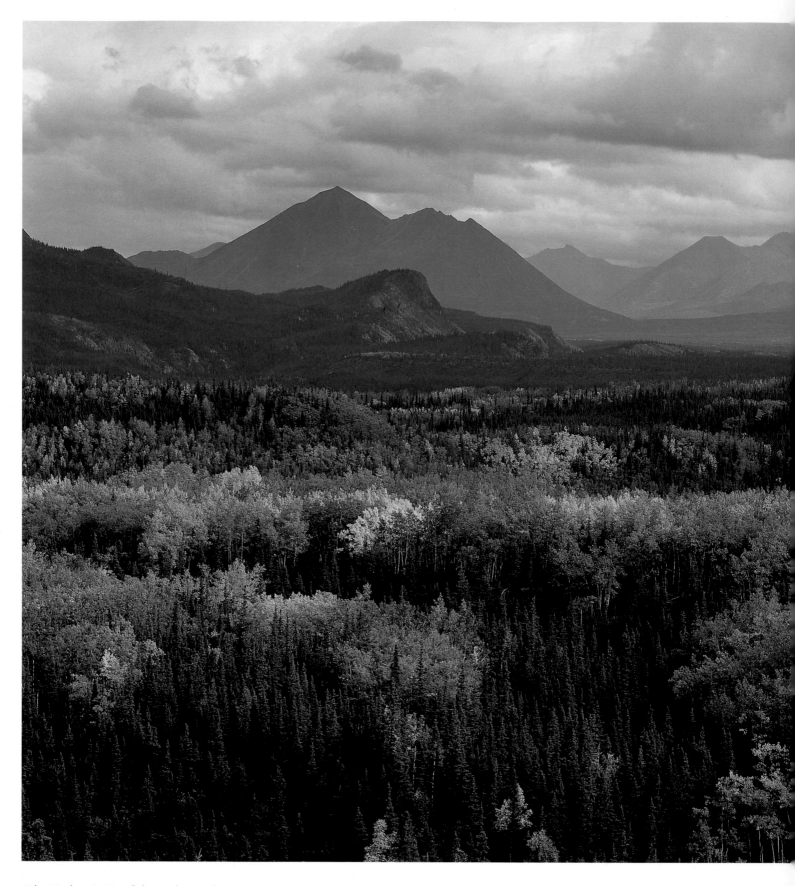

The Mackenzie River delta in the Northwest Territories
(previous pages, © Wayne Lynch) is carpeted by a dense
spruce/fir forest. Aspens invade it whenever possible
(above, © Carr Clifton), here turning gold in September
near the Alaska Range.

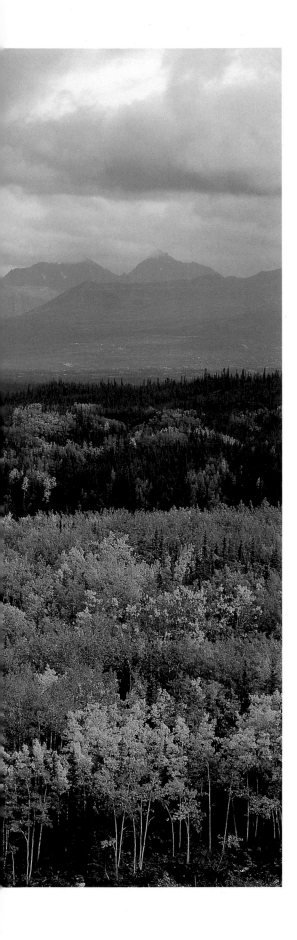

The Taiga ecoregion is the North Woods, stretching across the top of North America in a thick band of evergreens. Translated from Russian, taiga means "land of little sticks" and refers to the forests of small trees that are characteristic of this ecoregion. While the trees may be diminutive, the taiga certainly is not; it covers more than one-quarter of North America, by far the largest terrestrial ecoregion on the continent. Globally, the taiga wraps around the Northern Hemisphere, a green sward bounded on the north by the tree line, which is the northern limit of arboreal growth on Earth. North of this fluctuating margin lies arctic tundra.

From afar, this forest looks like an endless green stubble of evenly sized evergreens, softened by occasional stands of hardwoods. Up close, the damp ground beneath the trees is covered by a thick blanket of mosses and lichens, and growing through this verdant mat are bunchberry flowers and creeping cranberries, mounds of mushrooms, and clumps of ferns. Where the evergreen forest thins out, scrubby willows and alders grow in

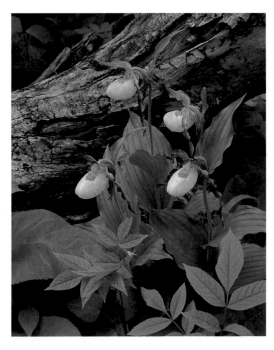

great tangles that are impassable without the legs of a moose and the will of a locomotive. Around the tangles grow blueberries and

The forest floor in a taiga blooms briefly but gloriously in spring, a time when wildflowers such as the yellow lady's slipper (above, © Nadine Blacklock) make a showy appearance.

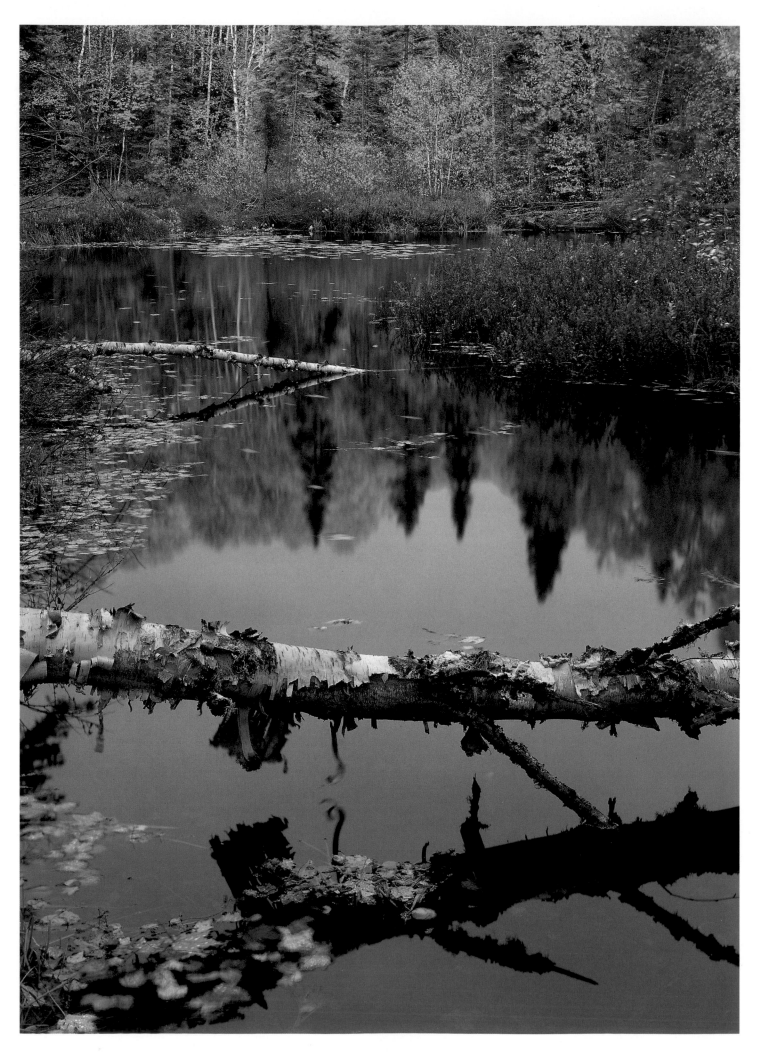

dwarf birches, which turn a dusty red color in autumn, a welcome relief from the ususal green monotony of the taiga.

Many call the taiga "the spruce/fir forest," a name divulging its dominant trees: white spruce, black spruce, and balsam fir. In many places, though, this mix changes to spruce/aspen or spruce/birch or tamarack/fir forest. In fact, the trees of the taiga vary according to environmental conditions. Black spruce grow where their roots will always be wet; white spruce prefer to be dry. Aspens grow in old fire scars. Alders are always near water. Firs cling to mountainsides where no other trees will compete, and tamaracks like old bogs quaking with orchids and sphagnum moss.

The taiga is also known as the boreal forest, an old-world reference to Boreas, the Greek god of the north wind. This has always seemed an odd choice to me for while the forest is definitely northern, to my recollection it is seldom windy. One of my strongest impressions of the taiga is of stillness, of sound completely muffled by the dense vegetation. Even the sounds of a heavy-footed bear or a stumbling human are absorbed by the thick carpet of moss. And at dusk when the world seems to stop turning, silence falls upon the taiga like a down quilt settling on a bed. Then the forest of shadows becomes a forest of eyes, and owls traverse its unlit paths on silent wings.

May and June are the only times when the taiga quivers with noise. Birds migrate to the taiga from the south to nest and raise their young when food is plenty and days are long. From every limb and across every bog, a chorus of birdsongs fills the forest during the courtship of the returning migrants. While songbirds sing melodically, the unlikeliest birds make the loudest commotion: the sandpipers. These usually silent birds of the sandy shore stand proudly on evergreen limbs and make an astonishing racket. But after mating and nesting season, when the days begin to shorten and the air chills, most boreal birds fly south to escape the long winter and the taiga is quiet again.

*In summer, around the taiga's stubbly trees and
shrubs grow many wildflowers, including the
poisonous veratrum, or false hellebore (right,
© William Neill), and in lakes and ponds,
fragrant water lilies (above, © Rod Planck).*

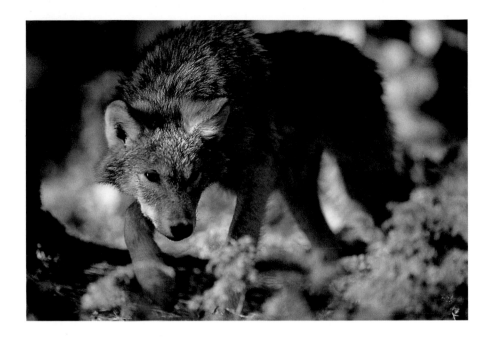

Caribou follow the same pattern of migration but in reverse. They migrate to the taiga in autumn to avoid the tundra's biting wind, and to find protection and food in the dense forest. In spring they return north, walking hundreds of miles through the taiga to traditional calving grounds on in the tundra's rolling hills. Pregnant females lead this trek north, headed by those that are closest to birthing; after them come the barren females. Close in tow are last year's calves, following their mothers to learn the migratory path, along with other juveniles.

That this route has to be learned and is not instinctual may seem surprising, but this is true for many mammals, including whales, and even for some birds such as geese that are mistakenly thought to be hard-wired for their worldwide migratory routes. For caribou, while the identical route isn't followed every year, the direction remains the same and the herd always ends up on the same birthing grounds. But, caribou must be imprinted for migration by walking the walk—it's the only way they know.

Bulls linger on the wintering grounds for up to several weeks before they begin to wander back to the tundra. Bulls don't participate in the birthing process so they have no urgency to leave in time to make the entire trip north. Once they reach the tree line, bulls disperse and linger there, waiting for the females to return on their way back to the taiga. The waiting is a calculated move in the mating cycle. The herd and the bulls reunite in early autumn, precisely when the females are ready to mate. No sense walking out of state when the dance is going to be held in your backyard.

A typical wolf pack needs to kill one caribou every two to three days to sustain itself. In central Canada, wolves depend on caribou for winter food, so they follow the herds on their annual migration through the taiga. When the caribou head north again in the spring, the wolves tag along, often culling weak or old caribou from the herd. At the tree line, the wolves linger and disperse, looking for sandy ridges in which to den. Some wolves follow 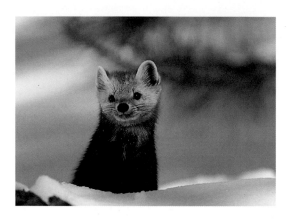 the herds all the way to their calving grounds, denning there, but that is less common.

Why do most wolves forego this moving buffet of migrating caribou? In summer, wolves can sustain themselves on voles, lemmings, birds, eggs, and even fish. By denning south of the calving grounds, wolves are able to shelter and protect their pups while they are still vulnerable, feeding them with small animals from the tundra. When the pups are several months old and growing quickly, they need ever-increasing amounts of food. Just then, in mid-July, the caribou return from the north, providing food for the pup's growing appetites at a time when they are big enough to participate in the hunt and begin to learn the ways of the wolf.

Caribou are forever being tested by predators and the rigors of the taiga. They thrive in a land of scarcity where the extremes of nature are so great that, as Richard Nelson writes, "weather is the hammer and the land is the anvil." And yet the caribou provide sustenance for both human and wolf, and carry the spirit of the taiga up to the tundra wind. The Inuit people know when the caribou arrive by listening to the attendant calls of ravens. Ravens follow the wolves who follow the caribou and pick at the scraps of their kills. The Inuit say "Thank you, Grandfather" when they hear the raven call, for they know the caribou are near and their lean time is over. Listen for the raven and thank the north wind for the great herds of caribou that still walk the taiga paths.

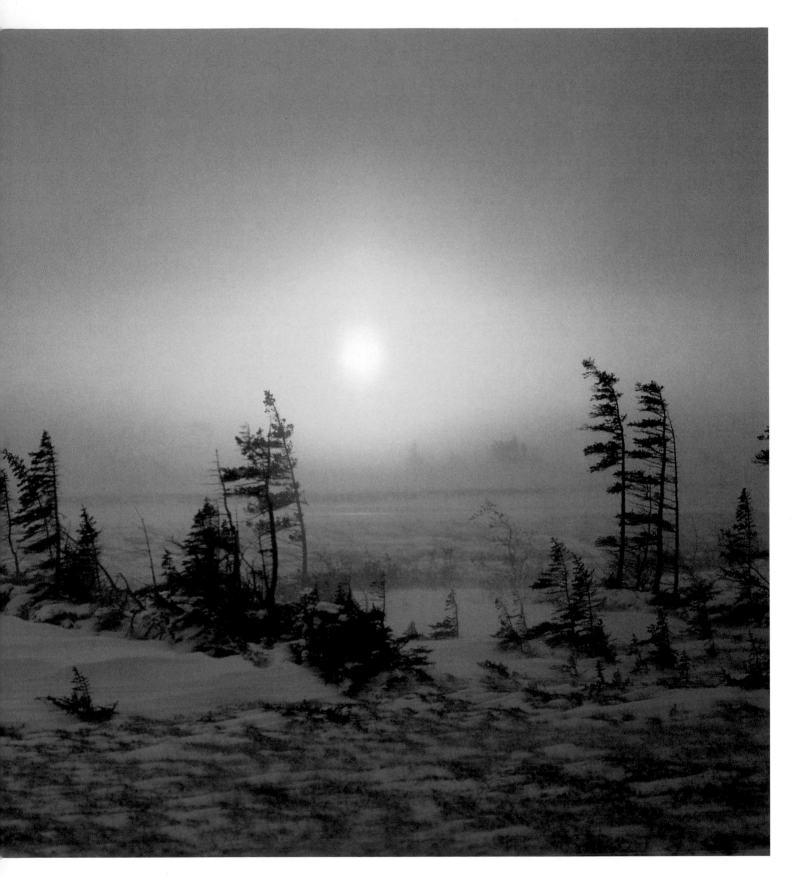

Winters are long and hard at the tree line (above, ©
Wayne Lynch). Most of the trees there are one-sided,
their windward branches pruned by blizzards of frozen
pellets that cut like icy knives. In the forest, the pine
marten (left, © Jim Brandenburg) survives by hunting
through snow tunnels and burrows for mice and voles.

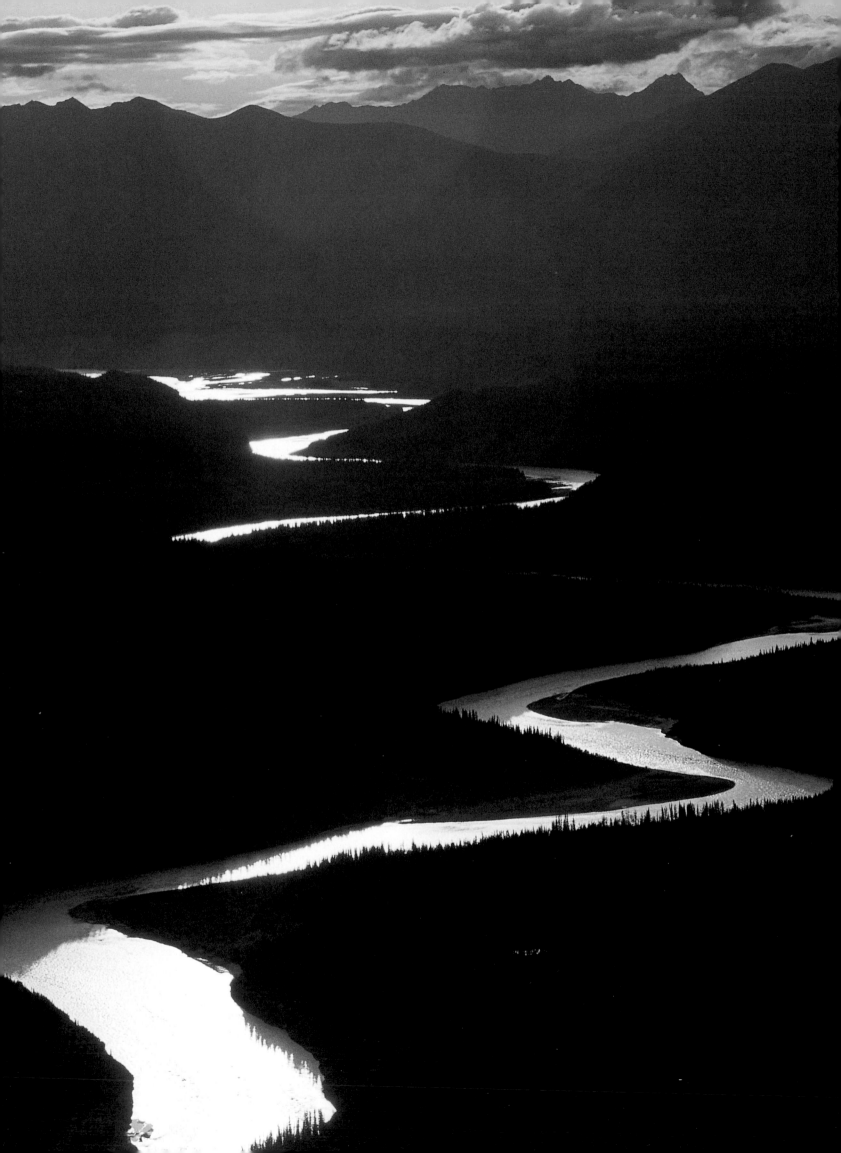

The aurora borealis (above, © Wayne Lynch) frequently graces the night sky above the taiga, especially in autumn and early spring.

Wrangell-St. Elias National Park in southwest Alaska (left, © Art Wolfe) has 8,331,604 acres, the United States' largest national park.

THE TUNDRA

"When you have walked for days under the enormous sky,
or been shown how some very small thing, like a Lapland
longspur eating the lemming's bones for calcium,
keeps the country alive, you begin to sense the timeless,
unsummarized dimensions of a deeper landscape."

—Barry Lopez

The great Tundra ecoregion is often described in low, husky tones with words that include "empty" and "cold." Who hasn't heard the phrase "ice bear" used to describe the white bear of the north, or the word "barrens" to mean the treeless tundra? From our temperate perspective, the Arctic has no natural features to rest human eyes or adjectives upon, so we imagine it as just being the Earth's icy skull cap, dull and soulless.

But when the tundra is walked, the truth is obvious: this great region deserves rich adjectives and flowing phrases as much as any other landscape. How else can the delicacy of baby birds, cradled in down and caught between the chill air and the cold earth, be captured? Or the grace of beluga whales at an ice

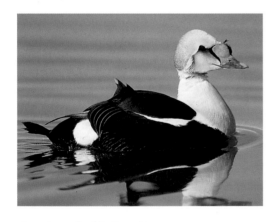

floe's edge, those shadowy ghosts whose canarylike songs resonate through the feet rather than reaching the ears? Or the tiny flowers with exuberant blossoms that cuddle together against the cold

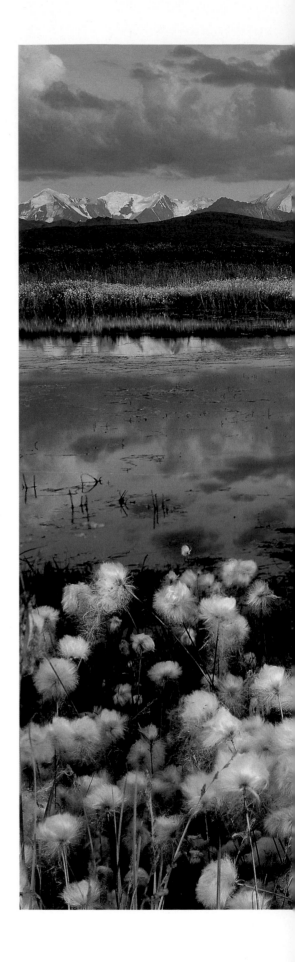

Arctic wind? During any season, a gentle beauty found nowhere else lies upon the tundra, a wedding of vastness and intimacy, of delicacy and perseverance.

Tundra covers 1.08-million square miles of North America, or about 20 percent of the continent. Winter, the dominant season, lasts eight to ten months, a time when snow covers the ground and darkness covers the sky. Summer, the growing season, lasts one-and-a-half to three months, a time when nothing is taken for

(Previous pages, © Galen Rowell) Sunrise is misty over the John River, Gates of the Arctic National Park, Alaska. King eider ducks (above, © Wayne Lynch) nest in the Yukon.

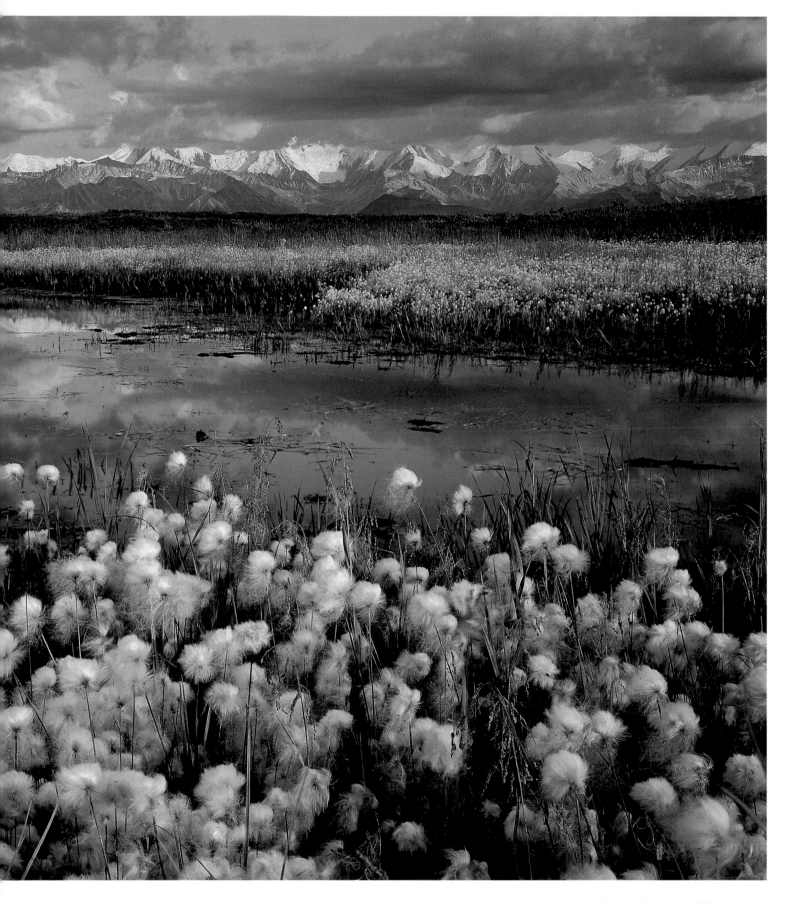

A summer tundra pond is surrounded with blooming cottongrass in Denali National Park, Alaska. (© Carr Clifton)

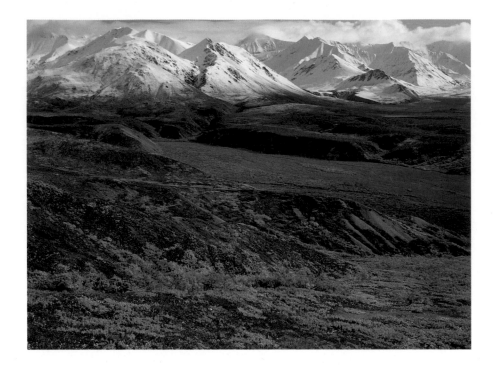

granted and everything is in a hurry. Summers can be quite warm, with temperatures sometimes reaching 80°F, and is always quite buggy with mosquitoes that swarm like bomber squadrons with bad attitudes.

The annual contrast between summer and winter marks the tundra. Spring and autumn are afterthoughts, usually only recognized when the next season storms in. "Remember those three days last week that were really warm?" So much for spring. And "Boy, these nights are getting cold" accounts for the few grand days of autumn weather.

Plant life on the tundra is compressed into a narrow band of possibility known as "the active zone," the space between the permafrost below and the killing wind on the earth's surface. Permafrost is permanently frozen ground, beginning generally 1.5 to 2.5 feet below the surface. Above it, the soil in summer is still biologically active. In this active zone, community is more important than individuality because the sharing of meager resources— warmth, pollinators, and water—is the most efficient way to live.

Growing in clusters on communal mounds or holding tight in cuddled masses, tundra plants not only survive but thrive. There are more than 2,000 species of plants in the Arctic. Many are mosses, lichens, and sedges, but there are also a surprising number of showy wildflowers, including roses, buttercups, pinks, poppies, and orchids.

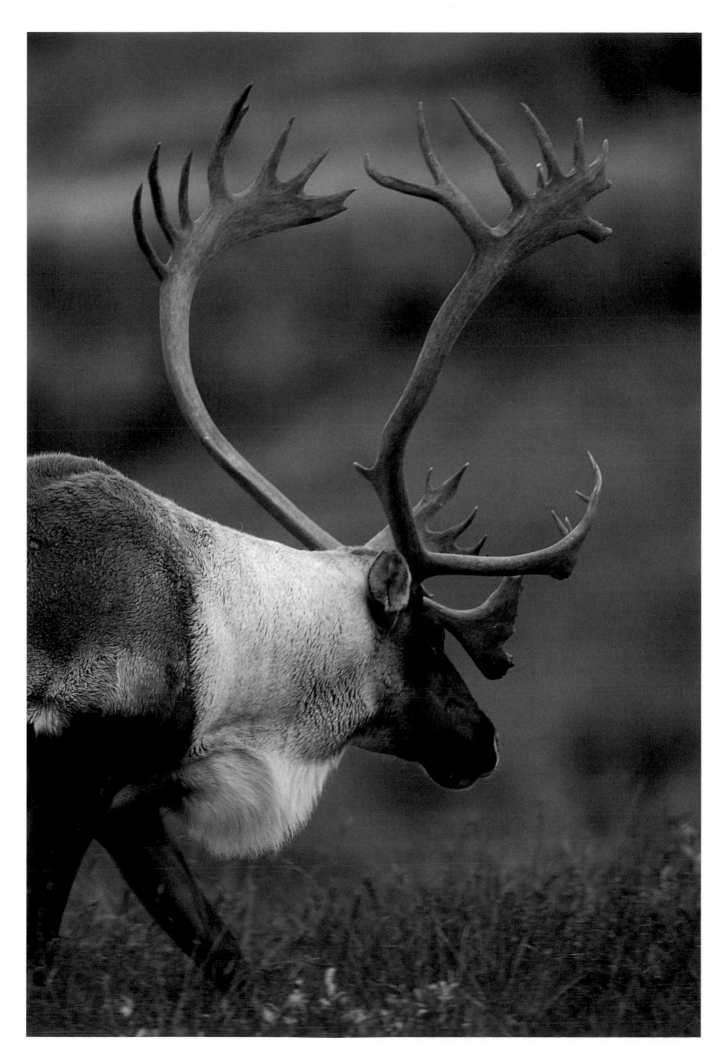

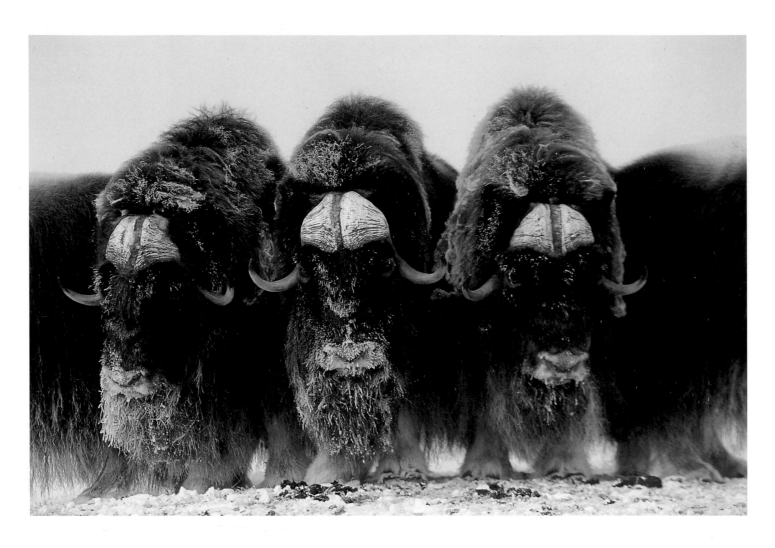

Among the animals that call the Arctic home is the polar bear, the largest land predator in the world. Big males are 10 feet long, weigh nearly a ton, and can outsprint a race horse over short distances. Actually, polar bears are more marine than land animals, for their life revolves around seals and the ice of the Arctic Sea. From November to July, all through the dark Arctic winter, the wandering bears of Hudson Bay live on the frozen sea, catching seals, mating, and teaching their young to hunt. But from July to early November, when the ice pack retreats and the southern Arctic waters melt, most polar bears become landlocked. Without the ice, polar bears cannot easily catch seals. To survive during this fast, polar bears, like all bears, hibernate.

However, hibernation for polar bears is not the typical "deep sleep" that little tundra animals employ. For example, Arctic ground squirrels and collared lemmings reduce their heart rate to just a few beats per minute. They drop their temperatures to either just above freezing (the lemmings) or just below freezing (the Arctic ground squirrels). All arctic deep hibernators stir every 10 to 14 days to urinate, defecate, and grab a quick bite to eat from

Muskox bulls (above, © Wayne Lynch), when threatened, form into a tight circle and present a formidable defensive posture, like these natives of Banks Island, Northwest Territories. Dall sheep (right, © Kennan Ward) wander the Alaska Range, climbing cliffs for protection.

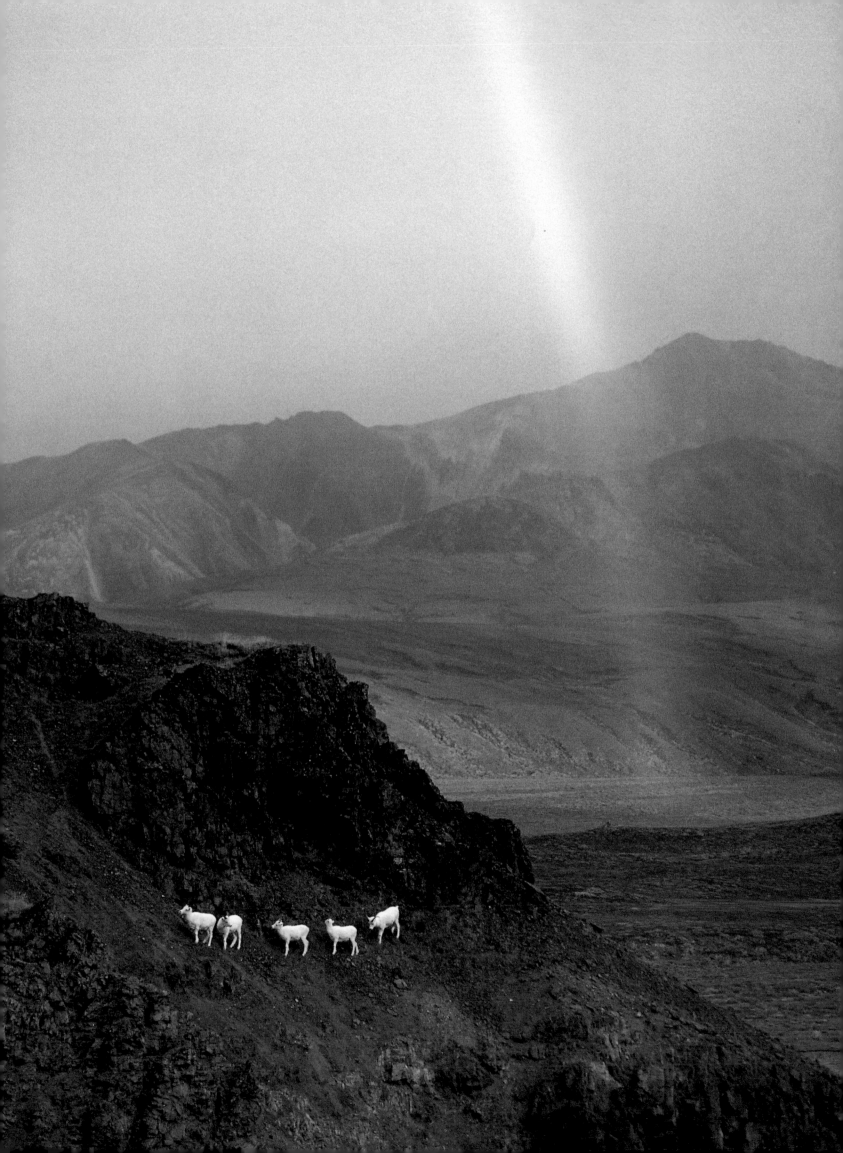

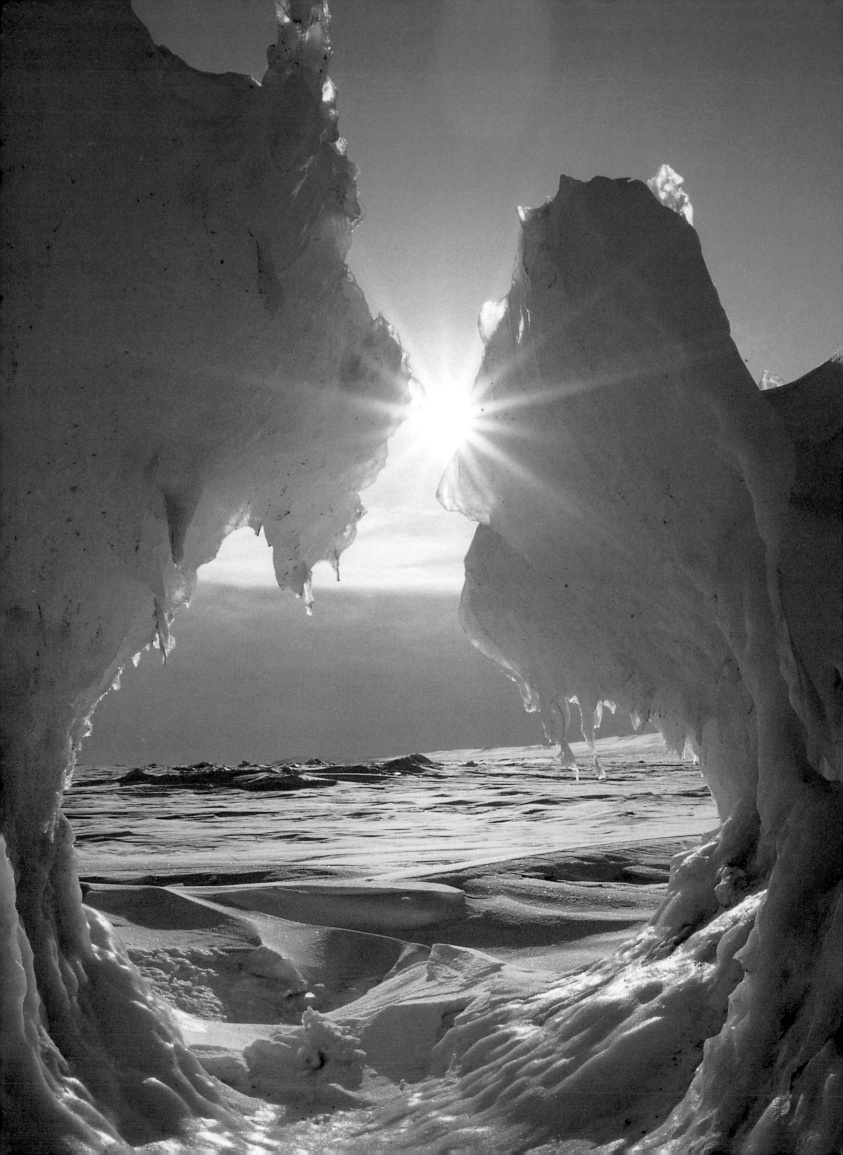

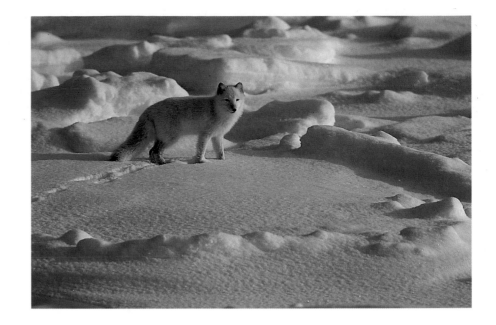

The tundra is winter's domain for most of the year, as snow drifts pile high against the blue Arctic sky. Some animals, such as the Arctic fox (right, © Tom Mangelsen) and the gyrfalcon (below, © David Middleton), are perfectly at home year-round in this frozen white world.

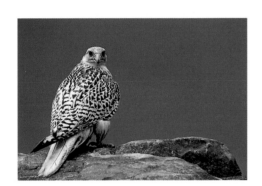

their larder. Polar bears are active during hibernation even though they don't eat, drink, or defecate. Pregnant females go through a nine-month hibernation during which they will sustain their pregnancies, give birth to cubs, and nurse them for three months.

Only the most fit females can endure such physical stress, and even then they will lose up to one-third of their body weight in the process. To ensure the mother's greatest probability of surviving this ordeal, upon conception in the spring, the embryo doesn't initially implant itself into its mother's uterine wall. Not until autumn, when the female has gained sufficient weight, does the embryo attach itself and begin to grow. This delayed implantation is the polar bear's insurance policy against a bad season on the ice. Better to begin again than risk the death of the mother.

Walk across the tundra and you are traversing the treetops of North America, your feet on the ground and above the trees at the same time. You are walking the sky, for it starts at your feet, and the view ahead is not of Earth but of the heavens. How can you have a bad day in the Arctic when your head is always in the clouds and your feet just barely touch the ground?

Sea ice (left, © Wayne Lynch) is carved into fantastical shapes by the weather on Banks Island, Northwest Territories.

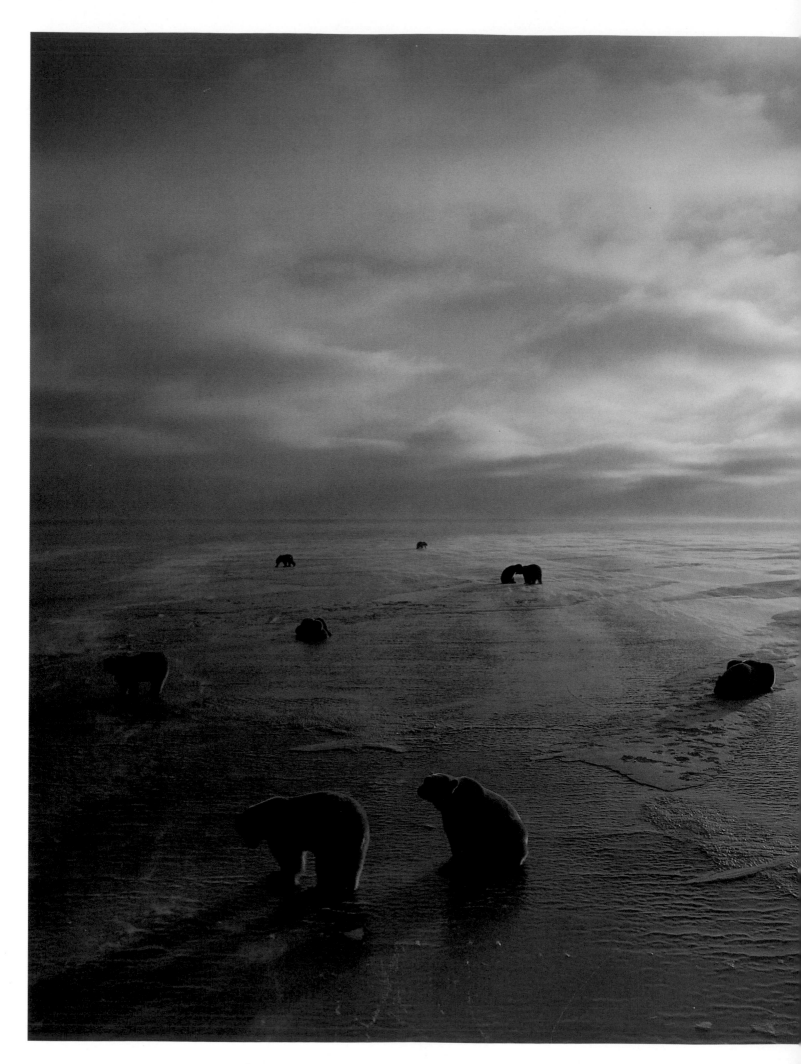

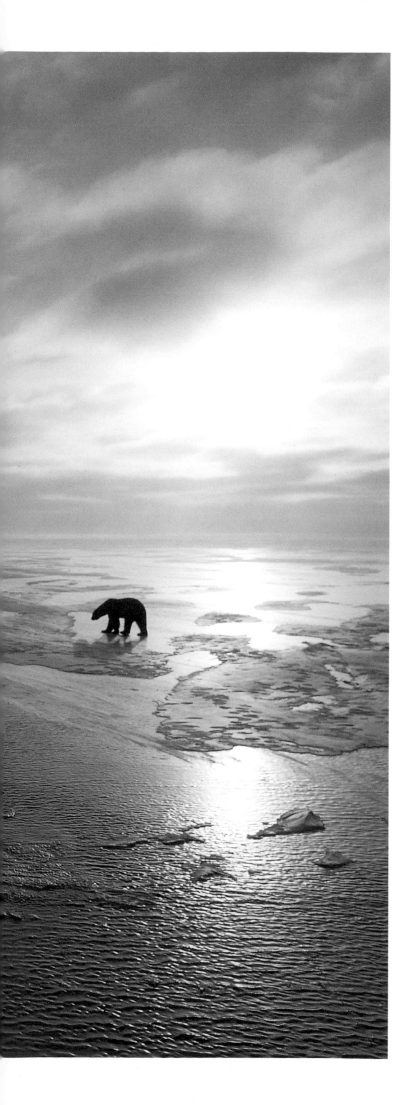

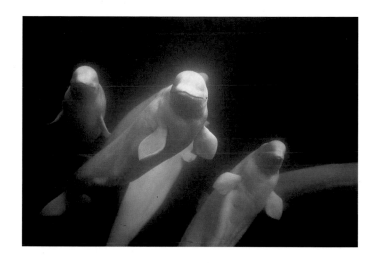

The Hudson Bay is home to beluga whales (above, © Jeff Foott) as well as polar bears (left, © Kennan Ward). The latter are shown here gathering in autumn to await the freeze and their chance to hunt seals again in winter. In November, pregnant bears head back inland to birthing dens where they will stay until their young are strong enough to travel to the ice. Polar bear cubs are born in late December or early January, but don't emerge from the den until March or April, along with one very hungry mother who hasn't eaten for nine months.

The Photographer's Seasonal Calendar

The photographs in this book testify to the importance of being in the right spot at the right time. That is a two-part equation: knowing where the spot is plus knowing when to be there. Many guidebooks talk about where to go to experience wild America but give photographers very little guidance about when is the best time to go. The following seasonal calendar to photographing North America does both. Remember, however, that nature doesn't follow perfect Greenwich time—the absolute peak moment of any natural event varies from year to year. Good luck!

JANUARY

Weeks 1 & 2 **Oregon Coast and Mountains**

The Oregon coast is photogenic year-round, but January's winter storms are the most dramatic backdrop for the seals, whales, lighthouses and harbors, wonderful tide pools, and spectacular coastal landscapes. For something different, head up into the Cascades, where piles of soft snow adorn magnificent trees and drape the landscape.

Weeks 3 & 4 **Death Valley and the Slot Canyons of the Southwest**

Death Valley is great in winter because the temperature is tolerable then, so you can photograph the bizarre landscapes all day long. The most famous slot canyon is Antelope Canyon, just southeast of Page, Arizona, but there are others less well known that are just as interesting. Try the Paria Canyon area, or ask the Bureau of Land Management for other locales.

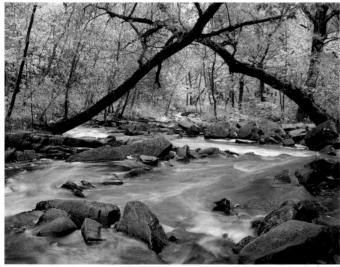

Moose Lake, Minnesota (© Nadine Blacklock)

FEBRUARY

Week 1 **Colorado Rockies**

February brings plenty of snow and, often, blue skies. Try any of the mountain passes with paved roads. If it is snowing, head into the forest for blizzard shots.

Weeks 2 & 3 **Yellowstone National Park**

This is the best time of year for photographing wild mammals and great snowscapes. There are herds of big-horn sheep, bison, pronghorns, and elk on the north side of the park, or you can take a snow coach or rent a snowmobile to visit the geyser basins in the park's interior.

Week 4 **Florida Gulf Coast**

Ding Darling National Wildlife Refuge on Sanibel Island is a magnet for wintering ducks, hawks, osprey, and waders. Also, visit the heron and egret rookery in Venice, located behind the police station, for close, eye-level views of the nesting birds.

MARCH

Week 1 **Harp Seals of the Magdalen Islands, Canada**

The pups are surprisingly easy and comfortable to photograph. Go with a tour group that spends more than just a few hours out on the ice, or else you will be bored for most the day.

Weeks 2, 3, & 4 **Arizona Desert Wildflowers** Wildflowers begin to bloom around Phoenix first, then Tucson, and then Organpipe National Monument. The Desert Botanical Garden in Phoenix is a good place to get information. Also, try the Superstition Mountains east of Phoenix, Picacho Peak State Park north of Tucson, and Gates Pass and the Saguaro National Monument, both west of Tucson.

APRIL

Week 1 **California's Desert Wildflowers**

The wildflowers of Anza-Borrega State Park and Joshua Tree National Park can be spectacular if the autumn and winter rains were good. Also, visit the Antelope Valley area, northeast of Los Angeles, for colorful hillsides of poppies.

Weeks 2 & 3 **Texas Wildflowers**

This is the time and place for anyone interested in wildflowers. The best flowers are right along the highways. Start in Austin and head for the National Wildflower Research Center, which has handouts detailing the best driving routes for blooming wildflowers and maintains a wildflower hotline (the telephone number changes every year).

Weeks 3 & 4 **Great Smoky Mountains National Park**

The Appalachians are the best place in the East to photograph spring: wildflowers galore, dogwoods, rushing streams, and mountain scenics.

MAY

Week 1 **Cuyahoga Valley National Recreation Area, Ohio**

This urban park on the outskirts of Cleveland is great for spring wildflowers, as well as forest and field landscapes.

Week 2 **Utah National Parks**

This is a favorite time of year to visit Utah's redrock country. Nice weather and fantastic landscapes are combined with unexpected wildflowers that make great foregrounds.

Weeks 3 & 4 **Ancient Forests of the Northwest**

At this time of year, the old-growth forests overflow with lushness. The Hoh Rainforest in Olympic National Park is the quintessential old-growth forest. As a bonus, in May there are often elk wandering through the forest.

JUNE

Week 1 **Yosemite and Sequoia National Parks, California**

In early June, the crowds are small, the meadows are fresh, and the animals haven't yet been harassed into

Little brown bat, Pennsylvania (© Joe McDonald)

the shadows. There are also wildflowers to find in the alpine areas and on the valley floor.

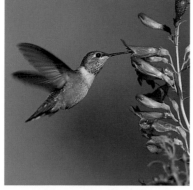

Rufous hummingbird, New Mexico (© Tim Fitzharris)

Weeks 2 & 3 **Yellowstone and Grand Tetons National Parks, Wyoming**
In Yellowstone this is the time of year for baby animals, especially bison and elk. In the Tetons, great fields of blooming mule's ears and lupine flowers create a dramatic foreground for the impressive mountains.

Week 4 **Rocky Mountain National Park, Colorado**
Trail Ridge Road traverses 12 miles of alpine habitat where the earliest summer flowers of Colorado can be found along with grazing big-horn sheep and elk. The sheep and elk are best photographed right after dawn. Later in the day, focus on the cooperative marmots and delicate alpine flowers.

JULY

Weeks 2 & 3 **Katmai National Park, Alaska**
This is the only time and place to photograph fish jumping into the bears' mouths. The bears are habituated to people, so you can get unusually close to them here. The park must be shared with some occasionally uncooperative fisherman, but the photography is worth it.

Weeks 2, 3, & 4 **Wildflowers of the Colorado Rockies**
The best-known spot is Yankee Boy Basin above the town of Ouray, but there are dozens of equally good locations to discover. The easiest alpine wildflower location, accessible by a paved road, is near the top of Mt. Evans, just west of Denver; you may have to nudge a mountain goat out of your composition, though.

AUGUST

Weeks 1 & 2 **Northern Cascade Mountains, Washington, and Glacier National Park, Montana**
Mt. Baker and the oft-photographed Mt. Shuksan in the northern Cascades are at their prime in early August. The Going-to-the-Sun highway in Glacier provides easy access to its magnificent alpine environment. Also, look for mountain goats and look out for bears.

Weeks 3 & 4 **The Palouse Grasslands, Washington**
The combination of plowed fields and ripening grains makes this area a must for all landscape photographers. For a different perspective, drive up Steptoe Butte, the highest point in the area.

SEPTEMBER

Weeks 1 & 2 **Alaska**
This is the best time to visit Denali National Park. The weather is cooperative, the animals look great (caribou have red antlers now), and the tundra has turned beautiful shades of red and gold. This is also my favorite time to go to Katmai National Park because the fishermen are gone, the salmon are bright red, and the bears are big.

Weeks 3 & 4 **Fall Aspens of the Rocky Mountains**
The best place in Colorado for aspens are the San Juan Mountains in the southwest. Drive the "Million Dollar Highway"

between Durango and Ridgeway for miles of aspen scenics, or cross the Dallas divide between Ridgeway and Telluride for classic views of the San Juans. The Tetons are also wonderful at this time of year (Yellowstone doesn't have many aspens).

OCTOBER

Week 1 **Northern New England**
The Northeast Kingdom of Vermont (north of St. Johnsbury) and the White Mountains of New Hampshire are best for autumnal colors. In Vermont, drive all the backroads around Granby and East Brighton, and in New Hampshire, linger along the Kancamagus highway (Route 112).

Weeks 2 & 3 **Central New England and the Upper Midwest**
My favorite roads are Route 100 in Vermont, Routes 4 and 113 in New Hampshire, Routes 8 and 2 in Massachusetts, and Routes 2 and 26 in Maine. Also, try the Chequamegon National Forest in Wisconsin and the Chippewa National Forest in Minnesota.

NOVEMBER

Week 1 **Polar Bears of Churchill, Manitoba**
The polar bear season starts in mid-October and goes to mid-November, but late October and early November are the best times to see them.

Week 2 **The Waterfowl of the Klamath Basin, California, and Oregon**
This is the best place to see blizzards of snow geese and swans. Tule National Wildlife Refuge also has thousands of ducks, and lots of hawks and bald eagles.

Weeks 3 & 4 **The Bald Eagles of Haines, Alaska**
The largest congregation of bald eagles in North America happens here. The area also has the biggest concentration of rain and snow clouds, so the photography is very weather dependent. When the clouds lift, though, the view is spectacular.

DECEMBER

Weeks 1 & 2 **Bosque del Apache National Wildlife Refuge, New Mexico**
This bird sanctuary provides the best winter wildlife photography in the West. Expect to see sandhill cranes, deer, bald eagles, and lots of waterfowl.

Weeks 3 & 4 **White Sands National Monument, New Mexico**
Here are the best sand dunes in North America. The dunes are here year round, of course, but there are fewer people and less wind in December.

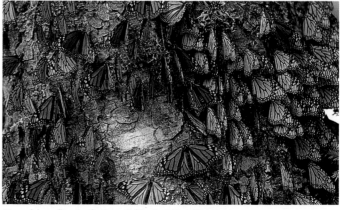

Monarch butterflies, Pacific Grove, California (© Tom Mangelsen)

Photographers' and Authors' Biographies

Craig Blacklock

Son of Les Blacklock, who was also a nature photographer, Craig Blacklock traveled North America's wilderness areas as a child and began photographing nature full-time in 1976. Since 1982, he has worked almost exclusively in Minnesota and the wild lands surrounding Lake Superior. *The Lake Superior Images* is the largest of Craig's 11 books; seven years of photography, including photographs made during a 1,200-mile kayak circumnavigation of the lake, went into this project. Craig views Lake Superior as a life-long subject and has future books about the lake in progress. Craig lives in Moose Lake, Minnesota, with his wife Nadine, who is also a nature photographer.

Nadine Blacklock

Nadine Blacklock has been interested in photography since youth. She has been a full-time nature photographer since 1982 and, recently, has worked primarily in northern Minnesota. Nadine is co-photographer of seven books including the *Hidden Forest, Border Country, The Quetico-Superior Wilderness,* and *The Duluth Portfolio.* Her books and posters have received many awards, and her photographs are in several private and corporate collections. Active in preserving the land she photographs, Nadine serves as a board member of several environmental organizations. She was also instrumental in the establishment of the Blacklock Nature Sanctuary, a nonprofit preserve for artists and naturalists. Nadine lives in Moose Lake, Minnesota, with her husband Craig, who is also a nature photographer.

Tom Blagden, Jr.

Tom Blagden has been a professional photographer for 20 years, concentrating his efforts on Costa Rica and South Carolina, where he has lived since 1977. His work has appeared in *Sierra Club,*

Cumberland National Seashore, Georgia (© James Randklev)

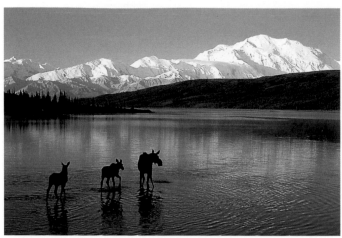

Wonder Lake, Denali National Park, Alaska (© Kennan Ward)

Audubon, National Geographic, and *Nature Conservancy* calendars, as well as in numerous magazines and exhibits. Tom has produced three exhibit-format books on South Carolina: *Lowcountry: The Natural Landscape, South Carolina's Wetland Wilderness: the ACE Basin,* and *South Carolina's Mountain Wilderness: The Blue Ridge Escarpment.* His current book projects include Costa Rica and the rivers of South Carolina. Tom lives in Charleston with his wife, Lynn, and daughter, Sarah.

Jim Brandenburg

Minnesota photographer Jim Brandenburg began his career as a natural-history photographer and filmmaker while majoring in art at the University of Minnesota. He went on to become a newspaper picture editor and a contract photographer for *National Geographic* magazine in 1978. Jim's photographs have been featured in many magazines and over 30 *National Geographic* books and articles. In 1988 he was named the BBC Wildlife Photographer of the Year. Jim has produced several award-winning books and films, including *Brother Wolf: A Forgotten Journey* in 1993, *White Wolf: Living with an Arctic Legend* in 1988, and *White Wolf,* a National Geographic film, also in 1988. Jim lives in the North Woods of Minnesota.

Willard Clay

Willard Clay is a man with two passions: photography and music. Music inspires him to photograph, and some have said it is reflected in his photographic work. Formerly a botany professor at the University of Arizona, Will left it all in 1982 to pursue photography full-time. His photographs have appeared in a myriad of national publications and calendars. Will has completed eight photographic books including: *Oregon, Northern California, Illinois: Images of the Landscape, Deep in the Heart of Texas, Wild and Scenic Illinois, Yellowstone: Land of Fire and Ice,* and *Grand Teton: Citadels of Stone.* Will lives in Ottawa, Illinois, the heart of prairie country.

Carr Clifton

Carr Clifton is widely recognized as one of America's leading photographers of wild landscapes. He is best known for his contributions to the Sierra Club and Audubon Society wilderness calendars, as well as for his seven exhibit-format books: *Wild by Law, The Hudson: A River that Flows Two Ways, New York Images of the Landscape, California Magnificent Wilderness, California Reflections, California Wildflowers,* and *Coastal California.* Carr's photographs have appeared in many magazines, including *Geo, Life, National Wildlife, Outside, Esquire, Natural History,* and *National Geographic,* and have been displayed in many prominent galleries. Carr lives in Taylorsville, California.

Kathleen Norris Cook
Kathleen Norris Cook is a native of rural southeastern Louisiana and a fine-arts graduate of Mississippi College. Her award-winning images are most frequently associated with outdoor subjects in the western United States. Kathleen is well known for her sensitive landscapes and ability to capture the definitive moment on film. In additiion to doing international advertising and calendar/editorial work, she recently completed her third book, *Yosemite: Valley of Thunder*. Kathleen has been chosen three times for Kodak's prestigious Professional Photographer's Showcase. She lives for part of the year in Ouray, Colorado, a scenic town tucked into the side of the San Juan Mountains.

Jack Dykinga
As a 21-year-old, Jack Dykinga broke into the Chicago journalism scene by working nights at the *Chicago Tribune*. After a year, he began working for the *Chicago Sun-Times*, where he won the Pulitzer Prize for Feature Photography in 1971. Ten years later, drawn to wilderness issues, Jack turned to nature photography full-time. Since then, his photographs have appeared in many magazines including *Audubon, National Geographic, Sierra Club, Outside, Time*, and *Outdoor Photographer*. Jack has produced four books: *Frog Mountain Blues, Sonoran Desert, The Secret Forest*, and *Stone Canyons*. The wilderness areas featured in his last two books—the Sierra Alamos in Mexico, and the canyon country of Utah—are now protected parks. Jack lives in Tucson, Arizona.

Tim Fitzharris
Tim Fitzharris is the author and photographer of many books on nature including: *Canada: A Natural History, Forest: A National Audubon Society Book, Nature Photography: National Audubon Guide, Wild Bird Photography: National Audubon Guide, The Sierra Club Guide to 35mm Landscape Photography* and *The Sierra Club Guide to Close-up Photography in Nature*. Tim also designs and produces all of his books. He lives in the pinyon/juniper woodlands bordering the Santa Fe National Forest in New Mexico.

Jeff Foott
Jeff Foott has been doing wildlife and scenic photography, and cinematography, for over 20 years. He has worked as a National Park Ranger, a climbing guide, and a research scientist studying sea otters. Jeff's first film, on sea otters, was shot in 1970 and was based on his postgraduate research. He has filmed for National Geographic, Nova, BBC, Survival Anglia, and the U.S. Fish and Wildlife Service. His most current projects include films on the Mojave Desert, great gray owls, and polar bears. Jeff's still photography has appeared in hundreds of magazines including *National Geographic, Audubon, National* and *International Wildlife*, as well as numerous books, calendars, posters and notecards. Jeff lives in Jackson, Wyoming.

Bill Fortney
Bill Fortney is one of the foremost entrepreneurs in the natural-history photography field. Former editor of *Nikon's USA Club* and *Nikon World* newsletters, he has over 25 years experience leading photography workshops, publishing, and doing photographic field work. Bill worked on both the *A Day in the Life of America* and *A Day in the Life of the Soviet Union* projects. He is the founder and director of the Great American Photography Weekend program, the premier natural-history photography workshop in the United States. Today Bill's work is widely published, and he is a much sought-after speaker and presenter. Bill is the Project Director of *The Nature of America* and is currently working on a companion book, *The Nature of Japan*. He lives in Corbin, Kentucky, with his wife Sherelene.

Jeff Gnass
Jeff Gnass spent his childhood in Alaska and realized his niche in life after picking up a large-format camera in 1978. Since then, he has pursued natural-history photography. Though completely self-taught, he has been a guest lecturer at universities and colleges, an instructor at field photography workshops, and has written numerous articles describing his techniques. Jeff has thousands of photo credits and is a regular contributor to a wide variety of books, calendars and magazines. He has produced three books: *Nowhere is a Place: Travels in Patagonia, Hawaii: Magnificent Wilderness*, and *Idaho: Magnificent Wilderness*. Jeff is currently working on a book project about the remote coasts of Alaska. Jeff lives in Juneau, Alaska.

Fred Hirschmann
Fred Hirschmann has been a nature and landscape photographer for 18 years. With his wife and fellow photographer, Randi Hirschmann, he spends five to seven months of the year photographing and exploring the back reaches of America. Prior to becoming a full-time photographer, Fred was a National Park Service ranger for 11 years. Fred has more than 5,000 published photos in magazines, calendars, notecards, books and advertising. He has produced 11 books of his work including: *Alaska, America, Arizona, Bush Pilots of Alaska, Rock Art of the American Southwest*, and *Yellowstone*. Fred and Randi call Alaska's Matanuska Valley home.

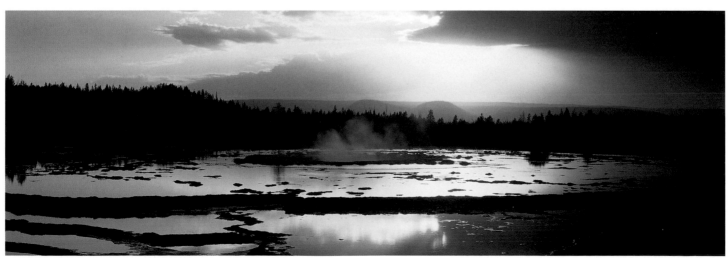

Great Fountain Geyser, Yellowstone National Park, Wyoming (© James Randklev)

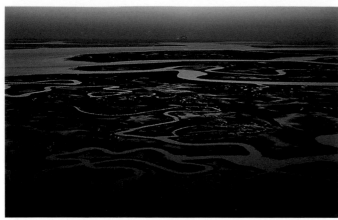

St. Helena Sound, South Carolina (© Tom Blagden)

Charles Krebs

Charles Krebs began photographing the natural world in the early 1970s. In 1979, he left the East Coast to settle on the West Coast, where his photographic avocation became his full-time profession. Charlie has contributed to and completed assignments for many national and international publications, and his work is regularly seen in *Audubon* and Sierra Club calendars, among others. Charlie is the author of two books, both regional best-sellers: *Seattle* and *Portrait of Seattle*. He has spent the past seven years concentrating primarily on stock photography, marketed through photographic agencies in Seattle, New York, and Tokyo. Charlie lives in Issaquah, Washington, with his wife and five children.

Frans Lanting

Frans Lanting has been hailed as one of the world's finest nature photographers. His distinctive images have been featured in virtually every major magazine. Frans is known for his compelling visualizations of the relationships between people and nature, as well as for his relentless patience and persistence in pursuit of an image. Frans was born in the Netherlands and moved to California in 1980. For the past 17 years, he has been a professional nomad, documenting wildlife around the world, including the first photographic coverage of the fabled pygmy chimpanzee of the Congo Basin. Frans has produced eight books, including *Madagascar: A World out of Time* and the award winning *Okavango: Africa's Last Eden*. Frans lives along the coast of California.

Wayne Lynch

Dr. Wayne Lynch is a former emergency physician who has worked for the past 17 years as a full-time science writer and photographer. He is the author of award-winning books and television documentaries, a popular guest lecturer, a Fellow of the Explorers Club, and Canada's best-known and most widely published wildlife photographer. His photo credits include hundreds of magazine covers, thousands of calendar shots, and tens of thousands of images published in over two dozen countries. Wayne is author and photographer of *Married to the Wind*, a natural history of the northern grasslands, and *Bears*, the definitive study of the comparative ecology of bears. His most recent and third book on the wildlife of the Arctic is entitled *A is for Arctic: Natural Wonders of a Polar World*. Wayne lives in Calgary, Canada, with his wife Aubrey Lang, who is also a writer.

Tom Mangelsen

Tom Mangelsen has long been recognized as one of the nation's premier wildlife photographers. With a background in wildlife biology, Tom's photography artistically captures the essence of the animal, for which he was named the BBC Wildlife Photographer of the Year in 1994. Tom is also a gifted outdoor cinematographer and has produced two films: *Flight of the Whooping Crane*, nominated for an Emmy, and *Cranes of the Grey Wind*. In 1978, he opened the first of nine galleries displaying his fine-art, limited-edition photographs. Tom's work is widely published in magazines and calendars. His first book, *Images of Nature: the Photography of Thomas Mangelsen*, was published in 1989. Tom lives in Jackson, Wyoming.

Joe McDonald

Joe McDonald has photographed nature professionally since high school, turning full-time in 1984. Although he enjoys all aspects of nature photography, his specialty is dramatic close-ups and action photographs of wildlife. Joe is the author of five books including: *The Complete Guide to Wildlife Photography*, *Designing Wildlife Photographs*, and *Photographing on Safari*. His work has appeared in every major natural-history magazine, including *Audubon*, *Birder's World*, *Natural History*, and *National Wildlife*. Joe leads photography tours throughout the United States and to many foreign destinations. Joe and his wife, Mary Ann, who is also a nature photographer, live in McClure, Pennsylvania.

David Middleton

David Middleton is a long-time professional photographer, writer, naturalist, and teacher. He has led photography and natural-history tours across North and South America for more than 20 years. David is also a noted teacher and a popular presenter of photography workshops. His numerous photography and writing credits include a wide variety of calendars, books, and magazines. David has produced two books, *Ancient Forests* and *The New Key to Ecuador and the Galapagos Islands*, a guide for ecotourists that he co-authored. David is director of photography and author of the text for *The Nature of America*, and is currently working on a companion book, *The Nature of Japan*. David lives in the Colorado Rockies.

David Muench

David Muench is perhaps the most well-known and respected landscape photographer in the world. David's primary goal in photographing nature is to capture the spirit of the land in order to make people aware of the importance of preserving what is wild. His sensitivity and determination to champion the strength and beauty of the land have led to extensive appearances of his work in magazines, books, advertising, and numerous gallery exhibits. David has produced more than 40 photography books, including *California*, *Arizona*, *Utah*, *New Mexico*, *Texas*, *Colorado*, *Oregon*, *Washington*, *Ancient America*, and *American Landscape*. David lives in Santa Barbara, California.

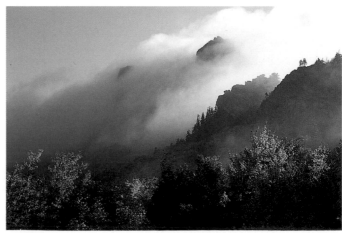

Grandfather Mountain, North Carolina (© Hugh Morton)

William Neill

William Neill is a landscape photographer whose images convey the intimate detail and abstract qualities of the natural world. His work has appeared in a variety of publications, including *Smithsonian, National Wildlife, Condé Nast Traveler, Gentlemen's Quarterly, Wilderness, Sierra,* and *Life* magazines. Six books feature Bill's photographs, including *By Nature's Design, The Color of Nature, Yosemite: The Promise of Wildness,* and *Landscapes of the Spirit.* In 1995, Bill received the Sierra Club's Ansel Adams Award for conservation photography. He is currently working on a book on New England. Bill is a long-time resident of Yosemite National Park, California.

John Netherton

John Netherton is a native of Tennessee and has been photographing nature for more than 25 years. He is a columnist for *Outdoor Photographer* magazine, and his work has appeared in a wide variety of books, calendars, and magazines, including *Audubon, Natural History, National* and *International Wildlife, Birder's World, Wild Bird,* and *Nikon World.* John has produced 13 books, including *Tennessee: A Homecoming, Big South Fork Country, Tennessee Wonders, Frogs, Snakes,* and *Smoky Mountains.* Over the years, John has studied with such greats as Ansel Adams, Eliot Porter, and Ernst Haas, developing a style that reflects his sensitivity and respect for nature. John lives in Nashville with his wife Judy and their five sons.

Pat O'Hara

Pat O'Hara's award-winning career has gained him international recognition. A longtime resident of the Northwest with a long-held interest in nature, Pat earned a graduate degree in forestry before turning full-time to photography. Initially specializing in western North America, his travels now often take him abroad, especially to Russia. Pat has been a professional photographer for 20 years, and his images have appeared in hundreds of publications including books, magazines, and calendars. Fourteen large-format books have featured his images, including *Wilderness Scenario, Olympic Ecosystems, Northwest Coast,* and *Washington's Wilderness.* Pat and his family make their home on the Olympic Peninsula in Washington State.

Bryan Peterson

Bryan Peterson specializes in nature and location photography all over the world. He is well known for his creative use of subject and light, and for his compelling graphic compositions. Bryan's photographs are widely published in magazines, calendars, and international advertising. Bryan has earned much recognition for his photography; he has won the Communication Arts Annual Photography Award five times and the Print Magazines Design Annual Award four times. He is the author of three instructional books: *Learning to See Creatively, Understanding Exposure,* and *People in Focus,* and he has instructed more than 12,000 people in photography workshops throughout America, Europe, and Asia. Bryan lives in Sonoma, California.

Rod Planck

Rod Planck has been a professional photographer for more than 20 years. He regards his career as a nature photographer as more of a lifestyle than an occupation. Rod's photographs have been featured in such publications as *Audubon, Geo, Sierra, National* and *International Wildlife, Backpacker, Birder's World,* and *Ranger Rick.* His photographs have also been used extensively in books, calendars, and advertising. The book *Nature's Places* is

Pointed Phlox, Texas (© Tim Fitzharris)

dedicated exclusively to Rod's photographs. Rod is a popular lecturer and enthusiastic teacher of nature photography throughout the United States and Canada. Rod makes his home in Paradise, Michigan, with his wife Marlene.

James Randklev

As a travel and scenic photographer, James Randklev has diligently pursued his unique portrayals of nature for more than 24 years. Photographing primarily with large- and medium-format cameras, Jim's explorations have led him through most of the parklands and backroads of North America. His work has been used in advertising, books, and such numerous magazines as *Omni, Travel & Leisure, Sierra, National Geographic Traveler, Natural History,* and *Outdoor Photographer.* Jim has produced over 60 calendars of his photographs and three books: *In Nature's Heart: the Wilderness Days of John Muir, Georgia: Images of Wildness,* and *Wild and Scenic Florida.* Jim resides in Tucson, Arizona.

Galen Rowell

Galen Rowell is America's best known adventure nature photographer. For the last 25 years his love of mountaineering and his talent for photography has led to his images appearing in countless publications around the world. Born in California, he made over 100 first ascents in the Sierras by the time he was 16 years old. Since then, he has participated in climbing expeditions to every major mountain range in the world, including first ascents of several Himalayan peaks. In 1984, Galen received the Ansel Adams Award for his contributions to the art of wilderness photography. He has produced 13 books of photography including *Poles Apart, Bay Area Wild, Galen Rowell's Vision, Mountains of the Middle Kingdom* and *Mountain Light.* Galen and his wife Barbara live in Emeryville, California.

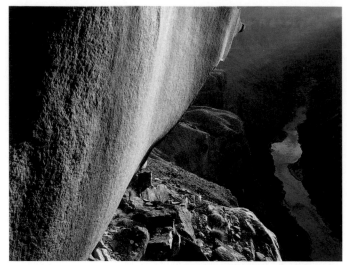

Toroweap Point, Grand Canyon National Park, Arizona (© Pat O'Hara)

John Shaw

John Shaw is one of the most accomplished nature photographers of our time. His photographs have appeared repeatedly in top national and international nature and photography magazines, books, and calendars. He is also a popular lecturer, teacher, and international photography tour leader. John is the author and photographer of five best-selling photography books, *The Business of Nature Photography*, *John Shaw's Landscape Photography*, *John Shaw's Focus on Nature*, *John Shaw's Close-ups in Nature*, and *The Nature Photographer's Complete Guide to Professional Field Techniques*. John lives with his wife Andrea in Colorado Springs, Colorado.

Jim Sugar

Jim Sugar is an award-winning outdoor photographer with 30 years of photography experience. For more than 20 years, Jim was a full-time photographer for *National Geographic* magazine, covering such diverse subjects as Iceland, Ireland, manatees, starfish, Ukrainian Easter eggs, wheat cutters, and Haley's comet. His photographs also regularly appear in a variety of other magazines, including *Smithsonian Air & Space*, *National Geographic Traveller*, *National Geographic World*, *Flying*, and *Popular Mechanics*. Among the awards Jim has won are first places in annual contests by the National Press Photographer's Association, White House News Photographer's Association, and the World Press Photo Club. Jim lives with his family in Mill Valley, California.

Steve Terrill

Steve Terrill is a self-taught photographer and a native of Oregon. Steve's career started when he captured the eruption of Mt. St. Helens in 1980, and he has been trekking throughout the Northwest and the United States ever since. Steve's work has been published in numerous books, calendars, and such magazines as *Audubon*, *National Geographic*, *National Wildlife*, *Travel & Leisure*, *Outdoor Photographer*, *Sierra Club*, and *Readers Digest*. Steve has six books to his credit, including *Oregon: Images of the Landscape*, *Oregon: Magnificent Wilderness*, *Oregon Coast*, and *Oregon Wildflowers*. Steve lives in Portland, Oregon.

Larry Ulrich

Larry Ulrich began his photographic career selling his prints at street fairs and craft shows throughout the West. He discovered that publishers would buy his images for books and calendars, so he started traveling and shooting full-time in 1972. Teamwork is essential to Larry's photography; his wife, Donna, is a second set of eyes, chief field critic, and a terrific companion. His

photographs have appeared in Sierra Club calendars and such magazines as *Audubon*, *Arizona Highways*, and *Outside*. Larry has produced eight books, including *Oregon*, *Arizona: Magnificent Wilderness*, *Northern California*, *Wildflowers of California*, and *Wildflowers of the Pacific Northwest*. Larry and Donna live in Trinidad, California.

Kennan Ward

Kennan Ward is an adventurer/naturalist who specializes in photographing wildlife in remote areas. Formerly, he was a ranger at Yosemite National Park but gave it up in 1980 to pursue photography full-time. Kennan and his wife, Karen, who is also a photographer, have lately traveled to Alaska, Africa, Hawaii, Costa Rica, France, Papua New Guinea, Russia, and Guatemala. His work has appeared in many calendars and magazines, including *Audubon*, *BBC Wildlife*, *National Geographic*, *GEO*, *Outside*, *National Wildlife*, *Stern*, and *Equinox*. Kennan has produced two books: *Grizzlies in the Wild* and *Journey of the Ice Bear*. Kennan and Karen live in Santa Cruz, California.

Art Wolfe

Art Wolfe is one of the most celebrated wildlife and nature photographers in the world today. With a degree in painting, Art is known for his unique work combining grand composition, subtle use of color, and unusual lighting. A native of West Seattle, Art travels 10 months of the year, shooting for magazines, his stock agency, and his many book projects. His images have long graced the pages of both national and international nature and wildlife magazines. Art has released 30 books, including the internationally acclaimed *Migrations* and *Light on the Land*. His three most recent releases include *Rhythms from the Wild*, *Rainforests*, and *Tribes*, a look at the indigenous peoples of the world. Art lives in Seattle, Washington.

Norbert Wu

Norbert Wu has been bitten by sharks, run over by an iceberg, stung nearly to death by sea wasps, and trapped in an underwater cave. His writing and photography have appeared in numerous books, films, and such magazines as *Audubon*, *International Wildlife*, *National Geographic*, *Omni*, *Outside*, *Smithsonian*, and *Time*. Norbert is the author and photographer of seven books, including *Life in the Oceans*, *Beneath the Waves*, *Splendors of the Seas*, and *A City Under the Sea*. Norbert has worked as chief still photographer for Jacques Cousteau's Calypso, as research diver for the Smithsonian Tropical Research Institute, as cinematographer for numerous television productions, and as underwater photographer for expeditions ranging from the freezing waters of the Arctic to the equatorial Pacific. When he dries off, Norbert lives in Pacific Grove, California.

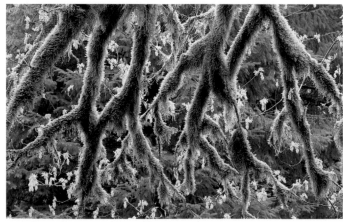

Quinault Rain Forest, Washington (© Charles Krebs)